BIG BUCKS

SELLING YOUR PHOTOGRAPHY

A Complete Photo Business Package
for All Photographers

CLIFF HOLLENBECK

AMHERST MEDIA, INC. ■ BUFFALO, NY

ABOUT THE AUTHOR

Cliff Hollenbeck is a leading photographer, film maker, and author in the travel industry. Along with his wife, Nancy, he specializes in commercial and editorial image making for major airlines, cruise lines, advertising agencies, magazines, book publishers, and tourism associations around the world.

The Hollenbecks have authored twenty books on travel, photography, and business, including *Freelance Photographer's Handbook, Great Travel Photography,* and *Make-up Techniques for Photography* (all from Amherst Media), and their current best-selling pictorials, *Hawaii* and *Portrait of Hawaii* as well as a coffee-table book, *Mexico,* with renowned novelist James A. Michener (all from Graphic Arts Center Pub. Co.). Cliff Hollenbeck is also the author of *Swimsuit Model Photography* (Amherst Media).

Cliff has twice been named Travel Photographer of the Year by the Society of American Travel Writers, and has participated in several *Day In the Life* (a series of books published by Collins) projects. He also authored the travel-mystery novel *Acapulco Goodbye* (Amherst Media) and has written and produced two music albums of Italian arias.

The Hollenbecks' film and video productions have received Gold Medals at the International Film Festivals in New York and Chicago, where they also won a coveted Golden Camera Award. They have earned several TELLYs for travel and tourism sales videos and international television commercials.

Published by:
Amherst Media, Inc.
P.O. Box 586
Buffalo, N.Y. 14226
Fax: 716-874-4508
www.AmherstMedia.com

Publisher: Craig Alesse
Senior Editor/Production Manager: Michelle Perkins
Assistant Editor: Barbara A. Lynch-Johnt
Editorial Assistance: John S. Loder

ISBN-13: 978-1-58428-216-7
Library of Congress Control Number: 2007926871

Printed in the United States of America.
10 9 8 7 6 5 4 3 2 1

CONTENTS

Thank you for reading my book and for helping to make it a perennial best-seller! I hope this edition adds even more profit and enjoyment to your successful photography business.

Several years ago the people at *Photo District News* (*PDN*) invited me to speak about travel photography at their annual conference in New York. During the question and answer period someone in the audience stood up and said, "All of these travel photos are beautiful, but what I really want to know is, how do you make the Big Bucks in photography?" My brief reply spawned several additional business-related seminars with *PDN* and became the basis for the first edition of this book. The question, how can you earn the Big Bucks? is one that must be revisited as the industry changes.

Amherst Media publisher, Craig Alesse, has asked me to review and update *Big Bucks* to produce a second, third, and now fourth edition. Each time, I have attacked the text with well-meaning intentions to completely revise every single word since the previous edition was published. And each time, including this one, I've found that the more technology changes in photography, the more the marketing, sales, and administration stay the same. Obviously, the constantly changing equipment and sales technology have also been modifying the way we do business, and they are the reasons for revising this book once again. However, creativity, good sales, and solid business practices are basically the same as ever, and they will always be the most important ingredients in the formula to make Big Bucks in photography.

Please forgive me if some of the suggestions and opinions I offer get to be a little repetitive throughout these pages. I've tried to make it possible to open up to a single topic and get useful information, without having to read everything in the entire chapter or book. The information in this book comes from my own business experiences, as do the names of people and products that are recommended. These should be considered starting points from which you learn and research what may help in your own business. If you find something, or someone, not to be as I've presented in these pages, please let me know and I will make appropriate changes in the next edition.

Once again, I thank the many people who have contacted me to exchange ideas and ask me to present seminars or workshops about *Big Bucks* and the other books I've written. The fact that you find what I have to say useful is an inspiration to my writing and photography. I appreciate your questions and suggestions. For those new photographers reading this book, hoping to learn the secrets of success in this crazy business, I hope you find them within these pages. I wish you good shooting and good business. For those of you who have hung around through the previous editions, I hope that you will once again glean something to improve and enhance your existing business practices.

I leave you with some sound advice from the great Gandhi:

Live as if you were to die tomorrow. Learn as if you were to live forever.

I also offer a little advice of my own:

Always get cash up front.

INTRODUCTION

It's one thing to make great photography, something else again to sell it and administer those sales into profit.

Photography, in its multitude of forms, is the most creative means of communication and art known to humankind. Best of all, it's within the reach and use of almost anyone who can see. It's so easy, in fact, that *National Geographic* once ran a cover photo taken by a gorilla (October 1978). We all know a few photographers who are related to this gorilla.

There is little doubt that the ease with which photography is made today is also the reason many people prematurely hang out their shingle as professionals. These new professionals often do not have the skills to be in any business, let alone those necessary to fulfill the far-ranging, roller-coaster demands of commercial photography.

This book can help you with ideas and suggestions about the business and selling of photography, which can make you a more successful photographer. There are no pretty pictures or claims about how great Cliff Hollenbeck can shoot. What you will read comes from over twenty-five years of photography business experience, plus a firsthand observation of the leading photographers in the world.

I've tried just about everything in this crazy business, and I've made a few mistakes and have had some pleasant success along the way. What I suggest may or may not be ideal for your own business. It should be considered a starting point for a never-ending education in photography. This book is a collection of my candid opinions, not gospel. If you follow my guidelines and suggestions and have great success, thank me. If your photo business is a total bust, blame your mother-in-law. Everyone else does!

KEEP THINGS SIMPLE

Success in any profit-oriented business requires a few simple talents, most of which can be learned or imitated well enough to make a decent living. Don't fool yourself or let others talk you into making things more complicated than necessary. The basic facts are that you need quality products, good business sense, strong marketing, outstanding service, and the right attitude to make the Big Bucks in photography.

Simply put, making Big Bucks depends on how well you provide those basics. Because photographers are the marketing tools of huge consumer-oriented organizations, things often seem anything but simple or profitable. It may be difficult to remember that the job is to drain a swamp when you're up to your Nikon in alligators, but try to keep your business and selling focus on the job and client at hand. Don't try to solve the many copyright, work-for-hire, electronic imaging, royalty-free photography, and mega stock agency problems, and the other uncertainties of our time. Leave those provocative subjects for the hotshots, who are much better equipped to do that worrying. You will be better able to deal with these things, and the day-to-day photography business, by joining a professional association and allowing its directors to take the lead. Otherwise, the selling and administering of your work will be a big enough job.

THE TRUTH ABOUT PHOTOGRAPHY

Two photographers were on Kodiak Island, in Alaska, making pictures of a huge grizzly bear. Suddenly, the bear rose up and charged. One of the photographers dropped everything and started wildly running away. The other shouted, "Hey, you can't outrun a grizzly!" Still running, he yelled over his shoulder, "I only have to outrun you."

Think of the marketing world, clients, advertising and stock agencies, and publishers as a huge grizzly bear. As this giant charges along in business, it eats creative people for lunch—especially photographers. Those who manage to stay ahead of the competition will be around when the bear takes a break. At this point, we have the opportunity to do a little business. And opportunity is all we need.

SELLING YOUR PHOTOGRAPHY FOR BIG BUCKS

Staying ahead of the grizzly bear and making Big Bucks in photography requires the following simple ingredients:

- Commitment
- Competence
- Quality product
- Outstanding service
- Goals
- Organization
- Humor
- Persistence
- Family wealth

Family wealth aside, this book expresses my thoughts on how to meet these basics of good business and stay ahead of that charging grizzly bear.

1. THE INSANITY OF FREELANCING

You don't have to be crazy to succeed as a photographer, but it sure helps. It's okay to be crazy, but not stupid.

A guy driving along a country road had a flat. While changing the tire, he placed the wheel's lug nuts in the hubcap and set it alongside the road. As he was about to replace the flat, another car drove past and hit the hubcap, sending his lug nuts to the bottom of a nearby creek. Banging his head against the car, the man wondered, aloud, how could he get back to town to buy new lug nuts?

"Why not take one nut from each of the other wheels? That should get you in to town," a voice replied. The man with the flat looked up to see a man leaning over a fence. A sign on the fence read Sunnydale Asylum for Mentally Ill Photographers.

"That was a pretty good idea," he said to the man. "How come you're in an asylum?"

"I'm crazy," he replied, "not stupid."

This story isn't true, of course, because all the really crazy photographers are still on the streets and in business for themselves. The stupid photographers are the would-be artists who think business and marketing will take care of themselves. They often just lose their assets and finally go into more meaningful careers.

HOW TO MAKE BIG BUCKS
Big Bucks photographers are made or unmade by themselves.

Every day you're in business there is opportunity to grow and prosper, and the equal opportunity to stagnate and fail. Your attitude, persistence, and goals determine which happens—to a far greater degree than your photographic talents.

Take a close look at the successful people around you. Read the books written by successful business and social leaders. What are the main reasons for their success? I'll bet each of them knows who they are, where they're going, and why they are successful. Even more important, they have a positive attitude and sensible goals.

To be successful in life and photography, be positive and planned in every action.

Rarely will you find a successful person who credits or relies on luck. The funny thing about luck is, the better prepared and more determined I am, the better my luck seems to be. The harder I work, the more sales calls that are made, the better my luck. Plan to succeed. Be positive. Prepare and get to work. Your luck will improve as a result.

SUCCESS FORMULA
My formula for success requires:

- Quality products and service
- Good business sense
- Persistent sales efforts
- A positive attitude

In order to make Big Bucks you must score above average in each of these areas and have a strong commitment and determination to succeed.

Right about now, you're thinking this formula isn't any new secret way to making Big Bucks and success. I know it sounds like pretty basic stuff, and that's because it is pretty basic stuff. As with any formula, the better your ingredients, the better your results. Any baker soon learns that if you cut corners, the cake will be a disaster.

If you produce sound creative work, provide excellent client services, and back these up with good business practices, a solid marketing program, and a positive attitude, success will be yours. It's just that simple. Notice I didn't say it was going to be easy.

A good attitude is the single most important ingredient in any successful business.

Freelance photography, in its variety of forms and specialties, can present many challenges on the road to success and continued success. As you travel along this road, you can be your own best friend or your own worst enemy. The choice is yours and it's made daily in every thought and action.

Over the years I've developed a simple philosophy to check and keep my attitude positive. It has evolved into a simple list of do's and don'ts. I suggest that you read it every Monday morning in planning the week's business activities:

- Think, act, and speak positively.
- Keep your sense of humor.
- Profit from mistakes.
- Enjoy your successes.
- See the best in yourself and others.
- Don't take a failure or rejection personally.
- Don't criticize yourself, competition, or clients.
- Don't make excuses or complain.
- Don't worry about what you can't change.
- Don't dwell on setbacks.
- Dream lofty dreams.
- Live life to its fullest every moment.
- Never quit.

PHOTOGRAPHY vs. THE BUSINESS OF PHOTOGRAPHY
Photography is a wonderful art. Just make sure you don't become a starving artist.

If you're going to succeed in photography, act and think in terms of running a business and selling a product. If you dwell on the artistic merits of photography, of which I agree there are many, do not let these thoughts interfere with taking care of your business.

Ever notice what happens when a good business idea takes off? Everybody and their brothers jump on the bandwagon. Take, for example, the movie rental business. It was a great idea. For a few bucks, you can rent and view in the privacy of your home thousands of movies. The idea was so good that thousands of places and web sites are now in that business. So many have sprung up that banks now refuse to make business loans to most new movie rental entrepreneurs.

And so it is with photography. The basics of the art and science of making images are easy. Its attraction as a business is compelling to those in seemingly more mundane professions. As a result, many people jump in with little thought about the realities of making that business profitable. These people feel that if they can make a few nice photos of flowers, lovers, and vacations, they should be able to make a living. I know that's how many of us got started, but the best of the best have brought a lot more to the business.

Business is Business. Whether you plan to make and sell widgets or photographs, the business principles are the same. Prepare yourself every day—mentally, physically, financially, and creatively—to take care of that business. If you don't, photography is so easy there will be someone there to immediately take over when you fail.

While I was growing up, my parents, teachers, bosses, and just about everyone else harped, "Learn from your mistakes." I profit from mine. I hope you will as well.

Profit from Your Mistakes. As a freelancer for some twenty-five years, I've tried many avenues that pointed toward success. I've also made a few mistakes along the way. I found out early that it's okay to make a mistake. Recovering and learning from your mistake is a valuable experience. Making it a second time is unacceptable, and it's your own darn fault.

Sometimes, a mistake or rejection can lead toward hard feelings, accusations, and even lawsuits. If there's one thing I've learned in the cruel business world, it's never to hold a grudge or waste time worrying or seeking revenge. The best revenge is your continued success and happiness.

So you made a mistake. 'Fess up right now, admit it to those concerned, and take immediate corrective action. Don't hope that no one will notice, that the client will miss the error, or that you can lay the blame on others. Don't get drunk, or there will be additional mistakes made.

I once worked for an airline public relations executive who was always saying, "We don't make mistakes or have problems, we are presented with opportunities." He was right, because everyone makes mistakes. It's how you react and what's learned that will determine what kind of businessperson you are in the long run.

Once you've corrected a mistake and the cause, put it in the memory bank and get on with business. Don't spend the rest of your day or life trying to figure out the mistake, or why there are mistakes in general. Leave this sort of thing to the people who have the time and money for analysis.

Profit from Your Success. Spend a little time thinking about the roots of any success in your business. Why does a certain approach work better with one client than another? What's the reason a client came back or recommended you to someone else?

Believe it or not, many people think success just fell into their laps. If you can determine the reason for a certain positive result, the action can be repeated again and again for even greater profits.

Ask clients how they came to do business with you. Was it your web site, a portfolio review, a sales call, a referral, a flyer, an advertisement, or what? This is a perfectly normal and expected question in the business world. The answer may surprise you. What you do with the answer should surprise no one.

FREELANCE PHOTOGRAPHY
The real world demands hard work to become a success. Photography also demands smart work.

The Perspiration Factor. Success and all that it brings isn't often the result of sweat. You can work yourself to the bone

every day, and it will probably cause a bad back, tired feet, and an empty bank account. You can also sit on your butt and get fat with similar results. Neither is the road to great success.

Work smart. Use your mind before breaking your back. Make good business decisions. Take a few risks in new markets. Try something new in selling and shooting. Keep track of what's working, and do it again and again.

All the talent, education, and hard work in the world will not replace persistence. Say this to yourself every morning.

The Persistence Factor. The more determined and dedicated you are, the more success there will be. Establish a good business plan, set sales goals, and start right now. Stick to the job at hand, get it done, and move on to the next one and the next one. Never quit.

Lots of businesses fail only inches short of success because their owners give up. Perhaps they don't recognize that success is just beyond the horizon. If they had just made another sales call, sent another flyer, or simply asked for the business of an old client . . . Don't ever quit.

In the music business, disc jockeys say that most songs are noticed by the public, becoming hits, at about the time everyone around the radio station is sick of hearing them on the air.

In his great baseball career, Babe Ruth struck out more times than he hit home runs. At one point, he held the world's record for both strikeouts and home runs.

I'm not crazy about comparing life with sporting events. Having the ability or guts to push for another yard on the football field doesn't always translate into success in the real world of business. Only a noted small number of professional athletes also win in business. Having said this, I should point out that beyond a natural talent, most athletes are successful because they are persistent. The harder and more often they try, the better they get and farther they go. These factors do translate into success in the real business world.

PLANNING TO WIN
All the world's great achievements began as dreams, and people turned them into goals and then reality. It's okay to dream, but it's not okay to be a dreamer.

Plan to win by setting business goals and establishing priorities. Write down your ideal business situation for one year and five years from now. Make the listings in the present tense, as though they already exist. Update your goals yearly,

taking a look at the previous year's desires for a little motivation. Some examples of this type of goal-setting include:

- Sell $100,000 in stock images yearly.
- Shoot a national client job each month.
- Add one major new client each quarter.
- Employ three full-time people.
- Occupy a 5,000-square-foot modern studio.
- Shoot with a supermodel.
- Shoot four national magazine features per year.
- Shoot in northern Italy every year (that's *my* annual goal).

List as many goals as you want. After setting your goals, rank them according to their importance to you and your business. Be honest with yourself about your capabilities. Assign the letter A to the most important and desirable items on all your lists of goals, projects, and desires. Assign the letter B to things that would be nice to accomplish immediately after the A section but that you can live without for now. Assign the letter C to all other items. Now put every A item on a special list and get going. B and C will fall into place.

Planning ways to get your photos in front of people who buy photos will sell your photos.

Action Planning. What you do determines whether or not goals and priorities become a reality. Talking, making lists, and waiting for the phone to ring won't bring in business. You must plan to go out and get it—and then you must do it.

Start Right Now. Take charge of your life and make business decisions that are aimed at improvement and growth. Do it today. If you wait around for the phone to ring, it won't. If you start making calls to all the potential clients out there, the phone will soon be ringing off the hook.

Let others know you're busy and successful, because that's the kind of professional they want on their team.

Always keep an active list of project ideas and high-profile clients. These might be potential editorial or stock shoots, or they might be dream assignments or just plain fantasies. Plan one of these shooting projects as though it were a paid assignment. Make a few calls to clients who share your interests and invite them to come along for the fun of participating. Call in a few favors from other potential participants. Shoot the project. Share the results with those who help. Use this project for sales efforts, stock, and an assignment teaser. Call this personal shooting, practice, testing, or whatever, but do it at least once a year. It will sharpen your skills and

keep you working toward shooting goals. They will also become good sales tools. And, when you read the chapter on taxes, you may find such self-generated work is tax deductible.

Freelance photography is a demanding mistress who rarely takes second place to anything or anyone.

Associates. The satisfaction and highs created by a successful photography business are wonderful. The most stable shooters keep these times constantly in their minds as a sort of bait, to keep them plugging away when business isn't so good. As in any profession, there will be times that are slow or seasonal. Planning and saving for these rainy days will preserve your sanity and keep you around until business picks up again. And business will improve if you keep making sales calls.

As a group, photographers are a little like cowboys. Few people really understand them or their motives. Their fierce independence often makes them fair-weather friends and difficult to know or appreciate very well. They have a selfish, constant desire to create and compete (mostly with themselves). However, when a photographer's life and business are moving along at a successful pace, they are enjoyable characters.

Even the most successful creative life is, at times, a rocky road to travel. More often than not, you must be your own best friend and your own counsel. Some of us are fortunate enough to form associations with positive and successful people of like minds. These people generally have the same holding and staying power we require for survival. I'm fortunate to share the photography business with my wife, Nancy. She is dedicated to our success, in addition to being an excellent shooter and businessperson.

You, too, must associate with positive people who not only believe in themselves but believe in you as well. However, the most important person who must believe in you is you.

Self-confidence is the strongest asset you can possess.

Who Are You? You must be happy with who you are and what you stand for as a photographer and as a person. These two are one and the same. You must feel good about yourself, look the part, and communicate this well-being to the photo buyers of the business world. Smile and show a little humor as you approach life's challenges. You only get one chance to live life, but there are always two roads from which to choose. Take the high road to success and happiness.

While you can't always choose your business circumstances, you can always control your attitude and thoughts.

Be positive, think great thoughts, aim high, and be happy with yourself. In the end, the business circumstances will improve, and eventually you will be able to control the choices.

PLAYING TO WIN
Photography, business, and life in general are all a big crapshoot. Play to win self-satisfaction with every throw of the dice.

You alone must determine what satisfaction, success, and financial rewards you desire from photography. In my case, I love to travel, explore, meet new cultural and language challenges, shoot beautiful images, and make a little money in the process. Pretty much in that order. I also planned to share it with someone special.

Most people are children of a material world; they keep track of their success strictly in terms of cold, hard cash. It's been my experience that most photographers have a drive to create images that is stronger than their drive to make money. Once this creative drive is being satisfied on a regular basis, the need for a little material comfort pulls into a strong second place. Well, there is nothing wrong with being able to pay the rent on time.

If you want to make Big Bucks selling your photography, you must dedicate your life to the business of photography—now!

I believe in karma, which, in simple terms, means you generally get what you have given and what you deserve. No one will be handing you assignments on a silver platter. What you get you will earn and deserve. What you don't get may come around if you give it another try. Never quit.

Get out there and let the people who control those Big Bucks know who you are, what you do, and what it will cost, and then deliver the most creative goods you can produce. Do it right now, tomorrow, and every day in every action.

Love what you do and do what you love.

After reading this entire book, please reread this chapter. Your attitude is just as important as your business savvy and photographic ability.

2. PHOTOGRAPHIC ABILITY AND CREATIVITY

"Nothing is more important than creative development. The best way to market yourself is to produce work that other people talk about. If you've got a great creative product, sooner or later you're going to be able to market it. No matter how badly you go about it." So says New York photographer Jay Maisel. And he should know, because he is one of the most creative and successful photographers of our time. Maisel produces rich, creative images that meet both the high standards he sets for himself and the equally demanding commercial needs of major business organizations. This in itself is an art. Anyone who meets Jay Maisel finds him to be every bit the creative artist.

If you expect to be successful in selling photography, you must first have the technical and creative ability to produce that photography.

But there is another Jay Maisel many photographers sometimes fail to immediately see. This is the shrewd businessperson. Despite being an artist with a camera, Jay doesn't rely on his art to sell itself. The fact is, his success also comes from good solid business practices. The combination of art and business makes Jay Maisel someone you should watch and imitate from both perspectives.

CREATIVE ABILITY
Creative ability to produce images is the foundation of a successful and profitable photography business.

Simply put, adequate images will provide adequate income, and great images have the potential to produce great income. There's a lot of ground to be covered in the process of making your images.

Your Creativity. Though some photographers were born creative, it is a capability that, to a great extent, can be learned and constantly improved upon. Several factors can be brought into play to learn creativity, but the primary method is to follow the work of successful shooters, attend workshops, and shoot, shoot, shoot.

I constantly review the best photography being made in the world. It's a simple matter of reading several quality publications each month. For example, *National Geographic,* *Communication Arts, Islands,* and *Nikon World* are magazines that specialize in publishing a wide range of creative photos. Professional publications like *The Stock Workbook,* *Photo Media,* and Fuji's *Professional Profiles* showcase the work of today's best commercial photographers. There are also a host of coffee-table pictorial books published every year. And, lastly, I constantly surf the web sites of the photographers who made the images I admire.

I clip the best images from these national and international publications and make printouts from web sites, keeping them in a working idea file. These clipped images are selected for a variety of reasons such as interesting subjects, unusual lighting, new thoughts in composition, hot color and contrast, and outstanding photography, no matter the subject or photo specialty. By reviewing this file from time to time, I am able to improve my own approach to creative thinking. I frequently ask myself why each image was selected for my file in the first place. I also ask myself if my own work belongs in my idea file.

Start your own clip file by selecting images that reflect the type of images you wish to produce. Use this file to develop your own self-generated assignments. This means creating something new, something beyond the present range of your work. It hinges on developing something that challenges your imagination, using the clipping as a reference or starting point only.

Warning. In reviewing and clipping the work of other photographers, *do not* copy their images when you shoot. This will cause legal consequences. Instead, use their images to stimulate your own shooting ideas, lighting, and composition of different subjects.

WHAT IS A CREATIVE PHOTOGRAPH?
Viewer impact is what makes a photograph creative to potential buyers.

I know there are a hundred things that may play into a potentials client's view of your creativity and the purchase of your images. It is, however, the image impact, or viewer stopping power, that will generally determine the difference between making Big Bucks or small bucks (or *any* bucks, for that matter).

After completing a shoot, I always view the images as a whole if possible. Or, when there are hundreds of images and dozens of subjects, I view them by subject. I am looking to see if any single image stands out. This is often how clients make their initial selection from proof sheets, discs, or web postings of similar images.

One of my all-time best-selling stock shots, a young Hawaiian hula dancer, has immediate impact. It draws the viewer's eye, even among dozens of other images. This initial impact keeps making sales over and over again—and that should be your goal in editing as well as shooting.

Impact can mean a lot of things to you and your potential buyers. It can be subjects of unusual interest, exotic beauty, or simply the shock of a tragedy. It should be something the potential buyer needs. Impact is also created through composition, color, contrast, or a combination of these and other graphic elements. Some photographers confuse images of sensational events, spectacular locations, or bizarre subjects with creativity. Jimmy Bedford, the late University of Alaska journalism professor, said it best: "A creative photographer has the ability to make uncommonly good images of common subjects."

Being in the right place at the right time with the ability to use a camera allows you the opportunity to use your skill and training. Hotshots like David Burnett and the late Pulitzer Prize–winning photojournalist Eddie Adams make it their business to be creative no matter who, what, when, or where they photograph. Such photographers may be shouted at, shot at, and totally ignored by every subject imaginable—but they always come home with quality photography—images with impact. They make these images happen, tell a story, or illustrate something rather than simply recording the event or location. This is the goal we should all strive to meet.

Garbage In, Garbage Out. We live in a visual society, and the mass media inundates us with thousands upon thousands of images every day. Many of these images are limited to the recording of events, or snapshots of a moment in time. Many of these images are way more than the average person needs to know about a given story or subject, often shown over and over. We are blasted with this visual garbage until nothing seems to have much value or impact on our senses. In many cases, the emphasis seems to be on quantity rather than quality. Do not let all of this visual garbage turn off your own creative vision. As photographers, we must learn to ignore all but the most significant or creative of these images, the ones with impact.

Warning. If you spend too much time trying to digest the bulk of today's mass media garbage, it will dilute your ability to see properly in your own image-making. Spend more time shooting and reviewing quality images, no matter where they may be found, rather than sitting in front of a television or computer all evening.

MAKING QUALITY PHOTOGRAPHY

The difference between a good, creative image and a very bad one is, or should be, immediately apparent. After evaluating why a certain image you made has failed, erase it forever. If you save a poor shot, sooner or later a client will see it, usually at the wrong time, and make the wrong assumption about all of your work. Also, don't spend hours behind a computer trying to save an image. Shoot it right in the first place, or shoot it over.

How does an art buyer decide between two good, perhaps equal, images? The answer is usually in the form of a sale. In fact, the decision may be reached for two separate reasons: your style and your ability to make an image, and your ability to sell that image to that particular client. Both must be creative.

Developing your own style, one that results in photography with impact and quality, is something that requires lots of thought and practice. I call it thinking and seeing in images. Study, experimentation, self-generated assignments, and constant shooting will eventually lead you toward your individual look or style. Your own personal likes or dislikes, experiences, and environments will also influence this development.

Great photographic images are made when everything comes together in one perfect moment. Believe me, you'll know when this happens. For me it usually means being in the right place at the right time, with a plan in mind, seeing images develop, and having creative freedom to work around the subjects and assignment.

I did a photo shoot in Cancun, Mexico, for Hyatt International some time ago. Their Cancun Caribe Resort is an outstanding property on one of the most beautiful white beaches on the turquoise Caribbean Sea. Hyatt provided a smart corporate location production manager, a very cooperative and understanding resort manager, the best models in the business and, most important, the freedom to be creative in shooting the subjects they needed. The results were some very nice images, which satisfied both my standards and the client's commercial needs. Many of these images are being used today, several years later. It's wonderful to have this type of client support and confidence. It's also profitable.

Keep Shooting. Make the best images you can in every situation and of every subject. Ask yourself, "Is this picture going to be worth my effort?" If the answer is yes, shoot a few extra frames (which are referred to as similars, not duplicates) for the stock files. Of course, if shooting for a client,

you will need their cooperation to make and use such images. The same goes for working with models. Now the question becomes, is this subject worth spending a lot of time and shooting and looking for different angles and compositions? It should be noted that a seasoned and successful professional will rarely shoot a single frame of anything. If it's worth their creative time, it's valuable enough to want additional backup shots, angles, and different compositions.

When the shooting is completed, edit your work for quality. Good image editing demands the ability to separate yourself from the shooting. Consequently, the best photographers are not always the best editors. The ability to separate yourself from the shooting comes with lots of editing practice. It means spending hours sitting before a computer screen, or over the light table if the job requires film.

Sometimes there is a great picture right in front of you, but you can't see it for all the images.

Eventually you will be able to quickly view a selection of images with little or no magnification and immediately determine if they have any impact. This is exactly what the photo buyers will be doing, so use this as your own editing guide. Always provide only your best images to the clients for their consideration. It's always better to say a photo opportunity was missed than to show a bad shot. Always.

Provide your images in a format that is easy to view. I generally send Photoshop-generated contact sheets, usually on a disc or as an e-mail attachment, for easy viewing and difficult "borrowing" without compensation. I make sure the images on the proof sheets are large enough so that several shots can be viewed at once.

Never take a buyer's critical comments personally. Their job, which is similar to yours, is selecting the best images to sell a product, not stroking your ego. Pay close attention to a buyer's comments about photo needs, ideas, and things that can improve your ability to make, sell, and edit images. Make notes if possible, and incorporate these suggestions in your next shoot—especially if it's for the same client.

TECHNICAL ABILITY
Your images must be of the highest technical quality to sell for Big Bucks.

The highest technical quality means properly exposed, sharp, well lit, and in focus. I know there is a lot of "moody" photography being created and shown in a few "with it" publications and advertisements. Most of the better paying clients, and the people who buy their products, do not want to spend a lot of time trying to figure out what the heck is wrong with an image promoting their product. Use motion, soft focus, very low natural light, and unusual compositions only if and after you are able to make clean and sharp images—or when that's what the client has specifically requested.

You must be able to operate the equipment that is necessary to make images within your specialty. You must be able to do it in your sleep and in the dark. There is no excuse for not knowing how a particular camera, lens, computer, hard drive, light system, or other piece of equipment works—if you have that equipment with you on a job. When making images, you need to think about making images, not how to set the camera or focus the lens.

That said, there are photographers who confuse their exceptional ability to use equipment properly with the ability to make great photography. These people spend most of their time playing with equipment, shopping at camera stores, buying the latest gadgets, and talking to other photographers about such equipment. This time should instead be put to work shooting and experimenting with new equipment, and learning to use your current equipment as an extension of yourself under any conditions. Fumbling with equipment will eventually result in missed opportunities and lost images.

You must have the right equipment to do the job at hand and the ability to use that equipment both efficiently and creatively.

The Right Stuff. Never say something like, "I could make a great picture with a different lens, a different camera, or another piece of special equipment." It is not smart, let alone professional, to let a client know that you don't have the right equipment for the job or don't know how some of your equipment works. If you need a special piece of equipment for a particular job, rent it and test it before shooting the job. You must have the right equipment for the job.

Capability. Pretend that your livelihood, which includes those little extras like food and rent, depends on your extensive ability and knowledge to operate all of your equipment correctly. Because it does. You can gain this capability through lots of practice and, when everything else fails, by reading the manual. Another idea is to take a shooting seminar provided by an equipment manufacturer or a top working pro. They will share the latest tricks and modifications available, which can improve your shooting edge in making and selling images.

It's easy, and fun, to bluff amateurs, lovers, and people on the beach with a fancy Nikon with a long lens hanging around your neck. You can't, however, bluff photo buyers about technical ignorance or poor-quality images. Your im-

ages must be technically correct, sharp, and properly exposed, or they won't sell. Photo buyers can spot a poor technician quickly, which is why such photographers leave the buyer's office without a sale.

Specialization. If you have a burning desire to create great pictures of bananas, then you've got to be the best-possible banana photographer there is and find a market that needs banana photos. This is called specialization. If you want to make pictures of anything and everything, think about being a generalist. Later, you may find a more specific type of work that is both appealing and profitable.

Don't waste your time and energy making pictures of things that you don't approve of or downright hate. If you dislike alcohol, tobacco, corporate America, cars, politics, religion, or whatever, then don't shoot those things. However, if you plan on turning down an assignment to photograph the *Sports Illustrated* swimsuit issue, please give me a call.

I specialize in travel-related subjects—resorts, destinations, cultures, location fashion, countries, airlines, cruise lines, and other travel-related subjects. My stock images reflect the fact that I have a burning desire to see the world and photograph these kinds of subjects. I also appreciate beautiful suites in the world's greatest resorts and destinations, and traveling first class to get there as well. Making images that reflect this passion is my specialty. It is my business product.

While you must have the technical ability to make good images, few clients really give a rip how or where that knowledge was acquired.

Education *vs.* Experience. Which is more important technically, education or experience? Your clients don't care; they just want to see the images. For you, however, the two are equally important.

I have worked with assistants who were graduates of serious photography schools. Technically, they were very good. Many were better than I am, as a matter of fact. What they didn't have was experience dealing with the hodgepodge of people, modified equipment, crazy logistics, even crazier hours, and general screwups photographers face on many jobs—especially when you're halfway around the world, the temperature is through the roof, and no one speaks English. An ability to deal with these dilemmas can only come through experience on the job.

I have also worked with assistants who learned everything by trial and error—that is, by doing the job on the job. They were very good all around. The one thing these people didn't always have was that finely honed ability to make a technically perfect image. Most professionals, it should be pointed out, are constantly striving to meet this goal as well.

A little education mixed with a little experience always wins out as the best formula to become a successful photographer.

Where to Learn. Learn professional commercial photography by attending classes, seminars, and workshops, and by assisting—not by seeking and accepting a job that you may not be ready to handle. If you attempt to learn any profession solely on the job, such as in your own new business, the profession as a whole suffers a loss of credibility. Learning only by experience can also become so complicated and costly that you lose your business and career in the process.

Schools and Programs. Photography schools and programs that are part of higher-education systems are good places to learn and practice the technical aspects of photography. This is the most direct, and probably the most expensive, way to learn photography. Knowing and working with a number of these graduates led me to believe that there are some very good instructors on the scene.

Workshops and Seminars. Attending workshops and seminars conducted by working professionals is the way to build on your basic business knowledge and photographic ability. The best place to listen to experiences, see work done, and ask direct questions of the top professionals is a *PDN* photo conference. Presented in major cities throughout the year, these conferences draw top equipment and material manufacturers who show and offer instruction on their wares. The conferences present comprehensive seminars that are worth a thousand times their minimal fees. You can read about the best of these conferences and other professional workshops by subscribing to *PDN*.

Assisting Working Pros. Assisting a successful professional, it seems to me, is the best way to expand your basic knowledge of the business of photography. This is the place to see what it really takes to make salable photos and administrate a complicated creative business. If you get the opportunity to participate in both planning and shooting, you and the pro will benefit. If you watch and listen to what is happening around the shooting (general administration, client participation, marketing, logistics, and general attitude), you may learn what it takes to become successful.

Many of today's leading professionals once assisted leading professionals themselves. Stephen Wilkes, who assisted with Jay Maisel, is an excellent example of an assistant who became one of the best in the business. This is an ideal way to get acquainted with commercial photography without the risks and expenses associated with starting a new business.

I started my professional photographic career in Alaska, which is an experience in itself, during a time when few professionals resided in that great state. As a result, I learned

many lessons the hard way. (I still do, for that matter.) *Life* magazine's man on the scene, Joe Rychetnick, University of Alaska Professor Jimmy Bedford, and *Alaska* magazine editor Dick Montague all helped me in much the way a professional would help an assistant. They candidly shared their knowledge, experience, and suggestions. They took the time to examine my work and push me in the right directions. I couldn't have had better mentors, and I thank them here again.

Such relationships are more difficult today. For starters, people in these positions are constantly under the gun to produce materials for their employers. Few have the time to cultivate a young photographer's goals and desires. However, all is not lost. Many of these people, including me, participate in group seminars and workshops aimed at helping younger people get started. We don't get rich off these programs; rather, it is a way to share some of the experiences that have helped shape our own careers. These programs also help ensure that the next generation of professionals are just that, *professional*.

ASSISTING

Assisting working professional photographers is an excellent way to learn the business. There are three general types of assistant: full-time, freelance, and professional.

The full-time assistant is a house employee, much the same as a corporate executive's assistant. (By the way, the IRS is firm on this employee relationship, so make sure your taxes reflect this relationship.) Getting one of these rare jobs means selling yourself to the professional. Start looking among photographers you admire. Check with the ASMP (American Society of Media Photographers) and PPA (Professional Photographers of America) for the specialties in which you are interested and get the photographers' addresses. Write a simple letter, make a follow-up call, and try to schedule an interview. If you do get an interview, look the part, sell yourself, and show a few of your very best images related to the type of work you wish to do in the future. It might be easier to catch the pros at seminars or conferences where you can gauge their personality and interest in assistants. While an assistant hopes to someday have their own business, the professional for whom they work hopes for a long-term employee. You must sell the photographer on your desire and ability to do things that will enhance their work, not replace them as a shooter or steal their clients.

The freelance assistant is hired on a job-by-job basis as an independent contractor. They operate as their own established business, much like the photographers for whom they work. In addition to the business licenses, tax registrations, stationery, and other business trappings, freelance assistants must market themselves to photographers. This requires the same marketing and business skills that a full-time photographer must possess. Ultimately, they hope to learn from the professionals they assist and eventually establish their own business as a working professional. Both the assistant and professional who hires them know this is their goal.

Working with a variety of photographers as a freelance assistant is both demanding and rewarding. First, you must have a wide range of experience and knowledge just to get hired. Second, it's a great way to see how several different photographers approach business and shooting. This is an excellent way to eventually become a successful commercial photographer. These people are my choice as assistants.

The professional assistant is in business to be an assistant, not to be a commercial photographer, though that may occasionally happen. It's been my experience that these independent businesspeople are very good at assisting and are in high demand. Of course, they must also meet all of the requirements of being in a freelance business.

Overall, assisting is the ideal way to learn on the job, assuming you work with quality professionals. Some of the professional photography associations have assistant membership categories and help these people get employment.

If you are seeking employment as an assistant, or to work as a commercial photographer for that matter, it makes sense to look in the area where you eventually hope to be established. Don't look for work in Los Angeles if New York is where you hope to make the Big Bucks. Don't head for any big city if your heart's in the countryside. However, you can assist anywhere as a temporary educational endeavor.

If you are interested in becoming that famous banana photographer, there isn't much sense in assisting in fashion, travel, or architecture. In all of your interviews, remember that you ultimately want to be a photographer, whereas the professional wants someone to be an employee. You'll be showing a portfolio, while the photographer is looking at you and your abilities beyond photography. Approach them with organization, intelligence, and a willingness to work. As an assistant, you will get to do everything in the office or studio. That means everything the boss doesn't want to do. You won't get to be the photographer very often.

As an assistant, you may work for photographers who aren't as skilled as you are, and there are times when you could have made a better shot. How you handle these situations determines your future role in photography, certainly as an assistant. Be too pushy or cocky, and you might be looking for another job with a very poor performance report following you around. Keep in mind that being successful has a lot of requirements beyond your photographic skill. That's what this book is all about.

Personally, I want assistants to participate in my shoots. This means working with me to make good shots, as well as doing the heavy lifting. It means thinking about the shot and offering ideas that may improve what's being done. It also means making a shot, on occasion, with me assisting. However, it doesn't include making me look bad, especially in front of the client! Working with an assistant allows me to utilize another set of creative eyes on the job. It also means someone could take over if I am unable to work for any reason. I still call the shots and control the overall production. I also have the client contact, the contract, and the responsibility to deliver.

When seeking work as an assistant, or working as one, you're asking a professional to open up and share a lifetime of work, not to mention client confidences, with someone who ultimately wants to be a competitor. Some professionals can deal with this thought, and many can't.

PROPER EQUIPMENT

Think of your work as a parachute jump. The last thing you want to worry about is having the wrong equipment.

Use the best equipment you can afford for the job at hand. What is the best equipment? It's not always the latest high-tech digital camera system, although that's exactly what I use. The best equipment is dependable, easy to use, made for the job at hand, and within your budget. There's no sense in spending the entire family inheritance on equipment, unless you've got plenty of shooting jobs scheduled. Rent what you can't afford to buy until you can afford to buy.

In considering an equipment purchase, the best gauge is your experience and need. Few amateur retail camera store salespeople have any serious professional experience. If you want to talk with someone who knows the latest equipment, and how it works, shop at a professional store. You can tell the difference in these stores by the prices. Professional stores do not discount Nikon or Canon equipment. You pay for their knowledge and the opportunity to compare the best in professional equipment available. See your local yellow pages, check the web, or call any pro and they will recommend a good local store.

Never test newly purchased equipment or use an untested piece of equipment on any job. I don't even recommend buying equipment you haven't tested extensively. So what's the answer? Test equipment on a simulated job by first visiting the rental department of those professional camera stores. You'll have to secure rentals with a credit card or first-born child, but it will allow you to shoot with the equipment you hope to buy. Some of these stores will apply some of your rental fee toward the purchase of the same new equipment. Rental equipment gets well used, so if it holds up under those conditions it will probably work for you as well. Ask the rental people for their opinion on the new cameras. Test the rentals and test your new cameras.

I replace my camera bodies and lenses every two or three years. This means I have new equipment and the latest technology at all times. When something goes wrong with any piece of equipment, which is rare considering my turnover rate, I have it fixed and trade it in for a new item. I also have backups for every piece of equipment. I do not want to have any problems with my equipment when I'm working in the middle of nowhere.

PRACTICAL DIGITAL

The digital revolution has dramatically changed the way photographers create, administer, and deliver images to clients. At no time in the history of photography has the average individual photographer had greater control over so much of the process of creating and delivering images.

Photographers who can keep up with the ever-changing realm of digital technology have an advantage. If you have a limited aptitude for working with digital devices, spend some time doing your homework and building your skills. Remember, shooting digitally requires more that just learning how to use a new camera system; you must also learn how to operate a computer, popular software programs, and the Internet to share your images.

With digital, as with film capture, you must create images your clients need and are willing to purchase. You must also deliver a high-resolution image in a format your clients can use, whether this image originated in a digital camera or is a scanned photograph.

Digital Camera Systems. There are dozens of excellent digital camera systems on the market. Your photo retailer can help you select a model that suits your needs. However, some basics are outlined below.

Megapixels and Resolution. Digital SLRs currently offer 10–25-megapixel image sensors, and the megapixel rating can be even higher for digital backs. The higher the megapixel rating, the more detail the camera can capture in each image, and the larger your images can be printed.

Focal Length Factors. Some digital cameras feature full-frame image sensors (i.e., a sensor the size of a 35mm film frame). This means that a 14mm super-wide-angle lens sees and records just as it would were it used on a 35mm camera. Many digital camera have smaller image sensors, however. In such a case, a focal length factor is employed to determine the effective focal length of the lens. (This number is provided in the user's manual.) For example, if you were using

a 14mm super-wide-angle lens on a camera with a focal length factor of 1.5, the lens would have an effective focal length of 21mm. If you shoot sports, news, fashion, or portraits, the 1.5x magnification will probably do the job very well and will cost you less.

RAW vs. *Other Formats.* Most professional cameras record images in a proprietary RAW format, which must be converted into JPEG, TIFF, or some other format for use by your clients. The RAW format allows you to bypass the automatic image corrections applied in the camera, thereby allowing greater control over the artistic rendition of your images.

As with any equipment you intend to use in a business, I suggest a little research of what's currently being used, and lots of testing, before spending any serious money. The digital revolution hasn't come cheap, so you will benefit from these efforts. Because digital cameras are really computerized cameras, I recommend taking a lot of time to learn how they work and the many things they will do for you. That means reading the encyclopedia-sized manuals. Many camera manufacturers offer workshops and professional classes for their equipment, which are also a wise investment.

PROFESSIONAL ABILITY
Creative and technical ability must go hand-in-hand with professional ability.

You are in business to provide a service, create a product, and administrate an ongoing business. The better you are at all of these things, the more clients and the greater the income that will result. That's what this book is all about.

Your professional ability means acting like a professional and taking care of business just as the client desires—in all respects. You can be an artist, perhaps a creative genius, but just make sure to show up on time and deliver what was promised, for the negotiated price, when it was promised. Businesspeople will consider you a professional when you show them you are indeed a professional. It's like being a great lover—a lot of talk will never replace a superlative performance.

3. PHOTOGRAPHY IS YOUR BUSINESS

$ *Act like an artist around creative people, amateurs, and potential lovers. Take care of business with clients, bankers, and IRS auditors.*

Being a professional photographer is a way of life. The hotshots of our business, such as Jay Maisel and David Burnett aren't thought of as just photographers. When someone mentions their names, we can't separate the person from their images and their reputation; neither can they. That should be your goal as well: to have people immediately associate the type of photography you make with your name. It's a difficult but attainable goal, one that requires *living* photography, not just being a photographer.

$ *A professional photographer isn't so much what you are, but who you are.*

PROFESSIONAL PHOTOGRAPHY

A photographer friend once told me about a potential client asking why his rates for shooting simple subjects were so high. Specifically, he wanted to know why he should pay so much for what seemed like an easy photo shoot. He showed the prospective shooter some prints shot by a niece, who had taken photography in college. They were pretty scenes, flower close-ups, and shots of couples gazing at each other. He suggested a lot of time and money could be saved by hiring his niece. This photographer, having done his research, pulled out copies of the company's last catalog and annual report. The publications contained complicated photo and lighting situations. "Does your niece have the experience and equipment to deliver similar images?" he asked. The answer, of course, was no. The client is paying for a photographer's experience, equipment, and the ability to deliver the images.

The real difference between a seasoned pro and an amateur, or even a beginning professional, is their ability to take care of business. Among other things, this means understanding the client's needs, budget, time frame, and creative opportunities. Seasoned professionals become seasoned because they always bring home the bacon. This means producing images that make the client happy. Top-selling professionals dedicate themselves to completing assignments that satisfy both their clients and themselves.

$ *Making Big Bucks in photography means living the business.* $

If you are a professional photographer, act like one. Dress and behave in the businesslike manner that the client expects from himself and his fellow employees. Act like an artist when someone wants to talk about creative photographs and dramatic lighting. Try to determine the client's immediate goal and take care of the business at hand. If you are successful, and expensive, clients may still show you their relatives' photos, but they will be asking for a few pointers.

LOOK LIKE YOU BELONG

One of my best clients, a major hotel chain, used my work the first time for one primary reason—the way I dressed. I received a call from their marketing director one morning, asking if I could immediately shoot an office situation with their corporate chairman. Money wasn't an object in the conversation. "By the way," she said, "would you wear a jacket and tie?" Of course. After I had made the shots, the client took me aside and said that a popular local photographer had been hired to do the shoot. He showed up in a T-shirt, jeans, and tennis shoes, all of which could have used a good washing. They asked him to leave and started making calls. I was the first photographer who was close by and available.

You make photography for a living and must conform to the desires of those paying for your work. Being creative should complement shooting what they want and dressing in a manner that will be met with approval. New York photographer Greg Heisler is known for his interesting suits, ties, and hats. He dresses creatively, as one client pointed out, not like a slob who just thinks he's creative. A fine line, perhaps, but you must know where the line is drawn. Heisler, by the way, has an excellent reputation for delivering creative images that meet his clients' needs.

If the client's receptionist calls the police when you arrive, take a look at yourself in the mirror. Potential clients will evaluate you during the first minute of contact. Watch what you say and anticipate what they see. Do this by putting yourself in the client's shoes and looking across the desk at yourself. Would you do business with yourself?

The Great Hawaiian Aloha Shirt Screw-Up. Early in my career, during a location shoot in Hawaii, I managed to

get portfolio interviews with both Aloha Airlines and Hawaiian Airlines. Putting on my best three-piece suit, I ventured into the Aloha Airlines executive offices for the meeting. Sitting around the conference table were the vice presidents of marketing, advertising, and public relations—all in bright aloha shirts. The meeting went fine, but everyone kept asking if this was my first visit to Hawaii.

Afterward, I went out and bought the brightest Thomas Magnum aloha shirt in Waikiki and headed for Hawaiian Airlines. The executives sitting around their conference table were all dressed in dark three-piece suits. Fortunately, no one asked if this was my first visit to Hawaii. The moral is obvious: check out your client before venturing onto their turf.

The Client Image. Your clients maintain a certain image of themselves and their business. They have goals that can usually be seen in visiting their offices or reading their consumer materials. Your job is to know about their image, in advance, and to help perpetuate it at all times.

If you want to do corporate annual report work, you must be prepared to fit in with Madison Avenue advertising people and Wall Street business types. These people take themselves very seriously, often wearing those three-piece suits, probably because they are dealing with very serious amounts of money. If you want a share in this money, look as if you don't need it. Look like your client. These people don't much care for artists or street people, unless or until you turn out to be an important and profitable part of their business. Their emphasis is on profit, not on working with poorly dressed slobs.

If you're dealing with computer programmers, editors, art directors, and designers, then go ahead and be creative. These people appreciate individuality and imagination. They don't like fitting into other people's molds any more than you do. Just make sure your creativity is clean.

Your image must be adjustable to every situation.

Positioning. Those who are seeking the big jobs—and the Big Bucks—position themselves with potential clients long before making any face-to-face contact. This is done by third-party introductions, letters from happy clients, sending a letter of introduction yourself, and researching everything there is to know about the client.

Go to a meeting armed with knowledge about the products, corporate affairs, people, and goals of the company with which you wish to do business. Check out their web site and ask the public relations department for annual reports, company history, and executive bios. These people love to give out this information, as does the local library, newspaper, and Better Business Bureau.

Prospective clients should be on your regular mailing list. They should get your informational flyers, copies of news articles on your services, and tear sheets that relate to work they might desire. Make them think you are somebody before making an appointment. Also have a specific proposal in mind before you reach their office.

Arrive five minutes early for every appointment. This is being a professional and will improve your image.

In your clients' eyes, your standing in the photographic community is generally determined by such things as trade publications, advertisements, flyers, mailings, and non-photographic accomplishments. In other words, the most popular photographers aren't necessarily the best shooters. However, they are the best promoters. Simply put, they have positioned themselves in the best-possible light within their respective markets.

BUSINESS GOALS

A good way to keep on the professional track is to establish and follow a good set of basic business goals. The real world calls these goals a business plan, and you should have one as well. For the most part, this means writing down and evaluating your assets, capabilities, clients, and realistic hopes for their use, growth, and profit.

This is something that you do at the start of a new business, again in a yearly review, and at five-year intervals in an established business. Start by asking yourself how things are going and how you would like to see them in the next yearly review. I've provided some suggested business plan outlines for photographers in chapter 6.

THE BUSINESS PROCESS

The photography business is comprised of a number of unchanging processes. The good news is, because these basic elements seldom change, you have the opportunity to practice and perfect each of the steps. This will allow you to isolate areas that require the most attention and deliver the most profit and satisfaction. A list of these requirements and a close-up look at each follows:

- Selling
- Showing
- Proposing
- Estimating (and quoting)
- Bidding
- Negotiating
- Producing
- Delivering
- Invoicing
- Collecting
- Following up

Selling. Selling is knocking on doors. It's convincing a potential client to use your photography. It's the direct mailer,

the phone call, the web portfolio site visit, or whatever else gets you and/or your work in front of a potential client. Selling is everything in the business of photography. Without selling, you don't get to shoot or eat (as a photographer, anyway). Selling is the foundation of making Big Bucks in any business.

Showing. Showing your work to potential buyers is part of the selling process. These showings to potential clients, in person, via mail, or on a web site will establish your capabilities and desirability as a photographer. Don't waste a lot of time showing your work to other photographers who won't buy your services. Show your best work to your lawyer, CPA, banker, and other non-photography associates; they may recommend potential buyers.

Proposing. Proposing is generally done in answer to requests from clients. It differs from bidding in that you can include shooting and marketing ideas. Unsolicited proposals require some advance knowledge of the client's needs and markets, in addition to presenting an unusual approach to a project. Few clients will respond to unsolicited proposals, unless they know you well and you know them well.

Estimating. Estimating is your educated opinion of the general range of what the basics should cost for a given project. The client is asking for your professional generalization of potential costs, which they know may change in practice. Estimates should include several options and variables. Give them a variety of things to consider and a range of acceptable prices for each stage. There's no reason to be exact in these estimates, unless the client wishes to have you make a hard price quote. An estimate is usually requested by a regular client who is happy with your past work and intends to award this job to you.

Quotes. Many clients want you to provide an exact quote rather than an estimate. Make sure you can deliver exactly what you promise, which is what a quote is. A promise.

There is a vast difference between estimates and quotes. Make sure you know exactly which one you are being asked to provide.

Having the opportunity to estimate or bid on a photo project means you're in the right place at the right time. It doesn't mean you're in the running.

The business world has focused its attention on the bottom line in the past few years. For creative suppliers, this has meant a lot less emphasis on talent, ideas, and creativity. What it means is the lowest bid. This is especially true of industrial and government-related organizations, who aren't known much for creativity anyway. Government-related organizations generally make sure artistic suppliers are anything but artistic. In dealing with these type of clients, have an attorney read the fine print and be sure you know what you are offering before you sign anything. This is especially important when it comes to copyrights and their future uses. Some governmental bodies, such as states, have their own copyright ownership laws. Make sure these are covered in your contract. Also, you can forget about getting paid in thirty days; this just isn't in the cards with most of these people.

Bidding. Your bid is your quote, or a guarantee that you will complete a project at a certain rate, usually following a client's specific requirements. I'm sure you know how many photographers it takes to complete the average job. Fifty. I know it only takes one to do the job, but forty-nine are there to tell your client that they could have done it cheaper and better. This is the mentality of bidding without knowing all the details.

The biggest potential problem with bidding is the insider. This is a photographer who knows the real budget and may already be the buyer's choice. Often, this person will have the chance to see the other bids before submitting their own. In these cases, all the other bids are to satisfy management or regulations. This is called wasting your time, unless you're the insider. Insiders are not uncommon in the larger commercial and government jobs. Being the insider is, on the other hand, a very nice position to occupy.

The best creative managers aren't always looking for the lowest bid. They know from experience you get what you pay for. However, creative professionals request bids, rather than estimates, for several other reasons. They want to see if their stable of photographers have been taking care of business, treating each project fairly, and are in line with photo buyers' expectations. The bid process also allows these people to take a look at previously unknown photographers. This may be your chance, if your marketing and sales efforts have been persistent and productive.

Most photographers fear talking about money almost as much as they fear making sales calls. Don't! Photo buyers have the ability to smell this fear and may use the bidding process to weed out the chickens, cut budgets, and keep themselves in the driver's seat. Settle financial matters early in your project discussions.

Your Bid Package. Keep a generic bid, proposal, and estimate package available in your computer. Only a few specifics—including the client, shooting requirements, and budget—need to be added to the basic draft for each new project.

Your proposal should be short and to the point. It must contain a brief description of the project, the client's use rights, a shooting schedule, estimated expenses, and your fees for photography and any additional digital work that

must be done in order to meet the client's format needs. You should preface bids with a cover letter that approximates the sample letter below.

Dear Potential Client:
I am pleased to enclose my proposal *[never say bid]* to produce photography for so-and-so company. Thank you for giving me the opportunity to present this information. Should there be any areas that need clarification or revisions you deem necessary to make the proposal acceptable, please feel free to call. I look forward to working with your company.

Sincerely Yours,
Tory Smith
Smith Photography

Your basic proposal outline should contain information on the project, its scope, the client application, and copyright and usage allowances, as well as outlining project activities, budget, fees, and expenses. Use the opportunity to discuss your work and include carefully chosen samples as well.

The Project. Briefly outline your interpretation of the project. For example: to research, plan, and produce photography for a product catalog suitable for all existing Widget Company markets. This is the place to be creative. You are proposing top-quality photography that will reflect the reputation for excellence and service that has been established by the company.

Scope. This is the place to outline your technical response to the shoot list and related requirements presented by the photo buyer. Your list might contain specific requirements in studio setups, location portraits, and generic workforce images.

Application. Spell out the exact purpose for the photography. At a later date you may refer to this application in selling additional uses and sessions. You can offer other uses, available at a later date and for additional compensation.

Copyright and Usage. Outline the exact rights your client is purchasing from your photography. Do it in writing and list it shot by shot if necessary. Don't use legal terms. For example, you might say that the Widget Company will receive unlimited national print advertising copyrights to the photography produced on this project for one year, described as follows. Again, you should say that additional rights, including electronic reproduction of the same materials and layered multiple-image creations, are available and negotiable. It's also a good idea, with the proliferation of photo-manipulation programs, to prohibit any major alterations or changes in your original image without specific written permission. Be prepared to answer with rates, rights,

and reasons when they ask about these additional requirements. There is additional information on the subject of rights in chapter 7.

Never Say Never. Some clients will ask for everything, which means all rights to all photography and their use of it in any manner they see fit. Don't let the first word out of your mouth be no. See if they really mean everything, and see if they really need everything. They may want to make sure the images aren't used against them in competitive markets. They may need unlimited use. They may pay handsomely for all these rights. If you interrupt and say never, they may decide then and there never to work with you. Be careful of making generic statements in the area of rights and uses. While this may be popular with many photographers, each job negotiation is different. Again, keep an open mind to all of their proposals. This is a sales opportunity.

Project Outline. This is the place to mention and suggest your approach to the photography. Talk about shooting opportunities, production planning, and allowing time for making spontaneous images. Let them know there are several ways to shoot a widget and that you'll be giving them something new and exciting to see, in addition to exactly what they are asking.

The Budget. This is your final offer, estimate, or quote (say which it represents), and it will be examined with great care. The projected budget should cover specifics such as photo fees, materials, processing, models, assistants, transportation, and so on. (Use the estimate guide provided in the Basic Forms section of this book.) Some clients will let you know how specific costing must be; others will leave it open. Use your best judgment. Err on the generic side; you can always get more specific in the negotiation stage, if they want to discuss your budget. No matter what your bid includes, there will always be some additional questions, needs, and negotiations. Give yourself a little wiggle room for these negotiations.

Include a paragraph that covers variables such as weather, model no-shows, acts of nature, fires, and whatever else could spoil a shoot, as well as who and how much must be covered. Be conservative and be reasonable with these variables, as clients will zero in on them as negotiation points. Remember, you have to live with and profit from the figures in this budget. Go over everything several times with a calculator before you send it to the buyer.

Payment of Fees and Expenses. Let the client know up front how and when you expect payment. Consider specifying the terms as follows: "Payment to Jane Photographer is expected for all estimated expenses and one-half the photo fees thirty days prior to shooting date. The balance will be paid upon delivery of the images, at which time an exact ac-

counting of costs will be provided. Any adjustments of costs will also be settled at that time."

Marking Up Expenses. Most businesses mark up materials and other items directly related to a project. Photographers, for some reason, don't always do this. Mark up anything you must spend your own money to purchase and any unusual items that take your production crew time to procure. I add a small markup to the cost of captioning, color correcting, unusual delivery, and similar items. Be reasonable in the submission and recovery of your expenses. This will be appreciated by all clients.

Your Photography. This is the place to tell clients about yourself, your work, and your other clients. Don't make the presentation look like a college résumé, telling them everything you have ever done. A short paragraph on your photography and recent clients will suffice. Let them know that references from current clients are available.

Samples. Showing a few of your very best samples will encourage the client to select you for the job. This might be a recent magazine cover, annual report, brochure, or advertisement. Do not show anything from a competing business. If you don't have any samples from previous jobs, send a few prints of subjects that relate to the work you are proposing.

Winning Bids and Proposals. Bidding should be considered a positive sales opportunity in business. Once you've listened to or read the client's basic needs, the first step is to decide whether or not you can handle the job. Don't bid unless you're capable, interested, and willing to complete the project and can do so at a profit. Always let a bid requester know if you are unable to participate.

In every bidding process there is usually a golden opportunity to talk with the person who makes the final decision. Use this chance to cover both the project and your personal involvement. For example, you might point out that this is an assignment you are particularly interested in completing and will therefore offer a better-than-normal bid. Make the whole process into a sales call, which it is. Let the client know that, whoever receives the bid, you're going to be on hand for future bids and that you appreciate the opportunity and prospect of future work. Use every contact with a prospective client as a sales opportunity.

I suggest providing a complete proposal as your bid. This means covering all the client's requirements in an organized and businesslike approach. Your competition may only respond with a simple letter and a basic budget. Make your business approach look just as professional as the client's.

Negotiating. Negotiating directly determines how much you charge for your product and services. When you get down to the stage of negotiation, don't flinch or even blink. Otherwise, you'll be working for little bucks and big headaches. Try something most salespeople and photographers don't do. Listen to everything the client is saying, not just an element in the proposal that excites you. They may be very happy with everything but want to tell you why.

Talk about and settle financial matters as early in this process as possible. Keep in mind that your potential clients talk about money in just about every facet of their business. They will want to know the basic costs just as quickly as you'll want their okay to do an assignment. Don't let finances be the only area of a project open to negotiation. While money is important, your use rights, stock opportunities, future work, job satisfaction, and profit margin should also factor into possible negotiations.

Successful people, which you must assume include your clients, consider the art of negotiation to be one of the basic aspects of business. An experienced businessperson can determine the cost of an average project based on the cost of past projects and will also know how much room there is for leeway. Make sure you do this, too, and are ready with an intelligent rundown on costs, market values, and proposals.

In the negotiating process, always give the other person a chance to talk numbers and commit themselves first. The figure they have in mind might be very interesting. It might be substantially higher than the one you were about to suggest. If this isn't the case, simply state your estimate of expenses, time, and a range of fees to complete the assignment and meet the client's needs. They've already heard everything before, so don't worry about causing a heart attack. Just stick to your well-prepared proposal.

If you are talking numbers rather than making a written presentation, start with a high estimate. It's much easier for a price to be negotiated down by a client than up by you. Few photographers are sure enough of their position that they can look a client in the eye and talk serious money. Most buyers know they are in the driver's seat and are more than willing to let you talk yourself down a bit. Don't do it just to get a job. At this point, the buyer will be watching, listening, and waiting to see how low you are willing to go. Look them in the eye the entire time and ask for the world, then let them negotiate you down a bit.

If a potential client seems happy with the general direction of negotiations, use the classic salesperson's approach and ask for the job. This means saying, "It sounds as though we can make this project work together. Are you ready to set a shooting date?" If the potential client says yes, they are no longer a potential client. Set the date. Say you'll send a simple confirmation letter in the mail, along with any other particulars needed to secure the assignment. This may be your contract, so make sure it doesn't change any of the particulars of your proposal.

Your client's needs are generally to increase business, show a profit, and look good to customers—and not always in that order. Your sales goal is to get the job, of course, meet all of the client's needs, and make a profit. Their objective in a photo project isn't always predicated on bottom-line costs so much as meeting a certain marketing goal. Listen to their expectations before jumping into the discussion or to a conclusion.

Your clients are businesspeople. They will respect your ability to understand the basic business process. They will enjoy your ability to negotiate a good deal for both sides. They will not appreciate getting screwed. They will, however, appreciate screwing you. That is the way of the business world.

The Confirmation. Once you've been awarded a job, get something down on paper to confirm things. Verbal job okays are fine, as long as you've been doing business with the client for a while and have established a mutual trust and understanding. Currently, the business world is litigation crazy, and that means the prospect of lawsuits in every project. Both you and the client should know exactly what is expected of each other. Letters of confirmation and letters of agreement are the best way to approach an assignment, because they spell things out specifically.

Ask for a company purchase order. This will tell you what the client's money people expect to receive and pay for the project. Purchase orders tend to be like photographers' delivery memos. There is so much fine print that the original intent can be lost. If there are any problems with the purchase order's fine print, especially something that is contrary to your understanding of the agreement, scratch it out and make a notation. The client will get back to you immediately if this isn't acceptable. More likely, the client's accountant will be calling to say, "This is the way we do business with all photographers. We can't issue a check if you make changes in the purchase order." The best reply is that you have an agreement with the client that is contrary to the purchase order's fine print. If that isn't acceptable to the accountant, suggest that they contact the person who signed your agreement. Otherwise, you may have to initiate a new agreement through another negotiation with your client. Remember that you already have an agreement in principal, and that a signed contract will generally carry a greater weight should it ever come to a legal dispute.

Your general organization and planning will determine future opportunities.

Many of the things you do and the people you meet during the negotiation stage of a photo project will never in-volve images. Their entire impression of you will be the business process and the initial impression you make. Make sure it's a good and businesslike impression.

Pre-Shoot. Immediately define the client's goals and uses of your images. No matter what the original project outline, there will be changes before shooting begins. If the client has potential future uses, additional products, changes in marketing, changes in people, and the like, you need to know. And they need to know that such uses may not be included in your agreement.

Define responsibilities for creative and financial approvals and how to handle any changes of time and production costs. Follow up all changes in the project in your progress reports, an e-mail, or short written note. This is your pass-the-buck protection against any finger pointing as to who did what to whom or what charges were incurred.

Present a schedule of proposed shooting dates and times if they don't have one already. Include an information sheet that lists every person involved in the shoot, their phone and fax numbers, e-mail addresses, social security numbers, and notation showing who they work for and who pays each one. This pre-shoot memo should cover and include copies of things such as model releases, insurance coverage, deadlines, props, and location requirements. It should also list your telephone and fax number as well as an e-mail address where you can be reached at all times.

Proposed shooting layouts should be distributed to all participants early. Your production people, models, transportation and office schedules—not to mention other shooting schedules—must be considered in pre-shoot plans.

Administrative checklists are the easiest method of keeping track of shooting schedules, props, people, and locations. This is your responsibility.

I use job envelopes—one for each project—to keep receipts, client documents, and related paperwork in one place. A simple ledger sheet is attached to the outside. Each expense is entered on it, along with the date and description, before the receipt is enclosed. A unique job number is given to each project and is written on everything associated with the shoot. In the confusing business of doing several projects at one time, this system has proved to be a real time-saver in finding important paperwork.

Successful photographers have two things in common: they are flexible and they get things done.

Variables. Model no-shows, bad weather, product failure, union objections, earthquakes, floods, bankruptcy, last-minute permits, even deaths and births, all have the potential of happening during your shooting project. The pre-

planning and on-site reaction will determine your client confidence and future work.

One of Mexico's most famous resorts called me for an over-the-phone shooting estimate. As a result, they hired me to do a six-day shoot that included two top models. Interestingly, they had been using a famous shooter for several years, yet there was no sales required on my part and no negotiation on my suggested rates. After a wonderful shoot, I pointedly asked the resort manager why he selected me. "Weather," was his answer. Seems his last project had been beset with several days of bad weather. As a result, the famous shooter sat around and did nothing for ten days, left without shooting a single shot, and invoiced them for ten days at his full rate. The client said my proposal required an extra day for potential weather at no charge. If the weather was good on that extra day, we took off or shot a little stock and the resort covered basic expenses. In our phone conversation, he had asked what would happen if the weather stoppage went on for more than an extra day. I suggested that our photo team would attempt to set up a few interior shots. If that wasn't possible, we'd give the bad weather two days at most. "How much would all this cost?" the client asked. "How about a day's pay and expenses?" That reasonable response has resulted in additional shoots with other resorts in the company's chain. And there hasn't been a single bad day of weather, either.

Good planning, memos, and proposals should cover the unlikely possibility of shooting interruptions. Include extra days and basic expenses for variables that relate to your client and the project. Be conservative, businesslike and, above all, reasonable. Keep in mind that you already have the job. The client is happy with everything else. Don't be so demanding that it might cost you future work or result in a lawsuit.

Producing. Producing exciting images is the basis of, and the supposed reason for, your being in this crazy business in the first place. This book isn't about the production of exciting images; that's your job before getting this far. It's about producing exciting profits. Tell that potential lover, off-the-wall art director, or amateur photo buff that you're in it for the creativity. "I'm making photographs as an artistic statement." You know this won't count for much with the landlord, mortgage company, or that fine Italian restaurant your spouse likes so much. These people want cash, which leads to the next step in the process of photography.

Never Kick Inanimate Objects. Never, never get mad at your client, the client's employees, your photo team, models, your equipment, or kick a cement wall in sneakers. Let the client blow up at employees. Let the models grumble about the hours. Let your assistant kick the wall. Pound a grape with a hammer and see what your finger could look

like if you got mad enough to hit it instead. You can always get another grape.

Client confidence is gained when you quickly and calmly take care of every situation that arises. Anyone can get nasty, get mad, and try to get even. The photographer who gets the job done while keeping everyone happy gets the next assignment.

I have had the pleasure of watching several of the world's best shooters in action, thanks in part to shooting a few of the *Day in the Life* book projects. These shooters can get anyone to do anything. No matter how bad a situation, they can make cookies out of cow chips and feed them to the most difficult editor or client. This is undoubtedly one of the reasons why these shooters have such good reputations. That should be your goal in every project.

Delivering. Delivering your photography should be done quickly and professionally. Package your work as though it's something valuable and important to both you and your client, which it is. Images should have individual numbers, information captions, release information, your name, a proof sheet, and a copyright symbol. The entire package should be backed with cardboard and enclosed in a strong, secure, well-sealed mailing container. I always ship by U.S. Priority Mail or an air express service, with a recipient's signature return card. This gives me a name should something go awry. Your clients will appreciate the efforts you take to protect their valuable sales tool, your photography.

Photographers are known for what they show, not what they shoot. Show only your very best work.

Bad Photos. There is a variable most of us do not even want to think about—and that's bad or no photos. What do you tell the client if, for any reason, every shot is a bummer? This might be due to a faulty camera system, stolen computer or hard drive, or some other insurmountable problem. Immediately let the client know that there won't be any images. Don't sleep on it or get blasted on airplane glue. Just make the call. The client won't be happy but may be able to reschedule another shoot, which you will offer to do free. Or, in some cases, the shots may be saved by computer manipulation, and you can offer to pay the costs. Remember that you provide a service that will be remembered beyond quality and price. How you handle the rare mishap will determine the degree of client loyalty.

Obviously, a good photographer will bring a backup camera to the shoot. A good photographer considers the security of his people, self, equipment, and images of paramount import. But once you say that something will never happen in this business, get ready for that exact thing to occur on your

next shoot. The smart shooter will make sure a client doesn't see any low-quality images from a shoot. Never give anyone the opportunity to see images that put you in a position of explaining. Always show your very best stuff. If a different shot is needed, you can review the outtakes.

Invoicing. Invoicing the project as quickly as possible is simply taking care of business and meeting deadlines. The sooner your invoice is received, the sooner it will be in the client's accounting and payment system. Your invoice should state the use and copyrights that are being purchased and should note that they transfer to the client only upon payment in full.

Collecting. Collecting the final payment for a job may include some additional negotiation with the client's accountant. If you've asked the client to cover basic estimated expenses up front and a portion of the photo fee, collection will not be a desperate effort. Up-front money is a must if it's your first job together. Any client who refuses up-front money will likely be a collection problem. Try not to play the bank by loaning a client money, at no interest, to do their job.

Collecting from slow, bad, and nonpaying organizations is a financial art. Your CPA and other business advisors may provide some hints in this area. Keep in mind that you may wish to do future business with this client, which they know, so don't send Bruno the Enforcer to their offices to make collections. If you don't ever want to see them again, then get the invoice into a collection agency or send Bruno.

In attempting collections, simply make a reasonable call to their accountant and try to work things out. If this doesn't pay off, try a reasonable letter with a second-notice invoice that has a service charge added. My invoice fine print says there will be a monthly re-billing charge after thirty days. After about forty-five days and a call to the client's accountant, I send a second invoice with the rebilling charge added, with a copy to my creative client. Sometimes an art director or editor can put pressure on the accounting department and get your check sent.

The big agencies generally work on their suppliers' money, some taking three months to pay an invoice. You can bet they have already invoiced and collected from the client, putting the money in a thirty-day money market fund. They may feel that your service charge is quite a bit less than the interest they can make with a certificate of deposit. These people are interested in making money, too, and this is a pretty interesting way. What photographer wants to quit the big

agency, Big Bucks scene? This is a good reason to request cash up front for expenses and partial fees.

If all of your reasonable attempts to collect on invoices fail, it's time to take more serious legal action. One of the best methods of taking action, which really is no action at all, is to write your lawyer and instruct that legal action be taken in ten days. Sending a copy of this letter to the client tells them that you're getting serious and they still have a few days to pay the invoice. Most of the time this letter is all the action that's required. Of course, the nonpaying client may call your bluff, at which time you should take another look at the information found in chapter 7.

Following Up. Following up the job with a simple thank-you letter may be the only reason you get another opportunity to repeat the whole business process. Following up is certainly less expensive, in both time and money, than starting all over again with a whole new selling and proposal process. Saying thanks for the opportunity to work with the client is the least you should be doing.

Following up also means checking to see that your client's mailing list entry is correct, for future marketing. The last thing you should do is clean up the shooting file and combine it with your regular client file. This means organizing model releases and other documents that may be needed later.

Profit and Taxes. Are you making a profit on every job? Profit is measured by money, satisfaction, reputation gained, the extension of credit lines, portfolio tear sheets you can send out in sales efforts, and client introductions. Try to cover all of these in your search for profit.

What is your tax situation at the completion of each job? Have you made a lot of money but not enough profit? Can you run a quick profit-and-loss statement? How is the cash flow, compared with the estimated taxes? Taxes and profits are discussed in greater detail in chapter 8.

Your Retirement. Someday you may wish to retire. I love my work so much that I plan to meet the Grim Reaper shooting somewhere in French Polynesia or Italy. Retirement isn't even a consideration. But if that's your goal, start planning today. Stick 10 percent of every check into a safe place for that retirement. Put it in stocks, bonds, money funds, certificates of deposit, savings, insurance, silver bars, gold coins, classic Chevys, stock images, or a sock under the mattress. Believe me, no matter how tight things are, saving for retirement is easier at age twenty-five than fifty-five—or so I've been told by the experts.

4. ADMINISTRATION IS AN ART

$ *The job ain't over until the paperwork is done.*

No matter how good you are at marketing, sales, and photography, if you overlook basic business practices, failure will rear its ugly head. A few years back, an international magazine assigned an Alaskan photographer to shoot an editorial feature. The article was important enough for the magazine to send an editor and writer to Anchorage for the project. It was a dream-come-true assignment for the photographer, who had been sending images to the magazine's editor for two years. On the day shooting was to begin, everything was in place, including a float plane, a remote cabin, a guide, and enough food for two weeks on location. Everything was there but the photographer. He never showed.

$ *There is more to photography than the ability to make and sell great images. You must also administer those images into a profit.*

In less than two hours, another photographer was hired and the group took off for Alaska's wilderness. The original photographer said he had overslept and forgotten about the assignment. And you can be sure the magazine will forget him when the time comes for future assignments.

Was this photographer just a flake? No. He was, and still is, a very talented shooter. So what went wrong? How could he forget such an important assignment? Obviously, he didn't take care of business and probably doesn't even know the elements of good business. He certainly hasn't much chance of making Big Bucks as a photographer unless some drastic changes are made in his professional attitude. Okay, so I happen to think such an incident qualifies that photographer to be called a flake. Don't let the same thing happen to you.

While most photographers will never forget assignments, it's not uncommon for them to show up late, dressed poorly or unprofessionally and, believe it or not, many forget to invoice the client for all the expenses of a job. Don't let this happen to you.

THE BASICS OF GOOD BUSINESS
Good business administration has been the subject of countless books and seminars, not to mention discussions with bankers and IRS auditors. Yet there seems to be a consensus that to be a good photographer means being poor at business. We've even heard photographers themselves claim to know little about the business side of things. What a crock! What a waste of talent!

$ *Good business practice is simply using common sense in making the journey.*

Without a doubt, the single most important ingredient of good business is organization. It means regular planning sessions, schedules, files, paperwork, bookkeeping, expense records, and taxes—all managed as carefully as you maintain your photo equipment. It means making a list of things to do, knowing what needs to be on it, and going down that list item by item. Business success, we all eventually must learn, comes from taking care of these details.

If you want to make Big Bucks in any business, especially photography, it's going to require lots of common sense. Having a masters degree in business from Harvard isn't worth much in the real world of freelance photography, where we must combine the skills of an artist, salesperson, business manager, collection agency, janitor, and babysitter. If, in fact, you do have an MBA, don't waste any more time as a photographer. Start up a stock photo agency. That's where you can shine as an administrator. Then you can sell it to one of those mega agencies and retire.

BUSINESS ADVISORS
Hire experienced business advisors for one-on-one counseling. Consider a successful photography advisor, lawyer, CPA, banker, and insurance agent. Expect to pay them hourly, based on their established rates, for a minimum of one hour per session. If you're short on money for this, turn to the Small Business Administration, which provides free help, information, and consulting from retired successful business people. I also highly recommend taking one of the many workshop and counseling sessions presented by professional photography counselors once a year for the first few years of business.

The best place to begin the search for experienced advisors is at one of the *PDN* photo conferences. Attend seminars

covering the areas in which you need help. Talk with or drop a note to the people you want as advisors. Some of these people offer regular seminars throughout the country and provide some individual counseling. Similar programs are frequently offered by the local chapters of professional photography associations—for members and nonmembers. All of this counseling should be considered before making any expensive business moves.

You should try to meet with advisors that have active business experience of their own, who have learned by taking risks and making mistakes. Think about the time, money, and emotion it cost them to gain that experience. Professional teachers, with no business experience, have only theory or other people's experiences from which to draw.

I happen to think that Maria Piscopo is among the very best business advisors in the photography business. A few hours with her will change the potential success of your business efforts. See the Resources section for more on her.

YOUR BUSINESS IMAGE

Look at any successful business, especially professionals such as CPAs, lawyers, or bookkeepers. They have the look of being in business; so should your business. Start with your telephone, stationery, web site, and business address.

Telephone. The phone is often your first point of contact for public relations and sales efforts. When a potential client calls you, they are looking for a photographer. Have a business phone number and answer it in a businesslike manner. Never use a personal or home phone as your primary business number. Never let the kids answer the business phone.

Cell Phone. It's fine to have a cell phone that's your business phone; in fact, this allows you to be available on a full-time basis. When taking or making calls, make sure you treat them like calls made from an office. Do not answer your phone in a bar or at a party or make calls from places that are loud and anything but office-like.

Business professionals expect to find a phone number listed in all of the proper directories and to have that phone answered in a businesslike manner. Call around to a few professionals, especially your advisors and other photographers, and see how they answer the phone. "Hi," "yeah," "yo," and a simple hello aren't all that unusual for photographers. These greetings are often accompanied by the jarring sound of screaming kids, barking dogs, a blasting stereo, or daytime television soundtracks. Is this any way to run your business? When was the last time your doctor's phone was answered this way? I wouldn't let a surgeon whose dog helps answer the phone cut into me.

Have an answering service or recorder on your telephone if you or an employee can't answer promptly. Your message should be short, say ten seconds, and also businesslike. For those who hate these recorders, keep in mind that they are much better than leaving a call unanswered. Please don't say, "Leave a message after the beep." Everyone already knows that answering machines have a beep. I suggest that you immediately follow up on messages left on your machine.

If you're on the phone constantly, making all those sales calls and taking assignments, get a second line—not a call waiting feature on your main line but a real second telephone line. Today, the multitude of phone companies offer a host of additional lines and services possibilities such as paying for time used rather than an unlimited line. Call your phone company sales representative and get some free advice. Listen to their sales pitch. Are you as prepared as they are?

E-mail. Once you're connected to the Internet, select and set up an e-mail address that's easy to type. E-mail is a very important part of today's business and will be covered throughout this book.

Gadgets. There are a lot of interesting little cell phone type gadgets available, with interesting names like Blackberry or Razr, which are aimed at making you buy and spend a lot of air-time playing with them. The best of these are combination phone, e-mail, Internet, walkie-talkie devices, and so on. They are great if you are a freelance shooter for one of the various fast-moving media. When used as a business tool, these devices can be very valuable. If you are a communication junkie, they can distract you from real business.

Stationery and Forms. Correspondence, especially sales pitches, bids, and proposals, should always be printed on first-class letterhead, which, along with your matching business cards, should have your correct information, without any scratched out and changed lines. It's okay to send a handwritten personal note to a regular client, especially when following up on conversations or meetings. I suggest printing up your own card for such purposes. Use one of your best images.

The term *stationery* refers to letterhead, business cards, envelopes, mailing labels, invoices, memos, and other printed items that leave your office. All of these materials should match and seem to come from a photographer. You should design a logo for these items. Our clients have come to expect this professional business look from their suppliers. In other words, they expect our paperwork and letterhead to resemble something that would come from a real business, like the one they operate.

You can get simple logos and stationery design done by most quality print shops. However, it makes more sense to contact an art director or designer you've worked with, or one that's recommended by an associate, to have something classier produced. Your stationery and forms are an oppor-

tunity to show clients that you are both creative and business-oriented. With very little effort, your office color printer can also be used to produce these materials.

My own letterhead, notepads, business cards, and related forms have a logo that incorporates some of my images. In addition to saying exactly who the materials are from, the graphic look portrays the area of photography in which I specialize. Yours should do the same.

Your Address. New York, Los Angeles, or even Beverly Hills may be good addresses for photographers. Others may disagree. That's not the point. While the location may not matter so much, you need a proper business address on correspondence, invoices, and proposals. Many photographers have a post office box so they can keep the same address while moving about. It's possible, although not too practical, to have a Beverly Hills post office box and live in East Los Angeles. The fast pace of photography will necessitate a street address for overnight deliveries and pickups. Many photographers who travel a lot, such as myself, have moved from big offices into big home offices. For the most part, our clients couldn't care less where we have an office because they never leave their office unless you invite them to lunch or dinner at a nice restaurant—hint, hint.

Office and Studio Space. You should have a place to administer your photography business—whether it's a studio, small office, warehouse, or a spare bedroom in your home. No matter where you've established your business, when you're in that place, it's for taking care of business, and it should reflect that fact to anyone who enters or calls.

Obviously, the better your office or studio, the better you are going to look to those rare clients who wish to visit. However, less than 25 percent of the average non–studio photographer's clients visit that place of business.

When visitors enter your space it should be immediately obvious that you are both a photographer and businessperson. It's okay to be funky. It's even expected by art directors. But it's not okay to be dirty or messy. Display samples of your best work and make sure the place looks businesslike. Keep it safe, secure, and clean. Sounds like common sense again.

Your Best Address. A professionally designed web site is probably the best and most sales-oriented business address you can hope to establish. This is the place where all of your business information is located. An easy e-mail address for twenty-four-hour communications is critical. This is also the place to display your best work. A lot more of this will be covered in chapter 11.

Office Equipment and Furniture. You should have office machines that can handle twice as much business as you expect for the next three years or so. This is your planned growth. The right office equipment, used properly, can save time, money, and people power.

A typewriter was once a necessity for clean and businesslike forms and other paperwork. I still use one for those odd-sized and single-sheet forms that are required by most bureaucracies, but computers can easily be used to create many such forms today.

A calculator with paper tape is another necessity. It's really a simple adding machine that does other functions. You need the paper tape to double-check figures on bids, taxes, and invoices; otherwise, this function could be performed by a computer. An incorrect figure can often make or break the assignment, profit, and tax audit. The IRS especially likes to see well-organized calculator tapes attached to receipts.

The more time you spend on the little things that a calculator and computer or typewriter can provide, the less your clients, bankers, bookkeepers, and tax auditors must spend fixing your mistakes.

Computers are no longer a luxury in any business. They have replaced the typewriter, file cabinet, telephone, calculator, and fax for many business applications. Computers have become our bookkeepers, secretaries, caption machines, salespeople, and post offices. Photographers also use computers to create and fix images in ways they are otherwise unable to accomplish. Making Big Bucks and competing with hotshots requires the ability to utilize computers in all their many aspects. In fact, computers are so important to our business that the following chapter is devoted to them.

The fax machine is still part of today's daily business routine, especially in foreign countries. However, it's quickly being replaced by computers and e-mail. The fax provides quick transfer of the written page or other graphics such as layouts and samples over a telephone line. They are especially important for the exchange of signed legal documents. Photographers use them to bid on jobs, receive stock requests, correspond, make travel reservations, and instantly invoice clients. Our clients use them to confirm assignments, provide comps of prospective shoots, request stock, and send purchase orders. While the telephone must be answered, often to the distraction of meetings and sleep, the fax machine just leaves its message for reading at any convenient time. You can rent fax services from local mailing or office companies. I suggest learning how to make your computer accomplish these tasks.

File cabinets, with room to grow, are inexpensive and a requirement for every aspect of business. Have separate file drawers for each part of your business. Invoices, clients, expenses, information, suppliers, inventory, mailing lists, and related items should each have their own place and always be in that place. Hard copies of all e-mails, correspondence,

comps, and related client communications should be saved in each specific job's own file. It's called organization and will make the IRS, your banker, lawyer, and CPA very happy.

Your photographic images should be organized and filed by job on a hard drive that is kept away from your working hard drive or computer. I also suggest backing up everything, paperwork and images, on a separate drive. It sounds excessive, but it won't seem so if you have a drive failure, loss, or emergency.

Obviously, desks, chairs, and similar office furniture are necessary to conduct business. If you're just starting out, visit the used-furniture mart and save some money. Take a look at the office through your clients' eyes. Make sure things are comfortable, clean, and competitive. Shop around. Don't ignore office equipment needs to buy the latest high-tech Nikon. Make your office efficient and productive first, then buy the new Nikon with profits from your business efforts. You may be starting to figure out that the investment in a new business will not be cheap.

With all this expensive equipment sitting around your office or studio, there may be those who wish to borrow it without your permission. Install the best monitored burglar, heat, and fire alarm that you can afford. This may reduce property insurance and will certainly improve your chances of owning the equipment long enough to pay off bank loans.

BUSINESS FORMATS

Talk with a CPA, lawyer, banker, and an experienced independent businessperson before jumping into any business format with both feet and your bank account. My descriptions and opinions should only be considered starting points toward forming the legal status of your business.

Business format means the legal description or makeup of your business. It can be a corporation, partnership, limited liability company, or sole proprietorship. Starting or changing the format of a business is a legal, and potentially expensive, proposition that should not be entered into lightly or without competent advise.

Most freelance photographers are sole proprietors. This is a designation that usually includes a spouse. This is also the easiest, fastest, and cheapest way to get started and operate a small independent business. These reasons do not necessarily make it the best for your business, but most of us begin this way.

Partnerships are little more than sole proprietorships with any number of proprietors. All partners share liability and are thus vulnerable to judgments and other potentially expensive situations, regardless of their percentage of ownership. Little is gained in a partnership that would preclude your consideration of a corporation or sole proprietorship.

A limited-liability company is little more than a partnership that reduces the liability of some participants. It's a type of business format often used to raise money and create and sell a single product, such as a movie.

As photo businesses grow, make more money, gain assets, have greater liabilities, hire employees, and sometimes seek outside agents and investors, they often elect to become corporations of one type or another. In this format there is some protection against bankruptcy and personal liability, a few tax advantages, and a great deal of real business credibility to be gained. Estate planning, which should be considered as early as possible in your career, is much simpler with a corporation than a sole proprietorship. There are other advantages of incorporation that are not immediately apparent, including a strong business stance.

Incorporation status raises you above the mom-and-pop image. It requires certain record keeping and official meetings, which means paying more attention to administration. Because of these requirements, a corporation is much more attractive to bankers and investors, while being somewhat less attractive to tax auditors. Ownership of a corporation is easier to transfer, through sales of stock, and easier to pass on in estate planning. Even if you are a mom-and-pop operation, both mom and pop can be corporate officers and paid employees. This may also allow deductions when both travel on assignments, attend seminars or conventions, and have company-owned equipment.

Stockholders of a Chapter S or sub-Chapter S corporation operate with all the advantages and protection of incorporation, while allowing stockholders, such as a couple, family, or limited number of partners to claim profits and losses from the business in their own income tax returns. This type of incorporation was provided by Congress just for smaller independent businesses. While this may sound simple, I suggest talking with a CPA experienced in forming new businesses well in advance of filing any sub-Chapter S paperwork.

There are packages available at office supply shops and bookstores that you can use to establish all of these business formats yourself. Don't be seduced by their low cost and seemingly easy application. Reading and following the suggestions in these programs can be of great value. However, do not start or change the format of your business without sound advice from a lawyer, accountant, and experienced independent businessperson regarding these matters. They may point out that the easiest method is not necessarily the best for your specific situation. You will have to live with these decisions for a long time.

Plan to be in business for a long time.

LICENSES

No matter how small your business or which business format you have established, you may be required to get a license. All cities, counties, states, and the federal government have numerous laws regarding the need for business licenses, permits, and various tax permits and forms. Your advisers will have all this information at their fingertips. Get the proper licenses before starting a single day's work. Most of these bureaucracies will provide you with some sort of a "Getting Started in Business" booklet. Read it and discuss the requirements with the same people who help you plan a business format. Don't overlook these forms, permits, and registrations, as our local and national governments have plenty of time and opportunity to levy penalties for such oversights.

Of course, all of this paperwork can also bring the bureaucrats around for inspections, audits, and little hidden costs that keep them in operation, too. These people have a job to do and are usually more than happy to help you help them do the job properly. When you have any questions, call and ask, or check out the many web sites available for this purpose. Fear of forms and the people who send forms is a serious problem with independent businesspeople. Overcome this fear and you will glide through the problems that cause administrative nightmares.

RECORDS

What are the first things tax auditors want to see? Receipts, bookkeeping records, and canceled checks. What are the first things bank loan officers want to see? Profit-and-loss statements, financial records, and tax returns. Everyone you do business with will eventually ask you to provide some type of records. The better you are at establishing, filing, and providing records, the easier things are going to be for all aspects of your business.

Accurate and complete record keeping is the heart of successful business administration.

Record Keeping System. Start a good system for information gathering and filing. Have a separate file folder for every type of expense you incur or expect to incur. Keep an individual file for every client: Be sure to list pertinent phone numbers, addresses, names of personnel, the type of business, and related information in your active client file. File a copy of every estimate, assignment, submission, and invoice. File copies of tear sheets, annual reports, and newspaper clippings. All of this information should be examined and updated as you progress with a client and in the event of a tax audit. Knowledge is power, and record keeping begets

knowledge. (*Note:* Stock photography has its own set of records and forms, which are covered in chapter 12.)

Forms. Business is always a battle of forms, and there is a form for just about everything in business. I've included several basic examples in the Basic Forms section of this book from which you can produce your own customized forms. The professional photography organizations have good generic forms available to their members and for sale to the general public. Just make sure you have whichever forms are necessary to conduct your business. Keep them as simple and readable as possible. Ask your business advisors to examine all your forms and paperwork. If they have problems understanding anything, so will your clients. Remember that long legal forms and accompanying explanations can be a burden to small business owners. The forms I use are short and to the point.

Your basic forms needs will probably include estimates, invoices, location expenses, cash expenses, model and property releases, checklists, and delivery receipts. File copies of completed forms in the appropriate expense, client, or information file.

Bookkeeping. Most record keeping is simple financial accounting for expenses and income. Our bankers and auditors want to see where the money comes from, where it went, and reasons as to why it went there. Accountability is what they call all of this financial record keeping.

New and small businesses generally keep their own records. Few of these people have had any experience in bookkeeping, and this is no place to scrimp. Get educated about the basics of bookkeeping. City college night programs can help. Even a bookkeeping book for idiots will be better than nothing.

If you are unable to do the books, hire the services of an experienced bookkeeper or CPA firm from the very start. Let this person evaluate your needs, set up a basic accounting program, and make frequent visits to update it as necessary. This person can assist with budgets, loan applications, licenses, federal employee requirements, your social security and retirement, and train you to do a lot of this work. This isn't an expensive service. It's something you will need as your business grows.

CPAs and computers can play an important part in your record keeping and accounting. Because of their role in our business, additional attention is devoted to both of these important subjects later in the book.

No matter who handles your financial records, always be the person who signs checks. That way you always know where the money is going.

Banking. Find a good bank and start a business checking account. Do not use your personal checking account for business. A banker will help advise you on loans, lines of credit, and ways to structure financial transactions. Good bankers seem to be as rare as doctors who make house calls, so seek referrals from your advisors.

Line of Credit. The bigger your jobs, the more immediate your financial needs. A line of credit is just a revolving loan that starts when you write a check. Set this up when you don't need the money. If you wait until a job starts, it will be much more difficult and time-consuming to establish. Because lines of credit are just like loans, and as difficult to obtain, you might want to start your own with a simple savings account and low-interest credit card.

Credit Cards. A low-interest credit card is a good way to get your hands on a few thousand dollars whenever you need money. While credit cards may be easy to get into, they can also be the source of financial problems. Pay off the total balance due every month and they are great short-term free loans. Pay the interest fee only each month and they can become the most expensive loans available.

Several airlines offer their own credit cards through sponsoring banks. With every purchase you make using their credit card, you also get mileage credited in frequent-flier programs. This is a good way to fly free in the future. Make sure you enroll in a program that allows your mileage to grow forever and never expire. Always check out the fine print when selecting an airline credit card. Alaska Airlines offers one of the best frequent-flier and credit card programs available. Regardless of which credit card you select, join all of the free airline frequent-flier programs.

Checking Accounting. My accounting system revolves around a spreadsheet checking account. A check is written for every possible expense, and all income is deposited. This provides a good solid account of transactions. Every check should be immediately noted under a budget deduction. See suggested listings in the budget section of this chapter. A business credit card is my second method of payment. The annual fee is deductible. It will also provide good financial records.

Paying expenses in cash is the poorest method of doing business. However, at times it may be the only method possible. Keep a written record of any cash expense, be it taxi, luggage porter, photo fee, or whatever. Basic cash expense accounting forms are provided in the Basic Forms section of this book.

Financial File/Check Systems. When you write a check for a deductible expense and make the entry in your accounting system, also write the check number and date on the receipt. Drop this receipt into the file that represents its

deduction category. Do this with every returned check as well. At the end of the year you will have every deduction category organized, and taxes will be a matter of using the calculator and filling in the forms. You can also immediately find a canceled check and the paid receipt should a question ever arise from the bank or suppliers.

Find, fill out, and file tax registrations before starting a single day of business; otherwise, you'll spend Big Bucks.

Taxes. Business advisors can outline basic tax requirements and necessary forms, as can the local Better Business Bureau, Small Business Administration, and city, state, and federal revenue agencies. Ask for a listing of basic start-up requirements from everyone. Some of these organizations provide free basic business tax guides. All of these organizations provide liberal help with questions. Some of them also have auditing powers, so following their suggestions closely can be a benefit.

Start an individual file folder for every single registration and department with which you have contact. Put copies of all the related paperwork in their respective files. For example, your city business license file should contain everything between you and the city. This way, you can pull out the file for auditors and advisors who may have detailed questions or who may have lost the original forms. Never attempt to answer detailed questions without a quick review of the related file.

Tax Records. Keep copies of everything related to taxes—and everything else for that matter. This means deductible expenses, which include those you have billed to a client job. It also includes any expenses that you cannot deduct, as these will be needed for your personal tax returns. You can't be too fanatical about anything related to taxes. The better organized your business tax records, the less potential for problems. The IRS, bankers, and related record readers are usually willing to bend a little on gray areas when you have well-organized records. Keep everything in an old shoebox until tax season and you will pay the consequences. Record reading people have the time, patience, and person-power to closely examine every receipt in every shoebox.

Inventory and Insurance. Your inventory of business equipment and stock images is very valuable and must be accounted for in records and administration. Such assets should be listed in a master inventory. Start with a complete description of the item, serial number, purchase price (include tax but not freight) or market value, and any special characteristic (such as being custom-fitted). Put a copy of the master list with insurance papers. An example of such a form follows.

```
EQUIPMENT INVENTORY
Item—Camera
Make—Nikon
Model—Z-28
Serial number—1234567
Description—Digital body
Color—Black
Purchased—07/08
Value—$5000.00
```

Keeping an inventory listing of your images is a lot more difficult, but it's important for such things as estate planning, asset management, and taxes. Image inventory is easier for current shooting, more difficult with files that were established last year or ten years ago. This inventory definitely requires computerization and constant immediate attention. You will have a much easier time collecting for major image losses, be it by fire, theft, or mysterious loss if an inventory and individual image number exists. Numbering images is better covered in chapter 12, but the following is suggested for financial image inventory records:

```
STOCK IMAGE INVENTORY
Image number—H-H-100-MR
Locations—Hawaii, Oahu, North Shore
Key words—Surfer, Ocean, Waves, Blue
Client—Stock Library
Format—Digital
Size—50MB
Released—Yes
Release number—H-1005-MR
Value—$5,000.00
Location—Hard drive S-D-5
```

Setting an image value can be tricky. If there is a major loss, you will undoubtedly be required to present some evidence on how the value was determined. If you haven't been in business long, I suggest using something slightly above the ASMP $1,500.00 lifetime image valuation standard. This has been recognized in several legal actions. If you're well established, then a lifetime sales potential can be proven in legal contests. This will probably mean showing one-time sales invoices for images similar to those that have been lost. Keep in mind that your evaluation of images may also be used by the IRS when calculating estate taxes in the event of your untimely passing.

Insurance. Your images can be of value when it comes to financial statements, loan applications, and insurance pro-

grams. However, even the most jaded banker or insurance agent will have a heart attack when looking at the value of just ten thousand cataloged images in your file. This is the more difficult insurance to obtain and afford.

When it comes to insurance, try to cover everything possible—that is, everything you cannot afford to lose. Your record keeping here is just a matter of making copies of inventory sheets available to your insurance agent. You may only be able to afford a basic business equipment and papers insurance coverage policy, which is a very small part of any true image value. Review all the options with a good business insurance company that specializes in coverage for photographers. Professional associations and publications are the place to find these agents.

Make copies of important insurance documents and the inventories they cover. Carry copies of equipment policies on location shoots, along with your agent's local and national phone numbers and e-mail address. If there's a problem, immediately contact your agent or the national hotline and ask for instructions on your liability and for help to get quick replacement rentals covered.

MANAGEMENT

Employees. Making money in this business often requires working with and managing people. With all the files and record keeping we've been talking about, sooner or later you're going to need help. Hiring employees, such as office assistants and bookkeepers, is an interesting proposition. Certain businesses pay employees just enough to keep them from quitting. On the other hand, certain employees do just enough work to keep from being fired. Therein lies the challenge of effective employee management.

First, you must find and attract quality people to help with your business. Your future employees don't necessarily need experience in the photography business. In fact, this could be a detriment. Don't hire the friend or lover of another photographer, or someone who hopes to become a photographer. At a minimum, they'll just rip off your best ideas and clients along the way.

Some people can manage an office full of people, while others can't manage their own schedules.

Employee Search. Look for someone who has been around a bit. Look for someone who has experienced different jobs, perhaps in completely unrelated fields—someone who has worked with people and someone who understands office work. I call this office smarts. You can easily teach the basics of a photography business to a person like this, and they can teach you a few tricks as well.

Hire employees on a part-time basis, if possible, at first. See if they can hack the crazy atmosphere of our business and the erratic personalities of photographers. Few spouses or lovers are secure enough in their own identities to survive the big time or the lean times with photographers. This may be due to the commitment we must make to photography.

Be sure to pay your help a reasonable salary. Offer an incentive—say a percentage of stock sales or assignments after six months' employment, something that makes them part of the business and not just hired help. Give them leads to contact about potential sales and share some of the goodies and perks available for making sales. Add them to your health-insurance program.

Don't try to avoid employee paperwork and tax withholding by contracting full-time professional services. This means having someone working full time in your office but calling them an independent contractor on paper. While this is an attractive thought, which eliminates a lot of tax withholding and filing, the IRS takes a dim and penalizing view of the practice. If you have a full-time assistant or office manager, then cover both yourself and them with the proper paperwork. Some states require freelancers to be covered for various medical and unemployment benefits. A CPA should be consulted early on in this very important area.

Have weekly planning sessions with everyone connected to your business. Use this time to establish short-term goals, schedules, and assignments. While employees may be dedicated and loyal, few will share your long-term vision. You must constantly sell employees, family, and suppliers on this vision in order to get their complete support.

Outside Services. There are many times when full-time in-house employees aren't necessary or desirable. Good assistants often work for several different photographers.

Managing the area of outside services is easy. Simply hire the best person or company available and pay them well. Let assistants share in the project. I have learned a great deal from assistants who are also working for my competition. Some photographers choose to boss assistants around, rarely seeking advice or, heaven forbid, letting them shoot something important. Assistants have eyes and brains, too, and these assets should be utilized.

Young and small businesses often find outside services to be more economical, of higher quality, and simply easier than hiring full-time, in-house people. You can operate this way for a while or a lifetime. Bookkeeping, accounting, legal, graphics, computer, secretarial, and just about every other area of business has service organizations. Try these established organizations first, because they will take care of all the employee and tax paperwork that you pay for but don't have to complete.

If you contract any freelance services, there are a few things to keep in mind. Make sure that freelance people have a business license, tax registration, and the trappings of a business. These should include a business card, letterhead, invoices and, most important, freelance work with other businesses. Keep copies of their paperwork in the file. The IRS may ask for this support material in an audit. It's one of the first places the IRS looks for irregular activity, which means money you get to pay them.

Managing outside services means having things ready for these people when they show up for work. Keep them busy and challenged. Let them handle some of the hard labor and some of the creative tasks. For example, I take my CPA on an occasional tropical beach shooting project as an extra assistant. He gets to hang around with hot models and shoot a few photos while I'm paying the basic costs. This has worked wonders for his understanding, not to mention appreciation, of my business. When an auditor, lawyer, or banker asks my CPA a question about my business, he knows the answer.

Never work with anyone you don't like or can't get along with, no matter how good or cheap, or how well recommended they come. Sooner or later, things will deteriorate into an unworkable and often explosive situation. In these cases, everyone loses.

It's okay to fall in love with someone you work with, someone who has an acute appreciation of your business. That's exactly what I did. My wife, Nancy, is an important part of our business. She is a positive survivor who shares all the highs and lows of this exciting lifestyle. However, not everyone can work with a spouse. In some cases, working together can cause divorce. Try it part time and remember to set goals and aim toward the same goals. Remember, too, that ultimately your wife is the boss.

Agents and Reps. If you succeed in photography, there will be agents and representatives to manage along the way. In reality, they think they are managing the photographers.

When it comes to these outside associates, work together. Read all of their paperwork and complete the tasks they request. After all, they represent you in the field and in the market. Communicate on a regular basis, equal to the amount of work they do with you and the amount of income they provide. Don't become a bore, and don't become a missing person either. Keep a good file.

Don't work around your outside people. If they are selling your work, let them sell it. Constantly calling to check out their progress is a waste of time. Let your agent's or rep's track record speak for itself. If they do a good job, keep them doing that job. If they fail, look elsewhere or do it yourself. Do not sell around or undercut your representatives.

A major advertising agency once called my office seeking stock images, then called my agency for the same photos. After some negotiation, my agency seemed to want more than these people were willing to pay. The ad people told the agency that the photographer would certainly come down in price if they dealt direct. This could have put me on the spot with both the advertising agency and stock agency. Fortunately, my stock agency communicates well with me and did so immediately. I managed to get the stock agency working directly with the ad agency by making it plain that I wouldn't sell around my agency—and certainly not for prices below what they negotiate on my behalf.

Time Management and Priorities. Seems there was this travel photographer driving down California Highway One, just outside Malibu. He saw a beautiful sunset and stopped along the road to shoot the view. As he opened the door to get out, a huge eighteen-wheeler came along and took the door off his new BMW convertible (he obviously read an earlier edition of this book). The guy was incensed, jumping around, and yelling at the truck driver, "You ruined my Beemer! You ruined my Beemer!" The driver looked on for a while and then said, "Boy, your priorities are all mixed up. When my truck took off your door it also cut off your arm." The guy looked shocked and screamed, "My Rolex, you ruined my Rolex!"

Setting priorities is relative to the business and personal life goals you establish. Over the years, I have found that the following rules help in the administration of my business tasks:

- Make a daily to-do list, in order of importance.
- Do first things first.
- Do one thing at a time until it's completed.
- Assign deadlines to all tasks.
- Delegate when possible.
- Have a hot spot on your desk for important things.
- Have a place for everything.
- Work on projects in the mornings.
- Schedule meetings and calls in the afternoons.
- Plan ahead.
- Don't worry about things you can't complete.
- Learn from mistakes.
- Set weekly, monthly, and ultimate goals.
- Aim every action toward meeting your goals.
- Take time for people and things you care about.
- Start every day with a smile.

Your Schedules. Ideally, business will be so good that it will require a monthly event schedule. Start keeping a daily, weekly, and monthly working schedule right now. I use a daily sheet, which is kept in my computer and has a phone log and schedule, for each day. I use this to keep track of marketing calls, appointments, shooting expenses, and related items. I update this information on a regular basis and cross reference it with my calendar in order to remember important items and dates. Both the IRS and courts have accepted my daily logs as accurate records.

INSURANCE PLANNING

Small businesses can't always afford to have the same general and medical insurance coverage that is provided to minimum-wage employees at fast food outlets. Welcome to the real world of running your own freelance business.

Insure everything you cannot afford to lose.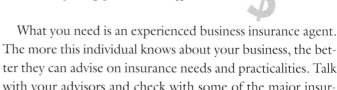

What you need is an experienced business insurance agent. The more this individual knows about your business, the better they can advise on insurance needs and practicalities. Talk with your advisors and check with some of the major insurance brokers. As mentioned earlier, check out the professional photography organizations; they may offer specialized insurance programs to their members.

First, consider a basic business insurance package, which includes most of the basic all-around coverage you will need. Packages can save you a lot of money and time in searching for specific coverage policies.

You must insure both your office equipment and photographic equipment. Lose this stuff and you may be out of business. Cover the most expensive items and live with the potential loss of smaller stuff. Remember that a good alarm system helps prevent loss and lowers insurance costs.

Health and disability should get the same insurance consideration as equipment. If you're sick or disabled, you're out of business. Check out international coverage, if your work extends beyond our borders.

Consider some type of umbrella liability insurance. This should provide protection if you're found at fault for an injury to someone on or near a job, for damaging someone's property related to a job, or if someone walks by your business property and somehow gets hurt. While you may be in the right, a legal defense could still be very costly. Read the proposed policy carefully and ask your agent if you are covered in every business situation and in every location you anticipate working. Liability insurance is also available for photo misuse (use without a release or in an obscene or objectionable manner). This is more expensive, but it's necessary in some photography specialties.

Property insurance covers your home or office, often including some of the liability questions just mentioned, and

equipment. It can insure important papers, computer software, and loss of income. In some cases it can cover image files, but this requires some special attachments to your policy.

I have five hundred thousand stock transparency photos insured under the important papers section of a business policy. They are covered for their material value only, which is about $1.00 each, with a $2,000.00 deductible. This means I collect on major losses, such as a fire, for the cost of production but not for market value. The cost is about $500.00 per year. I have some general business material coverage on my hard drive storage units of digital stock images. But this isn't much. I've found it cheaper to buy another drive and have a backup copy of every digital image stored away from my business.

Insuring images for today's minimum standard market values, $1,500.00 to $2,000.00 each, would be a gigantic expense, and such coverage is nearly impossible to find outside of Lloyds of London. Photographers frequently have had trouble proving image lifetime sales value in courtroom cases. Those who keep good records of past sales, image inventory, delivery memos, material cost, and the like have had the best results in court.

Convincing an insurance investigator that ten thousand images are worth $15 million would undoubtedly mean expensive legal confrontation. Insuring my five hundred thousand images for $1,000.00 each would be $500 million in coverage value. My agent says, "Get real." The alternative is insurance for material value, mentioned above, which does not alter market value. It's the same as an artist insuring the value of paint and canvas but not the value of the painting.

If you donate your time and photography to a worthy cause, and you should, the IRS only allows you to deduct the actual cost of materials and expenses—not your estimated market or insurance values. I suggest using this valuation and argument should your images ever become paramount in an audit.

Death insurance, which is called life insurance by sales agents, is necessary if you have business partners or family who must be cared for in the event of your passing. In the early stages of business, get low-cost life insurance to keep a partner afloat in the event of your death. After five years of business or so, this should be converted to insurance that pays off, or can be borrowed against, if you live.

Make sure your auto insurance covers any business driving, drivers other than yourself who drive for your business, and any car you drive or rent for business purposes. Make sure you see this terminology in your policy, and carry a copy when renting cars. Some auto insurance does not cover car rentals outside the United States. The American Automobile Association (AAA) has some excellent services along these lines. Read the fine print and ask your agent for these specifics.

Production insurance, which covers almost any part of shooting, expenses, materials, props, and so on, is available through specialty companies. Executives in the movie industry use this expensive type of insurance to protect their investment, which is usually in the millions. The insurance can cost more than $1000.00 a month for general low-end coverage.

Always read the fine print and ask questions before you have a loss.

COMMUNICATIONS

Good communications always accompanies success. If you don't communicate well with clients, employees, banks, auditors, and suppliers, you will become a lonely businessperson except for visits from the tax and loan collection people.

Most successful businesspeople, even those you purchase services and supplies from, don't always have the time to physically see or talk by telephone to everyone. However, these people will take the time to examine most written or e-mailed materials.

Correspondence. As was just mentioned, nearly everyone will read first-class mail. Businesspeople love to get interesting letters and rarely let them sit unopened. However, many of these people hate to write those same letters, so don't be offended when they don't write back.

Writing your thoughts and ideas is the easiest way to communicate. You can take all the time you want getting things just right. If it's well presented, your intended reader should have no problem understanding what you want and answering positively.

If you can get your thoughts down well on paper, you can be a success in business.

Your correspondence is important to administration, marketing, and sales. Business communications must also be answered to meet government regulations and requirements. Correspondence is also necessary to get, keep, and complete business. Don't let your active correspondence file become inactive. Answer important correspondence immediately.

Try to write your own correspondence. Compose it on a computer, where it's a snap to make corrections and check spelling. In the long run, this will help you become a better writer for all purposes and will save a great deal of time and money. It will also make you appreciate the necessity of good communications and let you include personal touches.

Keep filed copies of all written, faxed, and e-mailed correspondence, coming and going. You will refer to and use these files often. Use your professional letterhead and envelope for everything. Type or use the computer for everything except personal notes, which are nice when handwritten.

On Writing. If you have problems getting your thoughts down on paper very well, take a basic news writing class at the local community college. Do not waste your time with creative writing, novel writing, or advanced English classes. You need to write in a quick, efficient, and immediately understandable manner. A basic journalism course will help you accomplish this goal.

Proposals and Bids. As the world of photography slowly realizes that it's also part of the marketing world, we're required to compose extensive business proposals. If you have good ideas for proposals, get them down on paper and present them to the proper client. Turn proposals into promotional campaigns. If you have no ideas at all, look to the web or contact your professional photography association.

Administratively, proposals are easy. Develop a simple proposal format, covering your objectives, scope, markets, market value, logistics, budget, rights, rates, references, and samples. Your proposal can be bound in a small booklet, featuring your letterhead as the lead page with photos, newspaper clippings, and your promotional flyers included. Printers, office suppliers, business-service companies, and graphics houses can help develop effective proposal packages.

Ask your business counselors to read your initial proposals. They will have ideas regarding all aspects of proposals, including where to send them. Keep in mind that many business professionals are only required to write legal-type papers, not sales-oriented materials. Don't bother asking these people to read your materials. You'll know who they are by reading the materials they send you.

Keep proposals simple and to the point. Make up two or three extra presentation copies available for immediate shipment to potential clients.

Communicate your ideas to people who buy and use ideas. In our business this means art directors, creative directors, marketing managers, and small business owners and investors. Make lots of proposals. Learn what works and what doesn't. Keep copies. Get advice and ideas from others.

Every now and then, draw up a proposal for your dream job, project, and dream client. Use this as a working goal. Present it to your advisors. Present it to yourself. Present it to that dream client. Who knows? Your dream client may share your dream.

Research your markets and the market in general.

Research. Know what business is doing in general and what it may mean to you in particular. Don't rely on the boob tube. Read business and news publications. Learn everything you can about the markets in which you wish to sell. Research what's going on around the business and photography markets and your client markets as well as business in general. This is basically a matter of reading the trade magazines, business publications, regional news magazines, and checking client web sites. It will be a never-ending search.

Research your clients and potential clients. Get their annual reports as well as copies of their current advertising materials and handouts. Find out who's who in their business. Keep an active file of this research. Refer to it when making proposals. Clients appreciate and expect knowledge of their business.

Research changes in the photography business and the ever-changing tax requirements. This entails not just knowing what you need to file but also learning about trends and changes that are taking place. Much of this information is available from the professional associations, such as ASMP and PPA. Attend some of their meetings. Meet people. Stay on top of things that may change the way you do business. Research, be ready, and be there ahead of the others who don't prepare.

Clip and print out any interesting and important information. File this information and refer to it when planning promotions, proposals, client letters, and other communications that rely on such data. The more knowledge you gain from all of this research, the better prepared you will be to communicate with potential clients.

CAPITALIZATION

You are in business to sell products, just like a hardware or shoe store. Jot down all the elements you think are necessary to start up any basic business. These might include a store, office space, furniture, warehouse storage, plenty of products, display cases, salespeople, advertising, packaging, a service department, working capital, a bank account, and even parking.

Now narrow down each of these items to your business of photography. List exactly what you think it will take to establish and sustain your photo business. If you're not sure what's needed, go back and make a list from the items suggested earlier in these pages. Find out what everything costs before spending any money.

You need a plan. You need to know what's needed to be in business and to stay in business long enough to start making enough money to stay in business for an even longer time. Sound like a never-ending story? You're getting the idea! Use the information provided in chapter 6 to start mak-

ing your own extensive plan, no matter what the stage or age of your business.

Budgets. Everything in business revolves around your budget and budgets in general. Your clients want a budget for the job. Your bank wants a budget so they will know how you plan to pay off bank loans. You need a budget so the money is spent according to plan. Your spouse needs a budget for all those extras like food and rent.

Take a look at the IRS Form Schedule C, which sole proprietors must file if they utilize the standard 1040 individual tax reporting form. It will give you an idea of the basic items most independent businesses utilize. It follows that if the IRS has made provisions for deducting certain items in their tax forms, they must be related to the business process and generally acceptable as deductions. The test is if they are normal and necessary to your own specific business. If the item is of questionable value to your business and the business of photography, then it's probably not deductible.

The following elements should be included in most business budgets. I suggest you include each in a separate checkbook or bookkeeping record category, so they can be entered each time an expense is paid. You will see these same items covered in chapter 8.

BASIC BOOKKEEPING CATEGORIES

Advertising. This is the cost of advertising in creative books, web sites, and other media. Include the cost of design, photography, writing, color work, artwork, mechanicals or production time, and placement costs of your ad in the publication. I also include costs to do promotions such as news releases, sales postcards, and sample prints given to potential clients.

Bank Charges. These are the charges your bank imposes on business accounts for services of any kind. Include the cost of checks provided by the bank. I suggest you establish an interest-paying checking account, where temporary extra money earns something. Remember that your business credit card is a bank card, so annual costs and interest may also be deducted in this category. This is true so long as you don't use the card for personal purchases.

Capital Expenses and Improvements. This covers all office equipment, furniture, photo equipment, and major improvements made to business property. Budget the full amount you expect to spend in a given year. Remember, however, that for tax purposes, the cost of these items must be depreciated over their useful life. Instructions are available from the IRS on this subject.

Car and Truck Expense. Gas, oil, car wash, parking, and simple repairs made during gas-up should be filed in this category. Major repairs should be listed under repairs. Lease payments for business cars should also be included under this budget heading.

Commissions. Sales commissions you pay to agents and others belong in this category. Don't include your stock agent's commission unless you issue them a separate check for those commissions. Employee wages fall into another category, but their commissions fall under this one.

Employee Benefits. Health, vacation benefits, retirement, and other nonsalary or commission items are considered employee benefits. While a swimming pool may be an employee benefit, you might not want to include it in this budget or as a tax deduction unless you're ready to provide some serious arguments to bankers and auditors. Being an underwater photographer might help.

Entertainment. Hosting a client, potential client, assistant, supplier, employee, or other related person to a business breakfast, lunch, or dinner falls into this area. Budget the full amounts you plan to pay, but remember, only a percentage can be deducted in filing taxes. Other entertainment can include the theater, concerts, movies, and similar events that you can prove are normal and necessary to present and future business. Expensive wines, lavish catering, Caribbean trips, fancy yachting events, and similar items will be more difficult to get past the money-watchers and tax people. They do, however, need to be listed in your budget if you plan to spend money in this manner.

Goods and Materials (to Be Sold). Hard drives, discs, memory cards, props, and items necessary to produce your products or services should be included in this category. Include any taxes you must pay under this heading. Make sure you or the client pays retail taxes in accordance with applicable local regulations. You will also have to keep an inventory and deduct what's sitting on the shelf at the end of the year. To avoid this last part, I suggest buying just enough of these supplies to complete each job or self-assigned stock shoot.

Insurance. Budget any insurance you need for the business, equipment, employees, contractors, auto, and rentals. Do not deduct these items across the board without checking the latest tax rulings. Some insurance, such as medical, may be very necessary for a secure business operation but may not be completely tax-deductible unless you are a corporation.

Labor (Wages). All paid salaries should be in this budget. Do not list your wages or those paid to contract employees.

Office Expenses. Postage, petty cash items, window washers, stationery, flyers, software, office supplies, sodas for visiting clients, paint for existing walls, temporary displays, small Christmas gifts (under $25.00 each) and the like go into this budget category.

Freight. This category includes shipping of images to clients and freighting supplies to your location shoot or studio. Include air and ground freight expenses. Some location shooters air express their equipment to a site in advance of the shoot to avoid the security imposed at airports. These cost estimates go into this category as well.

Dues and Publications. The cost of membership in professional associations and subscriptions to publications and yearly directories should be included here. A reference book that is used for more than a single year is not a publication but a business expense. Your professional library may be a capital asset that requires tax expending over its useful life. Check the IRS manual to make sure on this last one. The cost of these items, no matter, should be listed in the budget for the year they are purchased.

Rents. List here your office rent, equipment rental, studio rental, and anything else rented for the specific purpose of business.

Repairs. This is the place to list business equipment repairs, which means fixing something that is worn or broken. Patching a hole in your roof or parking lot is a repair; adding a new roof or paving the parking lot is a major improvement and should be under that budget and tax listing.

Services (Contracted Professionals). This is the place to budget and tax-deduct the cost of any outside service provided by a lawyer, CPA, bookkeeper, assistant, production manager, or model. They must be bona fide businesspeople who provide similar services to others. Ask to see a business license, tax registration, and stationery sample.

Supplies. This category includes expendable props, items for marketing, and things necessary for business in general, but not a specific project or job. Do not include any office supplies.

Taxes. List here any taxes you must pay to be in business. Estimate high for budget purposes. Retail taxes, such as taxes paid on materials, should be expensed with the cost of those items, not in this budget or tax area. Talk with your CPA about specific tax deductions in this area as well.

Travel and Transportation. Costs incurred in getting to locations (but not business auto expenses) should be listed here. Include location car rentals and their gas, air transportation to a job site, taxi fares, a car with a driver, and even sailboats if they are a normal and necessary means of transportation in completing the job. Budget the cost for commuting to and from the studio or office, but don't include it as a tax deduction unless the CPA approves. Location accommodations, food, and beverage should be included in this category as well.

Note that you may also need to budget for expenses and list tax deductions that relate to your individual needs. For instance, I list location accommodations and related expenses in their own separate category. The IRS Schedule C tax return form, for small businesses that aren't incorporated, has a special category to list such deductible items. It follows the standard deductions listing.

HOW TO BUDGET

Annual Budget. I recommend establishing an annual budget around the Schedule C topics listed above. The first year in business you will just be guessing as to what's needed; the second year is based on what happened in the first year, and so on. When you've been in business a while, simply use the previous year's figures with a small growth markup added. If you're just starting or have never spent money for a certain category, estimate out a generic job and use that amount times the number of jobs you hope to complete.

For example, if you plan to shoot aerial photography for annual reports, call the local flight service and get hourly rates; figure about two flight time hours for a normal job. Multiply this by the number of aerial shoots you hope to complete next year.

Of course, the amounts spent for any given item may differ from your budget. If you think in terms of budgeting each business activity and back it up with research from similar or previous jobs, things will start following a pattern. Future budgets should reflect what you've learned from the past.

Keep an active budget for your office expenses as well as for all shoots, proposals, and marketing. Each should be tied in to the master budget. Keep everything on a word processor or computer that can perform simple math calculations and handle quick changes.

Checkbook *vs.* Budget. Assign each budget category a separate column in your checkbook spreadsheet so that every check will be immediately expensed. Some computer software keeps a constant running total for each budget item in the checkbook, so you always know how much is being spent. If not, you can easily tally things up individually each month or each quarter. Year-end tax computations are simple with such programs, as is developing future budgets.

Financial Statements and Loans. Keeping budgets and checkbooks that individually expense items by category is the primary method of establishing pro forma and financial statements. Both of these items, which pretty much show what's happening in your business, are key to getting loans for equipment and lines of credit for jobs, but not for the little extras like food and rent.

A pro forma is an estimate of income and expenses generally used by individuals whose business income fluctuates significantly over the course of a year. While the estimate is

usually generated for a particular quarter and sometimes includes a growth estimate, it can also be applied to reflect anticipated earnings for a month, a year, five years, and so on. Getting a loan or a line of credit to operate your business is dependent upon your ability to show the bank a good pro forma and some assets. This document will give them an idea of your operational and growth plans. Keep it simple and positive. Don't plan to make hundreds of thousands more next year than you did this year. Plan on and hope for a small and steady growth every year you are in business.

Your pro forma should also be reviewed in planning potential income for a photo project. How much will it cost? How much do you stand to make in gross income? What will be your net profit? What's left after expenses? Can you keep doing business and live on what's left after expenses? How long and how will you hold out until profits are high enough to keep you in business without outside help?

$ *Will the bank loan me enough money to make all of this happen?*

Where's the Money and How Can I Get My Hands on It? These are the real questions on most business people's minds.

As the bank robber replied when asked why he robbed banks, "Because that's where the money is." Capitalization, or getting the money to start and expand in business, is mostly a matter of budgets, pro forma, and financial planning, as I've outlined. Try telling this to a banker who only loans money to people who don't need it and are ready to pledge assets of more than double their loan's value.

The first thing lenders look at is your ability to repay the money, or your assets that can be grabbed in case the loan isn't paid off. Your well-presented financial statement, profit-and-loss statement, business plan for the next three years, inventory of equipment and images, receivables, and client list are all things that will help with loan applications.

Investment. The money may be in banks, but these folks are often reluctant to lend it to those who run an unusual independent business such as freelance photography—without substantial collateral. You may have to look elsewhere. Start with the people who offer interest-free money, including your family, friends, and non-photographic business associates. Don't play the starving artist, or you may receive a stern lecture and a hundred bucks for food. Or worse yet, you may not get the hundred bucks and go hungry.

Credit unions, credit cards, investors, and business professionals are possible sources of capital. Doctors, lawyers, CPAs, pilots, and other professionals often enjoy making small investments in creative businesses. They will undoubtedly want to participate in an occasional photo shoot, preferably involving hot models in hot locations. This could turn out to be more trouble than getting cash from the bank, or it could turn out to be one of the best ways ever for you to find money.

A word of caution about loans, lines of credit, and credit cards: make sure you understand all the terms of payment, interest, late charges, fees, and the possible penalty for early payoffs. Don't be shy or feel that the loan will be jeopardized if you ask questions. Make sure you can live with all the answers. People who lend money want you to be comfortable with the terms, not make so many mistakes they have to repossess and fire-sale your collateral and sue you for the balance due.

CAPABILITY

What do I need to be a successful photographer? One of the photography schools? Art school? Classes at the local college? These are questions many photographers come up with in their quest for making it big. They feel that capability means the basic ability to see and make quality pictures. Unfortunately, some of our better colleges, photo schools, and graphic arts professors perpetuate this misconception. You'll need a lot more than being able to make an image.

Obviously, a photographer must be able to make great images in order to earn the Big Bucks. However, the basic capability to make money with this great photography often has little to do with its creation.

Business administration, bookkeeping, and writing are the backbone of a photography business. Add in a little business law, accounting, and journalism and you have the balance. Without these skills, you have no business and you have little chance of success.

Most of this administration doesn't sound like anything a photographer should get too worried about. "Come on, we're artists aren't we? If we can shoot great images and get a *Time* or *National Geographic* assignment, the money will flow and the business end will be covered, right?" That's what the average photographers think, and it has kept many in an average business, but it hasn't made them a serious threat to the Big Bucks shooters.

Business smarts is where the hotshot photographer moves into overdrive and overtakes the also-rans. A semester or two invested in a few local college programs on basic business administration will pay off big time.

5. THE COMPUTER JUNGLE

COMPUTERS AND SURVIVAL

Being computer savvy is more than a luxury in the photography business, it's an absolute necessity. Without all the many services offered and completed by a computer and various software, you will not survive in today's marketplace. And the best part of working with computers is, you don't need to be an expert to make them do most of your work.

Years ago, too many to count, during a seminar for independent business owners, a company demonstrated the ease with which computer word processing could be mastered and utilized. The computer was amazing, it could spit out original typed letters that were matched to a client mailing list, and address the envelopes. The computer could do it so fast that a whole new marketing plan developed before my eyes. The speaker told us that businesspeople who fought computerization would eventually fight for survival in any market. Boy, was he right. Today this prediction is more true than ever.

The computer is as important to the business and art of photography as any other single tool has ever been—including the camera!

I purchased a basic word processing computer immediately following that seminar. In fact, I was the first photographer in Seattle to have a such a computer, and some of my fellow photographers said I was crazy to buy one instead of cameras and film. A few of the better shooters quietly went out and bought their own right away. Of course, that machine quickly became a boat anchor and has been replaced many times with successive bigger, better, faster, smarter, and more expensive computer systems. Obviously, that first computer changed the course of my business, as is has done for business in general, all for the better and for all time. Now who's crazy?

Unless you want to spend a lot of time crying, get computerized before going into any business—especially photography. If you're in the average American household, then you probably have some sort of basic personal computer system and experience. You may already know more about working with computers than many businesspeople; if so, this chapter will just be a review.

While a camera creates an image, a computer system will maintain an entire photography business. With a good system, you can complete all of the business administration requirements, manage image libraries, improve and enhance images, sell images, and a lot more.

BUSINESS COMPUTING

General Business. A computer will help your business operate better, with fewer people and for less money. This means spending more time shooting and less time on administration. I use several computers in my office and on location. The daily work accomplished with these amazing machines replaces at least two full-time employees. With today's excessive employee taxing systems, demand for perfect communications, and massive records, the initial expense of a computer is very low when compared to the never-ending cost of adding another employee and meeting the demands of bureaucracy in business.

Computers Are Our Business. We use computers to write and produce all of our correspondence, e-mails, client mailings, sales proposals, business plans, schedules, and a lot more. We also use them for location and client research, travel planning, transportation reservations, and purchasing of some supplies. We use them to develop client databases and mailing lists. Additionally, we use computers to create business forms and print manuscripts, flyers, advertisements, and similar materials.

Each person in our office has their own computer station and small printer/scanner. We use all sorts of software, large-screen monitors, a laser printer, a large fast black & white text printer, a flatbed scanner, and a slide scanner to bring older images into our library.

We use a Macintosh laptop computer for on-location correspondence, shooting schedules, e-mail, budget updates, image evaluation, and image backups. We still have a Trac Industry Slide Typer system for printing captions directly on 35mm mounts, for those few clients who still demand that we use film.

Finally, we utilize a powerful Macintosh system for image manipulation, design, temporary storage, and file transmissions. The same computer is used for maintaining our web site. It could also be used for video editing, but we prefer to

use the even larger machines at professional production houses. We also utilize the services of a good computer designer for the majority of our professional business image and branding development.

Today's computers can do as much as your imagination and pocketbook will allow.

Basic System. With a little help, or working knowledge, you can be up and running with a good basic computer system in an easy business day. The basics of business and communications functions can be performed by almost any desktop computer. And the best part is, you really don't need to be an expert to make a lot of these programs work. Advanced business programs and image programs do require a better machine, as well as some advanced knowledge.

Software. Software is available for everything you can possibly think of doing in photography and business. Some programs are simple to learn and operate and don't cost an arm and a leg. As with the advanced computer systems, some software requires a lot of study and practice and costs a lot of money. Many of these programs are worth all that extra time and money.

Obtain and learn to operate the software you need to complete essential operations in your business. Do not buy introduction or starter software; you will need the full programs, which are designed for an up-and-running business. This will probably include but is not limited to the following functions:

- Word processing
- Financial accounting
- Data collecting and processing
- Image management
- Image manipulation
- Communications
- Business and studio management
- Disc burning

Software companies offer some of these programs in combination bundles. They generally offer self-teaching programs as well.

COMPUTERS AND FINANCES

We use Microsoft Excel financial software in our offices. It's part of Microsoft's excellent office software package, a smart financial program that can do a complete and accurate budget proposal for the most complicated photo or motion picture project imaginable. After entering the specifics of the job, like the number of days, crews, setups, and so on, we can crunch the numbers to come up with a budget. With this we can accurately estimate the final costs for most projects, put them into writing the client will understand, and make a profit.

One of the smartest things computers do is math. Taxes, too.

How smart should your financial program be? We use Excel and Quicken for our checkbooks, which means the only mistakes are forgotten entries or typos no one has caught. It produces a clean and complete check register every time we write a check. It can also be tied into a profit-and-loss statement program, which tells us how much money we're making so far this day, week, month, quarter, or year.

At the end of the year, or whenever a taxing bureaucracy needs us to fill in a tax form and send them all our money, we simply tell our financial program to do the work. Zap! In a matter of seconds, we've got all the information. Our TurboTax software does state and federal income taxes almost as quickly, using imported data from the above programs and our previous year's information. Best of all, the computer doesn't make mistakes. In fact, it will tell you if you've forgotten entries, have failed to complete forms, or still need to fill out a form. It also has all of the current tax regulations, which allow you to make decisions without calling the CPA every five minutes. The IRS likes these programs because of their accuracy. You'll like them because of their step-by-step ease.

Once our taxes are completed each year, I take a few minutes to compare the past three years. The computer will run a sheet showing gains and losses in profit as well as major changes in expenses. It allows me to produce an estimated budget for the coming year. Banks and other lenders like this kind of information.

Don't worry about putting your CPA out of business because you have or are planning to get financial software. Unless you want to become a CPA, too, you'll only have time to take care of the financial basics of operating your business. That will certainly mean doing the taxes, budget, and estimates. My CPA likes it that I do all the financial entries and first-round work. That makes his job easier, faster, and less expensive. It also gives us more time to discuss tax planning and strategies for expenditures and the like for the next year.

Guess what? We've only started to scratch the surface of what computers can and should be doing for your business.

COMPUTER MARKETING
Your computer is a sales force just waiting for you to provide a little direction and client information.

Communications. Most of your marketing and sales computer efforts will be done in a word-processing program. Word-processing programs allow you to create and output proposals, letters, e-mails, mailing lists, and hundreds of

other written tasks. I love word-processing programs. They check your spelling, context, and grammar as well as provide a dictionary, thesaurus, and formatting tools.

Market Development. Computers and word-processing programs were made for client mailing lists, which are the very heart of a good marketing system. If you don't use it for anything else, the computer will pay for itself in new business opportunities.

There are many good sources for lists of photo buyers' names, which include street and e-mail addresses. You can purchase custom-made lists, adapted to your specialty, preferred type of clients, market area, and any other desired data. Mailing lists are also available from creative publications and professional and marketing organizations. These lists are available online or on discs. All you need to do is describe your business, the client demographic you want to target, and the location in which you hope to do business. These companies will create a very good mailing list for your own specific promotions.

While this direct mail and e-mail means of advertising is highly effective, you'll need to hold tight to your patience and stick with the plan until it starts producing new clients. Accordingly, be sure to resist the temptation to overfill your mailing lists, just because the names are available and they seem like attractive potential business. That can be very expensive in time, postage, and printing costs.

Eventually, through sales and client contacts, you will develop a useful and valuable series of marketing and sales lists of your own. I recommend that, in the beginning, you develop an individual mailing list for each specific market, rather than a single large, unmanageable list. The following categories will cover most markets:

- Advertising agencies
- Public relations agencies
- Design agencies
- Business corporations
- Publications
- Media
- VIP
- Personal

Within the above lists you should categorize, by their specific titles, individuals who may be potential photo buyers or decision makers. Key titles should include:

- Photo buyers
- Art directors
- Creative directors
- Advertising managers
- Marketing directors
- Sales managers
- Public relations directors
- Editors
- Publishers
- Photo editors

Marketing Plan. Use your computer to write a working marketing plan. This should start with current business goals, including to whom you want to sell, where you want to work, and what you hope to produce image wise. These items should be reviewed and refined on a regular basis. Each time you review these basic goals, ask yourself if the client lists reflect the original purpose of your goals. Are you making regular use of the lists? Are they updated and improved as your business changes and grows? Do you make changes in the list when a mailing is returned due to incorrect information?

You should also formulate a business development plan, which you can store as a computer document. To do so, follow the steps outlined in the next chapter.

Computerized marketing plans and client lists create opportunities to sell your work.

Sales Efforts. With a simple computer and basic software, a photographer is capable of producing hundreds of original promotional packages, tailored to each recipient, in a single afternoon. You can easily write one hundred or one thousand original letters and sales proposals, complete with envelopes, in a day. Each will have an individual's name, company name, address, and personal references within the body copy. These names come from your mailing lists. This means that each of your potential clients receives a one-of-a-kind package. Think about it. One thousand original sales letters in a single day. With a good proposal and client mailing list, this could be a good start toward making Big Bucks. This same computer application can be used to write postcards, flyers, and other marketing materials. It is one of the most important ingredients in a good sales program.

Client selectivity is simply a matter of having the right list, with the right information to sort. The more detailed your mailing list, the more options there are for being selective. Remember, you can purchase mailing lists for every type of business. Want to hit a specific city, state, and country? Your client list can be sorted, by the computer, into a single zip code, a single city, a single state, or any combination. You can sort by categories, by telephone area code, or by company and product. Looking for a high-end client? You can purchase a Fortune 500 mailing list of marketing directors. You can use as many subcategories in a mailing-list program as desired.

Mailings, and mailing lists, should be addressed both to an organization and to a specific individual and their position within it (e.g., ABC&D Advertising Agency, Jane Doe, Creative Director). Personalizing your mailings and mailing lists almost always gets the package opened and examined. There are so many mailings these days that materials simply addressed to the creative director at an advertising agency or the photo editor of a magazine will most likely be tossed without a look.

A commercial organization mailing list should look something like this:

- Company name
- Individual name
- Job title
- Address
- Telephone number
- E-mail address
- Web site address
- Fax number
- Products
- Advertising agency
- Design agency

An agency/marketing mailing list entry should look something like this:

- Agency name
- Individual name
- Job title
- Address
- Telephone number
- E-mail address
- Web site address
- Fax number
- Clients

An editorial/media mailing list entry should look something like this:

- Publication name
- Individual name
- Job title
- Address
- Telephone number
- E-mail address
- Web site address
- Fax number
- Editorial content

Using Sales Lists. While not every client will take your telephone calls, give a personal interview, or return e-mails, most will open first-class mail and interesting packages. With a good computer system you can send everyone on your mailing lists an original first-class letter with a new sales pitch idea every month. Think of the sales possibilities this opens up without your ever having to leave the office. Before computers, it would have taken a dozen full-time people to equal these efforts in the same amount of time.

Follow-Ups. A computer also helps you to be persistent. That means following up every mailing with another mailing or personal contact. Pretty soon, people will recognize both your name and your work.

Once a client has made contact with you, provide an immediate written follow-up. This can be a short thank-you note, a letter listing ideas, a confirmation letter, or a full-blown proposal and budget. The computer makes this easy with a sample letter for every occasion. You fill in the name, add a personal note, and the computer does the rest.

Promotions and Press. Your mailing list should contain listings for publications and news organizations that photo buyers, art directors, and editors read. Every time you do something newsworthy, write a press release and send it out. A mention in the media is another sales call. Reprint the mention, with the publication's title, and send it to your

clients. The computer does everything but come up with the newsworthy events. I keep an active file of projects that have the potential for being developed into press releases.

Daily Perk. I also keep a working list of the things needed to be done, active projects, ideas, personal commitments, and to-do items. I review and update this list once a week, after my Monday-morning office meeting. In the old days, I kept a list on a yellow legal pad, which was always a mess and difficult to read.

WORLD WIDE WEB

The World on Your Desktop. The World Wide Web (also known as the Internet, the net, or the web) is a television, library, bulletin board, and shopping mall all within your computer. It's also an extensive entertainment center, the world's largest library, millions of advertisements, clients, photographers, and stores selling just about any product you can imagine. You can find information, provide information, show and sell photos, and sell or buy almost every product imaginable. It's a lot more than I've listed, and whole books have been written about this subject.

Photographers and the Web. Want to know how to price a photo shoot or a stock image use? Want to know how the latest camera system stands up? Want to know anything that's going on in photography, or any other profession for that matter? There's a site for all of these things, and a lot more. There are professional photography sites with thousands of suggestions, all based on other photographers' experiences. The same goes for purchasing equipment and supplies. All the best professional photo equipment and material outlets have web sites featuring extensive catalogs. They also feature safe and secure ordering systems. Want to see the world's leading photographers' work? Most of them have a web site. The mega stock agencies have sites that show and sell thousands of photos.

There are thousands of sites on the Internet specifically designed to help and inform photographers. Just Google Photo Forum and see for yourself.

Most commercial web sites also include instant e-mail contacts that allow users to ask specific questions, follow up on orders, and request notification when new products are introduced. Some of the sites include chat rooms, or forums, which allow users to write and receive instant messages with others using the same site. Do you have a problem or a need? Looking for a seminar or location workshop? Looking for a good used camera or computer? Someone has been there before and will help you. Places like Photo Forum, PDN Online, New York Film Institute, and Photo.net are but a

few of the many sites you can go to exchange ideas and information about photography.

Web research may sound confusing, or impossible, if you've been living in a cave somewhere. However, it's really not difficult to manage or find out anything about anything. There are search programs that will locate sites for your consideration. It's like a huge telephone book, giving you lots of choices and a little information on each site to help you make a choice. In fact, most of the telephone numbers throughout the world can be found on various web sites. All you do is enter a subject in the search field and within a second or so, there will be hundreds of places to review.

When I got started with the Internet, I treated it just like a television with a keyboard instead of a remote control. It takes only a few minutes to realize the Internet is a powerful remote control tool when used properly. Google (www.google.com) is the first place you should look to search for and research any topic. Anything. It is an amazing place that will always provide the information you need. Always.

The World Wide Web is one of the most exciting marketing tools ever, and www.google.com is the key to unlocking that huge vault of information.

Selling on the Web. There are several ways to sell your photography using the Web. The best is to establish your own web site, which displays and encourages the purchase of your photography. You will hear how easy it is to design and set up your own site. While this may be true, keep in mind that the people who buy images are usually designers who see the best of the best. Hire a good web site designer, preferably one who uses your work. Experienced designers know what works computer-wise, and what doesn't.

Your web site is a portfolio. You can include pages of your very best images reflecting subjects you want to photograph, a biography, client recommendations, recent assignments, personal work, and similar materials. Start by taking a look at sites featuring your competition, other leading photographers, and the better-quality stock agencies. This should give you a lot of starting ideas to build your own web site.

Make sure you have several ways for potential clients to contact you listed on the site. A link directly to your own e-mail is essential. Most importantly, ask viewers for the sale or assignment. Make it easy for them to buy your work. Note that you don't have to put every image you ever made on the site. Keep it simple and easy to review, and make viewers want to contact you to see more.

Other Web Selling. Some photographers send e-mail images to potential clients from time to time. This is a good way to send your images to a lot of people for very little cost or time invested. Keep in mind that photo buyers are very busy and can become annoyed at what they think is "spam," or junk e-mails. Make sure they purchase the type of work you create, and be sure your stuff is short, good, and marked as a promotion in the subject line.

There is a good side to sending e-mail images to designers. This is the way many of them already receive images from stock agencies and photographers, so they may take a moment to see how your work looks. If the page is interesting, they may check our your web site or request additional images. Always give them a way to be removed from your e-mailing list. This may hurt your feelings, but if they don't want your mail, it's best. It will also keep them from calling to complain or telling their designer friends you mail spam.

You can also place images on photo sites specializing in selling to photo buyers. The cost to be included in such sites is often low, and the method can be productive. Make sure the site also has a method of selling the images on your page directly to clients. Otherwise, you need a good system by which potential clients can contact you and buy directly.

There are also sites that offer wholesale art products to home and office designers, architects, commercial space rental firms, and similar places. If your work looks good on walls, which usually means it's generic and colorful, these sites may be a good place to post your images.

You can also sell the use of your images to illustrate sites for other organizations. In my case, airlines, travel agents, and tourist organizations often lease images for their sites. Always try to get some type of photo credit and copyright notice. The better clients will let you have a link that takes interested viewers directly to your site.

COMPUTER BUSINESS ADMINISTRATION
The computer was undoubtedly invented for the business world.

If you haven't figured it out, everything you ever wanted to conduct a successful business is available in one computer program or another. There are studio and commercial photography business programs available, as well as stock cataloging and storage programs. You can also buy stock image and assignment programs, not to mention a wide variety of bookkeeping, employee, and tax programs. An employee program helps small businesses simplify, calculate, and estimate things like hourly wages, salaries, overtime, vacation time, comp time, health insurance, sick leave, liability insurance, retirement benefits, and taxes. Sometimes such programs are a part of a larger business office management program. All of these, and more, are reviewed and advertised in dozens of monthly computer magazines. Most of the bet-

ter photography software is reviewed frequently and advertised in issues of *PDN*. You can also find these programs advertised on photography web sites.

Record Keeping. Every time you create correspondence, proposals, or similar materials on your computer, it acts as your filing cabinet. In fact, document storage is considered the most basic and essential business use of a computer. Eventually everyone related to the business and governmental worlds will agree to accept e-mail records, computer records, documents, signatures, and similar materials electronically, without a hard copy backup, and there will be no need for conventional file cabinets.

Stock photography record keeping is one of the best time-saving capabilities of a computer system. Image information can be recorded in a system and cross-referenced by subject matter in such a way as to enable anyone to find the right shot for an immediate client need. By assigning a unique number to every stock image, you can also develop lifetime sales values, sales records, and a simple filing system.

Record keeping for photographers covers a wide variety of uses, which include, but isn't limited to, the following:

- Active clients
- Appointment calendars
- Assignment or job development
- Assignment or job completion
- Checkbooks
- Contracted services
- Equipment inventory
- Inactive clients
- Invoices
- Mailing lists
- Materials
- Office supplies
- Payables
- Photo supplies
- Profit and loss statements
- Receivables
- Sales records
- Schedules
- Stock library
- Stock submissions
- Suppliers
- VIPs

Accounting. Bookkeeping, invoicing, taxes, and other financial operations are often the primary reason businesses purchase computer systems. These are usually the first thing business computer salespeople will discuss, pointing out how easy it is to keep a checkbook, figure employee taxes, and so on. They're right. A computer and the proper software can make it easy to accomplish most financial business tasks.

To me, figuring taxes and keeping the checkbook have made the computer worth its weight in Nikons. Make an entry, say for a check to pay a supplier, and the system subtracts the amount from your checkbook and adds it to the proper tax-deduction file. If all your payables and receivables have been entered in the system, year-end tax computation is simply a matter of letting your system quickly and accurately do the job.

One of the best things about most accounting packages is their ability to churn out a profit-and-loss statement each month, quarter, and year. This immediately tells you how the business is operating financially. Your profit-and-loss (P&L) statement will split fixed overhead and assignment costs into separate categories and show any profit for the period. Obviously, you must make a profit most of the time in order to keep doing business. Some P&L statement programs will analyze your figures and show where additions or cuts need to be made. Banks, CPAs, lawyers, and the IRS love these accurate financial records.

Job Tracking. The busier you are with selling, planning, shooting, and delivering jobs, the more difficult it is to keep track of costs, materials, time, and profits. A simple tracking program can do this task daily. Spend a few minutes each morning reviewing the computer schedule, appointment calendar, job progress, material needs, and assignment development. The computer will never forget something it has been asked to remember—and, as a result, neither will you.

I print out a working progress copy of jobs and schedules on a weekly basis. Copies are made for any assistants or staff as needed. This is my daily and weekly work plan. I consult and revise it as jobs are completed or accepted. In other words, I make a list of things to do, and go down the list with the help of a computer that never forgets a single item that's been entered.

It's an easy task for the computer to catalog all of your jobs and provide an overall chart or scale by year, or for five years, and so on. With this, you can compare averages of time to complete jobs, costs for materials, number of employees involved, profits, and any other category desired. This same program is ideal for stock image production, sales, and uses.

COMMUNICATIONS

The following are examples of the type of communications you can easily produce with the assistance of a good computer system:

- Agreements
- Bids
- Budgets
- Collection notices
- Confirmations
- Correspondence
- Delivery memos
- Editorial text
- E-mails
- Financial information
- Follow-ups
- Images
- Invoices
- Letters
- Press releases
- Proposals
- Promotions
- Statements
- Stock lists

Once you've produced a communication, you can use your computer to send it through the phone lines (or whatever

connection is used to connect your computer to the outside world), producing instantaneous computer-to-computer contact or read-later letters, computer-to-fax machines, and computer-to-web site correspondence. Of course, your computer can receive similar materials too.

There are also a number of web sites you can subscribe to for such things as assignments, stock needs, and prospects. Some provide postings by prospective clients; others are electronic mailboxes; while others offer information services covering photography, hard news, travel, sports, and much more. These services are also available by normal mail and fax services. The people at PhotoSource International provide some of the best of this type information, as well as a host of other very useful photography information.

While telephone, fax, and "normal" mail are fine for many projects, communications via the Internet and e-mail are nearly instantaneous. You can also include pictures or attach documents that include very good quality images. This type of communication is important when an art director wants you to see their ideas or layouts right away, or you want to send samples from a session to an anxious client during the shoot. The quality of sending images this way has become so good that digital photographers frequently send their images for immediate use by clients and news organizations only moments after they are created. This type of image communications has all but eliminated the fax machine for anything but sending legal documents. In our need for immediate gratification and information, a photographer who can accomplish such speed of image delivery can make Big Bucks.

Global Connection. With your very first search on Google, you will see that the World Wide Web is truly worldwide. Anything and everything you post on the web, communicate via the web, or search for on the web is global. You are connected to any and every other person or business in the world that also uses the web. You can e-mail a university in Bangkok, a tourism organization in Moscow, a shirt shop in London, a restaurant in Rome, and a million other places anywhere in the world. Probably more than a million. You can check out their web sites as well. You can also check out a corporation located a block away from yours, or one in the next city or the next country. The Internet is truly local, regional, national, and international. Because of this, you can be as well.

Global Markets and Sales. Because you are connected to the World Wide Web, you can market anywhere you chose, both near and far. You can send proposals and sales pitches to any company in any city in the world. You can send your local mailings and pitches to a few of the world's very best potential clients, no matter where they are or how big the company. If your work fits their needs, you may find yourself on a jet to somewhere very interesting or exotic. That's how it works for me in the travel business, and that's how it can work for you.

FORMS, FORMS, FORMS

Your computer should also be used to produce graphic business materials, such as forms and flyers. It is the perfect machine for creating these type of printed and web site materials. For years all of my business forms and related print materials have been produced on a computer system right in the office. They can be changed, updated, or eliminated with the stroke of a key. These materials include:

- Accounting ledgers
- Advertisements
- Books
- Business cards
- Cartoons
- Checks
- Collection notices
- Copyright use transfers
- Delivery memos
- Envelopes
- Estimates
- Expense sheets
- Flyers
- Invoices
- Letterheads
- Mileage logs
- Model casting sheets
- Model releases
- Notepads
- Petty cash vouchers
- Phone logs
- Postcards
- Promotions
- Property releases
- Purchase orders
- Stock photo logs
- Stock photo requests

IMAGE CAPTIONING

Computer image captioning will change the way you manage and administer all of your photography, especially stock.

Image Management. It's easy to shoot thousands of images in a few days, but not so easy to properly caption the results with key words, numbers, copyright, and other needed information in the same amount of time. No matter how prolific your shooting is at the moment, you will need software that helps manage, correct, manipulate, and file images. Adobe's Creative Suites, which contain Photoshop and Bridge, are ideally suited for all of these functions, as well as some very interesting design applications.

When I started shooting on film and selling stock, we used a typewriter to make small slide caption labels. Each image took at least two minutes. Lots of slides went into the file with little or no information. Eventually I used a Slide Trac computer and software, which prints several lines of type directly on hundreds of slides in a few minutes.

Today, every image I shoot gets an immediate, complete, and accurate computerized key word caption. Doing this immediately after a job has been shot makes the images easy to find. Clients like the fact that I can find just about any and

every image I have ever shot in a minute or two. I can also find the shoot file in about the same amount of time. This translates into sales and is an important part of my business administration. If you can make it easier to do business for and with a client, odds are they will do more business with you.

IMAGE MANIPULATION

If you've been in photography very long, you already know the computer plays a significant part in the storage and sending of images. Software can be used to digitally enhance and manipulate images. The most popular and productive software for photo manipulation is called Adobe Photoshop, and it is a wonder. This can be as simple as making a sky brilliant blue, the water a deep green, or correcting the color cast in an image that results from improperly paired color temperature of your light source and the camera's white balance. You can also remove blemishes, eliminate unwanted image elements, composite elements from multiple shots, and more. A good artist can remove or add sunglasses, change a one-piece swimsuit into a bikini and back, and yes, remove the suit all together. Knowing how to use the manipulation software does require some study and practice.

Warning. It's acceptable to make small corrections in color and simple changes in images, especially at the direction of a client for a product. However, if you substantially change an image so that it legally compromises another person, company, product, or situation, there can be legal consequences. Making a resort look as though it sits on a beach when it's actually across the street, putting a person in an illegal situation or making it look as though they have broken a law, or making a competitor's product look inferior are just a few of the scenarios you should strive to avoid. If you think a photo manipulation will violate any rights whatsoever, save yourself a lot of grief and potential legal liability and skip the manipulation.

IMAGE LIBRARIES

There are thousands of specialty photo disc libraries and web sites available. Just about every subject, location, product, and emotion can be found in one or another of these places. They can be an excellent market for industrious photographers. In addition, several stock agencies have their catalogs available on low-resolution discs and sites for their clients to view and make comps. There are photographers who have changed professions to enter this realm of shooting, feeling it plays an important part in the modern world of electronic photography profits. The better designers, advertising agencies, and similar image users have created their own libraries of special images made for their clients.

Royalty Free. Most of these images and their libraries are available to buyers for a one-time payment. This is called royalty free. A note of caution if you plan to enter the explosive arena of producing such images for any place except your own sales: you will compete with contract photographers who shoot for producers on a work-for-hire basis, keeping copyrights and most of the future profits for themselves.

In the event you wish to join an agency or producer, to shoot for some of these markets, treat their creation and your acceptance of the work as you would any other assignment. Make sure you understand what is being created, who owns what rights, who pays, and who gets paid when, how often, and how much. Make sure you can and do live up to the contract you sign. Make sure you make enough money and royalties to make such a deal worth your time, talent, and investment.

Libraries. Many photographers, including myself, maintain photo libraries of their images. Mine are on hard drives and in extensive slide files. I also supply a web site, which sells uses in low and high reproduction quality. My images are travel oriented, based on countries I cover and books I've published on specific locations or subjects. My images are licensed for one-time use, campaign use, and royalty paid in advance uses and source libraries.

Big Bucks. As you can see, there are a multitude of ways to sell your images using the computer. Almost all of these are done through a specific computer program. The more you know about all of these options and programs, the better your images will sell and the more markets you will create for their sales. This is the route toward making Big Bucks.

ELECTRONIC COPYRIGHTS

Your Copyright. Copyright ownership is important. Generally it's a simple matter of you making an image and owning the copyright. Registering the copyright is easy and also important should there ever be a need to make a claim for improper use of your image. Unfortunately, digital photography has added a few kinks to copyrights.

Combined Copyrights. With the advent of photo-manipulation programs, images can be changed so much they take on a whole new look and, some claim, become new images. Copyright ownership questions regarding images that are composites or created into completely different images, in which the original is significantly altered in some way, are driving most of the professional photography associations and commercial shooters a little crazy. In such images there may be layers of copyright ownership, in which each element copyright is owned by its creator, while the creator of the new multi-image claims copyright for the overall image. Sound confusing? It is.

Image development costs and copyright questions have driven many photo users and stock agencies into their own work-for-hire photo production businesses. By owning the work, they eliminate any question of copyrights. It's an easy way to make a few quick bucks as a photographer, but the larger and longer-term profits go to the company. Remember, the producing company is footing the bill in advance. It's almost always a take-it-or-leave-it deal, if you make the decision to participate in these projects.

Copyright lawsuits make their way through the courts on a regular basis, attempting to determine who owns what part of a manipulated or combined image. The primary questions arise when an electronically created image uses existing images to make a completely new image, and the creator doesn't feel the original image owners have any right to the new image. While this is an ever-changing legal question, in the end, courts have generally sided with the original creator of a specific image. Who knows what will happen next? Most of the big photo users and sellers have the bucks to keep searching for a court that will give them the rights to your images. You need to stay ahead of all these changes.

Protect your images by registering their copyrights, and always invoice for any improper use or infringement.

Self-Protection. If your images are used in web sites, on photo discs manipulated by clients, stored electronically by agents, or in a similar manner, they can be easily duplicated and manipulated by others without your knowledge or consent. These images may be used in the old and new forms without compensation as well. Always put your name and copyright symbol on all of your photos. Demand that users of your images do as well. Follow up with invoices to organizations that use your images in any manner, without your consent. Just because your image is a small part of another image doesn't mean it's no longer your image.

Make sure you search for and keep track of where your images are used electronically.

Make sure your contracts, delivery memos, and invoices all spell out exactly what a client may and may not do with your images as a result of their purchase. This paperwork should limit a client's use to exactly what's on the invoice and your contract. If they want additional web site use, digital storage in their photo library, or unlimited unknown future uses, make sure your invoice and other paperwork says they must compensate you for such uses.

When it comes to digital photography and the many uses and copyright questions, a subscription to *PDN* is worth its weight in gold. The publication addresses all of the current concerns, legal decisions, and related information.

Copyright ownership, registration, and transfer are covered in greater detail in chapter 7.

SELECTING A COMPUTER
Computers are available in systems, just like cameras.

Just as there are a large number of photo equipment manufacturers, there are a large number of companies selling computer products and software. Before making any computer purchase, do some homework and research. Talk with your business counselors, other photographers, and friends. Ask what systems they use and recommend. Visit a few computer stores to see what's hot at the moment. Talk with one or two of the major software dealers advertised in *PDN*. Talk with the designers and photo buyers who use your work. Go on one of the many Internet photo forums.

Everyone will have an opinion about which computer system and software will do the most for the least investment of time and money. As with camera systems, you get what you pay for in computers and their operating programs.

Macintosh and Microsoft. Throughout this book I mention the names Macintosh and Microsoft. They manufacture most of the computer hardware and software I use and refer to in this book. I feel they are the best in the business and have the photography-related products and reputations to back up my opinion. No matter what the federal government may have against Bill Gates, I think he's a wizard and deserves everything he's earned. I agree, there are also some very fine products produced by other manufacturers. Much like selecting a good camera system, your choice will be predicated on the type of work you hope to accomplish, and if you buy cheap, inferior computer products and programs, you'll be more inclined to buy the best your next time around.

What You Need to Start. A photographer's computer system generally includes the following:

- Computer
- Monitor
- Printer (black & white laser for paperwork, color for photos)
- Scanner (to convert images into digital files)
- Software
- Telephone or cable Internet modem
- Image storage
- CD/DVD drives and burners

Simplicity. Computer people often say that their systems are user-friendly, which really means it's easy to understand and

easy to learn various techniques. Having used several different systems, I can't say enough about the simplicity Macintosh has built into their systems for photography and graphics people. With a few minutes of instruction, most beginners can be left alone to use the system and teach themselves to do just about anything. When something is complicated or won't work, you can rely on the Mac's Help feature to show you what to do next.

When considering computer system options, have the salesperson show you the ropes. Sit down and try to perform a few simple tasks that are common in your business. Write a letter, draw up a typical invoice, lay out a promotional flyer or a proposal. Bring along a disc of images and see how the system responds to your corrections and manipulations. Is it easy to use? Easy on the eyes? Are there several options available? Are there a variety of accessories and programs available? Are there a series of free or low-cost classes available?

Basic System. Costs for a basic system that will take care of your photography business (computer, monitor, and simple printer) can be reasonable. These basic needs can likely be met for the same cost as a basic camera-and-lens shooting package. A good software package, on the other hand, which includes all the basic programs you'll need in a photo business, will cost substantially more. A big storage drive and backup drive will also be necessary if you want to build a good photo library. By the time you get beyond the basics, you'll also need a computer guru to help sort out the products and prices.

You will upgrade computers and software many times over the years of being in business.

Economics and Expansion. Don't expect to run a major marketing program and photography business on a $500.00 computer system that includes software. For this price you can write letters, surf around the web, and play a few games. Computer systems are sophisticated business machines that cost money to purchase, operate, maintain, and expand. Software can also be expensive when it comes to offices and photography. All of these purchases will be a major investment. Start small and expand as your needs change.

Internet Junkie. Just like the cell phone gadgets, your computer, software, and the Internet can become addictive. Remember these things are tools and should first be used for your business. I agree, it's fun to surf around the Web, and do it often myself. It's a good way to find news from around the world, learn about new products, look up old friends, find the best entertainment, and research your next vacation. I know people who spend several hours every day doing these very things. Take care of your business needs first, which should allow you the time and money necessary to play on the Internet.

Quality computers and software aren't cheap, and they tend to expand into large systems very quickly.

SOFTWARE PACKAGES

There are thousands of good computer programs available. A dozen or so companies produce programs that are designed specifically for commercial photographers. The best of these are advertised and reviewed in the leading industry magazines and web sites. Always talk with someone who has practical experience using any software in which you have an interest.

I suggest and recommend the following software. Different creators have different names for their programs, and some offer bundles, but you'll need software that accomplishes the following tasks:

Word Processing. Used to produce correspondence, proposals, purchase orders, invoices, scripting, scheduling, press releases, and some mailing lists. Microsoft Word is my choice.

File Data Systems. These programs work with word processing programs, allowing you to develop and maintain mailing lists, client lists, estimates, and purchase orders and to store documents and other important data. Microsoft Excel is my choice.

Financial Programs. Allow you to complete taxes, simple accounting, checkbook balancing, invoicing, financial statements, budgets, and proposals. Quicken is my choice for checkbook and general finance management. TurboTax is my choice for taxes. Microsoft Excel is my choice for budgets.

Photo Pricing. Used for stock and assignment cost estimating. FotoQuote is my choice.

Page and Form Design. This program is used to create graphic layouts, including forms, stationery, flyers, advertisements, and books. Adobe Creative Suite InDesign is my choice.

Image Correction and Manipulation. Used for image enhancements, correction, construction, and to acquire images for scanning. Adobe Creative Suite Photoshop is my choice.

Image Management. Used to sort, select, caption, and edit batches of photos. Adobe Creative Suite Bridge is my choice.

Studio and Business Management. All-around photo business management. StudioPlus is my choice.

Software Copyrights. Software is copyrighted, just like your images. The creators and manufacturers receive royalties for your purchase and use of their programs. Don't duplicate and pirate software for your business use or for friends. It's illegal and unethical. As professionals who don't want our product copyrights stolen, we must respect those same rights regarding products created by other businesses.

COMPUTERS ARE OUR FRIENDS

Computers are both easy and fun to use. They are an absolute necessity in the modern business world, especially for photographers. Start with a simple system and learn as you go. Ask for help along the way. We've all been there in the learning stages and understand why you're frustrated. Making mistakes is, for most of us, the route to computer literacy. A good computer system will teach you how to use it. You can't hurt the system by experimenting. Learn to live with computers and you'll learn to love them. You'll also make more money on which to live. Everyone wins.

SOME FINAL COMPUTING WORDS

We don't have any game software installed in any of our computers. While such programs are amusing, they are also time-consuming. We're in business to earn enough profit so everyone can play computer games at home. Our systems do have music-playing capabilities, so we can listen to CDs and downloads of our choice while working.

Save Me. Computers are like magic. When they work properly, and you know how to make them work properly, they perform seemingly impossible tasks in the blink of an eye. But sometimes computers strike out on their own and crazy stuff happens—huge files disappear, last year's taxes are lost, software fails or drops everything it has created lately, and photos drift into a computer never-never land. While these little problems can't be eliminated or prevented, there are a few things you can do to ease the pain.

Save Yourself. Save what you're working on frequently, and set automatic saving features to save frequently. Back up everything on CD, DVD, or stand-alone hard drives. Be sure to keep these backups safely away from your general office operations.

E-mail Jokes. Please don't put me on your e-mail joke list. There's enough humor in my life as it is. However, I do enjoy hearing about your successes and ideas to improve both my writing and the business of photography in general.

6. YOUR BUSINESS PLAN

Plan for success and there's a chance. Fail to plan and you will fail.

THE FORMAL BUSINESS PLAN

Bankers will give serious consideration to a loan application if your business plan is a practical approach to production, sales, administration, and profit. Consultants can provide much better suggestions and advice if they've seen a written plan. You will also perform better in business, having taken the time and effort required to produce a good plan.

A good business plan is a combination encyclopedia and road map. It contains the information that leads to success. How you write and read it will determine your destination.

A business plan isn't so much a plan as it is a complete look at your business assets, marketing strategies, goals, finances, and growth. The process of considering all the aspects of your business will help provide a clearer view of the necessary goals that lead toward success.

Photographers who set realistic goals, based on a sound plan, have a chance in meeting those goals. Photographers who don't, don't.

THE PHOTO BUSINESS PLAN

If you haven't figured it out, photography is different from most other commercial businesses. We have a wide variety of creative, personal, and marketing questions to consider that aren't part of the rest of the business world. We lean toward creativity rather than "corporativity." For that reason, most standard business plans lack inspiration and relevance to photography. In fact, many real business plans revolve around business and financial questions that are aimed at getting investors and bank loans rather than building a solid business.

YOUR BUSINESS REVIEW

Your photography business plan is little more than developing, in writing, a series of financial, operational, marketing, sales, and creative goals. Doing this requires making an honest review and inventory of yourself and your business.

Spend an afternoon with an experienced business advisor reviewing your business, using one of the models in this chapter. Small business owners, successful freelancers, CPAs, and bankers tend to be the best people for these sessions. Don't bother taking notes. Record the conversation so you can listen to it several times.

Have your advisor read one of the following programs, an item at a time, while you respond. The initial session will take about two hours, which includes a little time for conversation. Answer each question as best you can without the help of any references or resources. Ensure that your answers to the questions in these programs are spontaneous and honest. They will be the basis for developing and writing your goals and plans for business in the future.

START-UP PROGRAM FOR NEW BUSINESSES
(FOR BUSINESSES LESS THAN A YEAR OLD)

Starting a new business is a little like raising a child. At first, you only have an idea of what to expect. Soon, things take on a life of their own and you're along for the ride. Later, things settle into a pattern, which you control or are controlled by.

I. Outline Your Assets
- What are your creative talents?
- What kind of photography are you doing?
- What kind of photography have you done?
- Is this a specialty type of photography?
- What is your photography knowledge?
- What are your business abilities?
- What is your business experience?
- What is your educational background?
- What are your mental strengths?
- What are your physical assets?
- What is your financial strength?
- Does your family offer moral support?
- Does your family offer financial support?
- What friends can you rely on for support?
- Do you have influential contacts?
- Have other family members started their own businesses? If so, how long have they been in business?
- Has anyone in your family ever gone bankrupt?
- Have you gone bankrupt? Why?

II. Market Analysis

- What are the potential markets for your photography?
- Do you have any serious prospective clients?
- Are your clients local, regional, national, or international?
- Should you hope to expand into a wider market?
- Is your family involved in, or does it own, a business that might be a prospective client for your services?
- What are your proposed clients' best-selling products?
- Are they a high-end product?
- Who are the consumers/clients of your clients?
- Do you personally use any of these products?
- Who are the leading photographers in your market?
- What are the general trends in your chosen market?
- What are your favorite things about this market?
- What is the future of your proposed market?
- What part does photography play as a sales tool in your proposed market?
- How many businesses are there in this market?
- How many specialize in this type of photography?
- Does your market use stock photography?
- What are the leading trade organizations for clients in your market?
- Can you purchase mailing lists comprised of their members' names, addresses, and other contact information?

III. Your Market and Sales

- What kind of photography sells best in your proposed market?
- Does your work compare to that of the best photographers in this market? Can you compete with them?
- What is the average photo day or job rate in this market?
- What will you be charging for a day or job rate?
- How many days do you expect to be selling in the first year?
- How many calls should be made in a day/week?
- How many calls do you think it will take to make the average sale?
- How many days do you expect to be shooting in the first year?
- What is your first year's anticipated gross income?
- How did you arrive at this figure?

IV. Business Outline

- Do you have a business budget? A personal budget?
- How long-range is your business budget?
- Do you have the needed business equipment? Is it paid for?
- How old is your business equipment?
- Do you have the necessary photo equipment? Is it paid for?
- How old is your photo equipment?
- What is the ideal photo equipment?

- How much space does your business require?
- How much can you spend on rent?
- How much will the monthly utilities cost?
- How much will you spend on advertising and promotions this year?
- How much will you spend on phone services each month?
- What do you need, financially, to survive each month?
- What do you need, financially, to survive in business each month?
- Are you properly computerized?

V. Capitalization

- How much money do you have immediately available?
- Do you have a source of income (or cash) other than photography?
- How do you plan to finance your photograph business?
- If your first year is profitable, what will you do with the money?
- Assuming it's a disastrous first year:
 - *Do you have a backup plan?*
 - *Do you have a cash reserve?*
 - *How much money do you owe right now?*
 - *How many credit cards do you have?*
 - *What are their credit limits?*
 - *What are the balances due on these cards?*
- What is the name of your banker?
- If you need business money and the bank says no, can you survive?
- What is your credit rating?
- Would you hock the family jewels to start this business?

VI. Market Entry

- How will you announce your entry into business?
- How will you announce your entry into the market?
- Which potential clients will you call on first?
- Have you drawn up a prospective client mailing list?
- Who are your preferred clients?
- What is the ultimate job in your market? How much would it pay?
- What are your prospective clients' trade publications?
- What self-generated assignments do you plan to shoot?
- Can these assignments be done in cooperation with a client?
- Can they be done for stock?
- Describe the ideal portfolio to compete in your market.
- Describe your portfolio.
- Is it your best work?
- What does the average portfolio cost in your field?
- What is the best way to generate work in your market?
- What does your competition do to generate work?

- Do you have the annual reports from several businesses in your market?
- Who is the top buyer of photography in your market?
- Are you a good enough shooter to compete?
- Name the reasons a client will want to work with you.

VII. Progress Planning

- What is the best source of information about your market and clients?
- How do you plan to improve business?
- What is the best source of business advice for your growth?
- Are you a member of ASMP or PPA?
- What are the advantages of membership in these organizations?
- Describe where your business should be in five years.
- Describe how your photography will develop in that period.
- Do you have an overall life strategy?

REJUVENATION PROGRAM FOR AN ESTABLISHED BUSINESS (FOR BUSINESSES UP TO FIVE YEARS OLD)

Starting and running your own small business, in my opinion, is more valuable than the best university business degree. Nothing can prepare one for the reality of owning and operating a business more than taking the plunge. Learning from early mistakes is the basis of a mid-business review.

I. Creative Talents

- Describe your portfolio. Is it filled with your best-selling images?
- What is your strongest creative asset?
- What is your weakest creative point?
- Describe your personal photography.
- How do you rank among the photographers in your market?
- Who is the best photographer in your market?
- Who is the best business photographer in your market?
- How does your creative standing compare with your business standing?
- Describe your specialty.
- Describe your creative growth in the last three years.
- If you could change places with any photographer, who would it be? Why?
- Describe this photographer's images and clients.
- How does your work compare?
- Do you share a specialty with this particular photographer?
- Describe your stock file's size and categories.
- Describe your stock sales.
- What is most important to you about photography?
- What is your attitude about the business of photography?
- What is most exciting about your own photography?
- What is the most exciting thing about your business?

II. Business Organization

- Describe your business.
- Describe your studio or office.
- What do clients think of your working space?
- Is your best work displayed in your working space?
- Is your studio convenient?
- Put a value on your products.
- Put a value on your services.
- Describe your profit-and-loss (P&L) situation for the past three years. Explain why it is in its current state.
- What is the working capital balance in your checkbook?
- Name your biggest sale this year. How big?
- Name your poorest and/or slowest-paying clients.
- What was your gross income last year?
- What was your net income last year? How does this compare with the previous year?
- What is your projection for next year?
- Describe your various employees' functions. How does their pay compare to other photographers' employees? Are they happy? Are you happy with their work?
- Describe your contractors' functions (assistant, stylist, etc.).
- Describe your business equipment inventory.
- Describe your photo equipment inventory.
- Do you have the necessary business/photo tools?
- Are you good at business administration?
- What are your credit card balances?

III. Your Market and Sales

- What is your position in the market, compared to other photographers?
- Are you considered one of the best?
- What can you do to improve your ranking?
- How many clients have been working with you for over three years?
- How much of your business is repeat business?
- How much of your business is one-time jobs?
- Are you happy with your client base?
- Are your clients happy with you?
- How many prospective clients can you talk with right now?
- Describe your latest sales effort.
- What is your next sales idea or promotion?
- How much did you spend on sales efforts last year?
- What is your sales budget this year?
- Is your chosen market lucrative?
- Who is your best client?
- What is the average income each month from this client?

IV. Business Satisfaction

- Outline your original goals for your business. Have you met these goals?

- What are your goals for the coming year?
- What are your goals for the next five years?
- Is your business fulfilling?
- Are you happy with the growth of your business?
- Are you happy with your own creative growth?
- How do your clients describe you in their introductions?
- How do you describe your business to potential clients? Friends?
- Describe your standing in the community.
- How do you compare with your role models in photography?
- Is photography giving you all that you expected?
- Will photography be your business in ten years?

REORGANIZATION PROGRAM FOR A SCREWED-UP BUSINESS (FOR BUSINESSES OF ANY AGE)

If it's time to reorganize your failing business, start by taking this review and setting new goals.

I. New Goals

- How long has it been since you evaluated your business?
- When did you last set new goals?
- Why are things in a slump?
- Is your business administration strong?
- Are the taxes paid in full and on time, every time?
- What can you do to streamline operations and costs?
- When was the last time you updated your office forms?
- Have you shown a profit for the last three years? Why or why not?
- Describe your market.
- Is your market considered a growth market?
- Are you exploring new outside markets?
- Are there areas of your market that haven't used your work?
- What is the primary method of selling your work?
- What are your secondary sales methods?
- How do other photographers sell in your market?
- Describe the differences between you and your competition.
- Have you considered changing your sales techniques?
- Describe your personal photography.
- Have you added any new creative shooting tricks lately?
- Have you tried any creative approaches to sales? Business?
- How did you make your first sale?
- How did you make your most recent sale?
- How do you plan to make your next sale?
- How did you make your best sale?
- How much stock did you shoot last year?
- How much stock did you sell last year?
- Does your business need new tools in order to compete?
- Have you been involved in any lawsuits?
- Have they had a positive or negative effect on you? On business?

- Are your associates/employees growing with the business?
- Are you growing with the business?
- Have you reviewed any portfolios lately?
- Have you visited a photo art school lately?
- Have you attended a photo conference lately?
- Do you subscribe to *PDN*?
- Are you a member of ASMP? PPA?
- What have you done to improve business and personal creativity lately?
- What can you do to cut business overhead?
- What business investment would make you the most money?
- Describe your most successful project.
- Describe your best client.
- What percentage of your time and income are based on your best client?
- Describe your worst photography and business experiences.
- Describe your ultimate business fantasy.
- What are the two hottest sales ideas you've seen lately?
- Why did they work? What is your estimate of their cost?
- Can you come up with something equally exciting?
- How many sales calls did you make last week?
- How many new clients have you acquired in the past year?
- How many clients have been one-shot jobs in the past year?
- Do you like the business of photography?
- Does photography seem to suit you? Why?
- What is the most exciting thing about photography?
- What can you do to expand this excitement?
- What is the least exciting thing about photography?
- What can you do to improve this area?
- What is the most profitable thing you do in photography?
- What can you do to expand this type of work?
- How does your most profitable area compare with your most exciting area?
- Can you find ways to combine these areas?

PLANNING FOR SUCCESS
No businessperson in their right mind plans to fail. Some don't plan to succeed, either.

Developing business goals is easy. The review just completed provided an outline of the current state of business. Use the answers to make a list of where you would like your business to be at this time next year. These goals should be written in the present tense and active voice—as though the desired result already exists. For example, your goals might include:

- I make six new client sales calls per week.
- I make four weekly calls to current clients.
- I mail one promotional piece each quarter.
- I call each person on my mailing list every six months.

Your plans should be based on what you want and expect next year for the following categories:

- Assets
- Business operations
- Clients
- Creativity
- Debts
- Equipment
- Income
- Investments
- Sales
- Personal life
- Products and services
- Projects

I review my basic goals often, generally about once a month. I read and repeat the goals two or three times during a session and visualize them in my mind's eye.

Using your own list of business goals, try meeting them in every business activity and transaction. Of course, there will be goals that can't be met, just as some goals will be exceeded almost immediately. Do your best to meet goals, and don't despair when something isn't completed. Set a few new goals at the end of each review.

Organization. By keeping daily, weekly, monthly, and yearly goals written down, it's easy to evaluate how things are going. Of course, each list has different priorities. Your daily list contains things that must be completed immediately. The weekly and monthly lists involve the longer-range projects and marketing, and so on.

Organize your time and projects around completing the list one goal at a time. Sooner or later, everything on the list will be more a reality than an ideal.

REAL BUSINESS PLANS

I know that all of this reviewing and goal-setting isn't the type of business plan bankers and investors, or you, might have expected. No matter, these people will expect you to meet such goals in order to succeed.

Your real business plan should begin by gathering all the following information:

- Business financial statement
- List of owned business assets and property
- Small business administration loan application (filled out)
- Personal financial statement

Filling in the information required on these forms and listing your assets and property makes for a comprehensive business plan.

Basic Business Plan. If you're seeking money or financial approval, I suggest using a standard business plan outline, prepared from the above completed information. Keep your answers simple and complete, as has been done in the outline shown here.

I. THE BUSINESS
- Outline your industry and field
 - *The ideal situation for your specialty*
 - *The reality of what you can do*

II. YOUR COMPANY
- The business format
 - *Why you want this format*
- Your business goals
 - *Where, when, how much*
- Officer's and partner's backgrounds

III. THE PRODUCT/SERVICE
- Describe the product/service you will offer
 - *Outline costs and expenses for sales*
- Describe the process and equipment needed to produce the product/service
- Explain any uniqueness you have to offer
- Show product/service price cost and sales structures
- Describe needs and growth expectations (over the next three years)

IV. MARKETS AND SALES
- Define your market and ideal customers
- Outline the plan to reach this market
- Describe sales, advertising, and promotion plans

V. FINANCIAL
- Budgets for:
 - *Operation and administration*
 - *Legal and tax consequences*
 - *Marketing, sales, and promotion*
 - *Screw-ups and slow downs*
- Outline desired and proposed financing
- Outline the potential risks and profit
- Project your three-year financial profile

VI. YOU
- Samples (miniaturize your portfolio)
- List best clients (attach complimentary letters)
- Photos of your business (it's different and will impress)
- You and crews in action (on assignment)

Business Plan Format. You're a creative person. Make your business plan a creative package as well. Put your all-time best and most appealing photo on the cover. Bind the statement like your portfolio. Show those financial people that you're more than some shoe salesperson hoping to open a shoe shop.

7. PHOTOGRAPHY *vs.* THE LAW

$ Working within the laws and regulations is a lot more productive than the alternative. It's also a lot cheaper.

LAWS AND INDEPENDENT BUSINESSES

Sometimes it seems as if it's us against the laws that regulate small businesses. Is there a conspiracy to keep freelance photographers from earning a simple living? Everywhere we turn there's another legal roadblock, loophole, permit, or regulatory form someone uses against us. While the situation is pretty much the same for large businesses, most of us small folks don't have the same resources to fight, keep up, and quickly recover—unless we educate ourselves.

$ Memorize the phone number of a good lawyer and call before there's a problem. Make sure the lawyer is successful, experienced in the arts, and a tough SOB.

Independence. Today, independent businesspeople, that means freelance photographers, have a host of legal options available in their fight (and it always boils down to a fight) against heavy-handed legal actions. Not only is there a growing interest in legal representation in the arts by a few hot-shot attorneys, but our professional associations have begun taking stronger legal stands. As a result, we're winning some important decisions and learning how to take care of ourselves in the process.

The world's population is growing rapidly, and more and more people are entering into small businesses like photography. All of this interest and growth means a lot more attention to our business. Add this attention to the fact that communication is almost immediate, and we're on the carpet about fifteen minutes following a stupid, perhaps illegal, business mistake. Would that our time on the legal carpet were limited to fifteen minutes! Unfortunately, legal actions can last a very long time, and in the legal business, time is money—even if you're the eventual winner.

While there isn't an easy solution to the growing number of legal problems and actions that photographers may face, with a little foresight we can take some steps to lessen or even eliminate the potential blows. This requires two things: spending time getting informed on the changes and developments that legally affect our business, and spending some

time with lawyers. A little humor goes a long way toward improving your attitude on the laws of small business, and the business of photography. Most of those laws would be humorous if they applied to someone other than yourself.

Money Up Front. Early in my career, an independent publisher contracted me to do a three-month shoot in a tropical location. The job was perfect for the kind of images I produce. We signed a short agreement, and I borrowed money to cover expenses rather than asking for an advance. I was naive enough to think that asking for advance expenses might cost me the assignment. Upon completing the shooting, processing, editing, and captioning, I presented the publisher with an invoice. After about three months of invoicing, calling, and pleading for payment, I realized they never intended to pay. Luckily, I had held the images.

$ My first freelance job was a near legal and financial disaster, because I was overeager for the work.

I hired a lawyer, filed a suit, and went to court. The publisher denied even signing the contract and said I did the shoot on speculation. Fortunately, it was notarized and that argument didn't go far. During our time in court, we were personally attacked with additional comments that also proved to be false. It is amazing what people will swear to under oath. In the end, after three very long days in court, the judge ruled completely in our favor. However, the legal lessons and expenses were just getting started.

Following the judgment, the publisher declared bankruptcy, closed the business, started a new corporation, and immediately went back into business producing and selling the same products. I couldn't prevent the new business from starting, and I couldn't collect from the old one. Then my lawyer presented me with an invoice that was several times the amount agreed upon for handling the matter. After I questioned the amount, he asked if there was anything in writing to substantiate the quote. There wasn't, but I offered a cash settlement or another opportunity for him to appear in court. Neither of us wanted to see each other again, and he accepted the cash. Lastly, the bank that loaned me money to cover expenses in the first place and wanted payment in full or my equipment, which had secured the deal. We found

yet another lawyer to convince the bank to accept a longer term of payments. It took a while to pay everything off, but this early lesson about the legal system has paid off many times over. I call this experience my masters degree in the real world of small business.

Getting all the expenses and part of the photo fee in advance would have prevented most of the mess. If a client isn't willing to advance your expenses, you become the bank and risk never getting paid. Whomever holds the money holds most of the cards in such a deal. Don't deal yourself short.

Ever wonder why sharks never attack lawyers? Professional courtesy.

Lawyers. "Every independent businessperson needs a smart lawyer with the instincts and attacking ability of a tiger shark, because that's exactly what you'll be facing on the other side of the table in legal actions taken against you." My brother, formerly an experienced and successful lawyer and now a tough-minded judge, told me this only half in jest. Unfortunately, my brother didn't become a lawyer until well after my fiasco described above.

The smart businessperson knows that lawyers need to be more than attacking sharks—a whole lot more. Their responsibilities are as wide-ranging as those of a commercial photographer. To communicate effectively with legal counsel means educating yourself on their roles in the business community and the business of photography.

Advice and Protection. The most important role of lawyers is to advise and protect clients in advance of potential problems. How do you know what's a problem before it's a problem? Obviously you don't, so you need to take advantage of the lawyer's knowledge and role to protect. This means having your lawyer look at the way you do business and your paperwork to spot potential problems. This also means that you must have some basic knowledge of what's going on legally in the business of photography. You can keep up with this stuff by reading *PDN*, including surfing through their past issues online (www .pdnonline.com).

An experienced lawyer should examine all estimates, image delivery memos, invoices, photo releases, collection letters and agreements or contracts you intend to sign. The professional photo associations provide excellent forms and formats for some of these documents, which you can adapt to your specific needs. I've also provided samples in the Basic Forms section of this book. Most photographers modify mine, as well, to suit their own business. As you'll see, the forms I use are simple and straightforward in non-legal terms. You and your lawyer may desire more strict legal language. Follow his advice, not mine.

The more your lawyer knows about our business and about your business, the better the advice. If you're involved in a copyright legal action, don't rely on the lawyer who has been writing your family wills. Violation of copyright, trademark, logos and the like is a serious, expensive legal business and requires extensive knowledge and experience to fight.

If your images are used without your consent, send an invoice immediately. This should be your first legal action against unauthorized uses.

Say a client improperly uses your original images, without payment. I would immediately send an invoice for the use—and at the highest current rate for whatever that usage might be. For the sake of this book, let's say you call the client instead and he wants to pay a total of two or three hundred dollars for pictures you feel are worth two or three thousand each. This is serious business. Talking with a lawyer who specializes in these types of actions, before they arise, could help you solve any problems—or to avoid them altogether.

Representation. Lawyers generally represent us when legal actions are already taking place. This means they are acting on our behalf and in our best interest. For me, this also means appearing in my place whenever possible, since I don't like the stress and time away from work it takes to fight with other lawyers and disgruntled clients. I have come to admire and appreciate the relationships between lawyers. They have a common respect for each other and understand that a given case isn't personal, it's business. They know this relationship means they might meet again in future actions, perhaps on the same side. It also means they can talk and settle differences reasonably if allowed to do so. It's just business and negotiation. Don't interfere with this professional relationship and understand that in the end, it works in your favor. Settlements are always preferable to litigation.

Photographers often have difficulty keeping cool enough to handle legal situations and their resulting negotiations. The best advice I can give you about any legal action that you are unable to solve directly and quickly with the other party is to get out of town on an assignment and let a trusted lawyer settle the dispute. The lawyer represents you completely and, if you happen to participate, does all the talking. The net result is that the lawyer gives you his or her best advice on what moves to make. Some-times this means litigation and going to court, and sometimes it may mean accepting less than you feel is adequate. Ask your lawyer to spell out the time, costs, and potential results of any action.

Use your head when being represented by a lawyer. Don't let the shark attack until and unless there is little chance that anything else will work. Once your shark attacks, the other

side's shark will have no choice but to defend, which almost always means an attack against you. Once a shark bites a chunk out of your north end, you'll find that the south end often has difficulty making sound decisions.

No legal problem is so serious or seemingly impossible that it won't look less threatening in the morning. No problem is so small that it can't be legally fought into a major expensive impossibility through neglect and presumption. Let the lawyers bite chunks out of each other's north ends, while your south end heads south for the week.

HOW TO HIRE A GOOD LAWYER

Find a good lawyer early in your business career, when things are going along just fine. If you wait until problems develop, there will be some expensive time spent educating a new lawyer on your business and the problem. The key word here is *expensive*. If you have a problem that may require legal advice and help, take care of it quickly. The longer you allow a problem to sit, the less likely it is that it will be settled in your favor. In fact, there is no known small problem that won't become a big one through neglect and disregard.

Recommendations. A personal reference or professional association referral is the best way to find a good lawyer. Just for the record, a good lawyer is one who has experience with the arts, meaning copyrights, image uses, creative contracts, and the other things mentioned in this book. A good lawyer will also try to keep you out of court. Be wary of those who would immediately sue, even if that's what you're demanding. Remember that some sharks are quick to attack anything in sight. Look for the lawyer who pulls on the flippers and bares the teeth only when it's impossible to avoid a fight.

Schedule an appointment asking for an opportunity to get acquainted with a lawyer, keeping in mind that her or his time is for sale just like yours. Don't be shy about asking the price for this or any other session. Be honest and say that you are shopping for an attorney and their name has been recommended by so-and-so. The first meeting should take less than thirty minutes, during which time you should share the basics about your business, growth, and any areas in which they can provide counseling. In turn, they will tell you what to expect from their services, what you pay for advice, the cost to review or write documents, and the cost to defend or initiate and try a lawsuit. They may even have this information available in a booklet.

Select an attorney you are comfortable talking with and in whose ability you have confidence. You don't need to be their friend, in fact you want someone who can be tough, not friendly. Since you've gotten a recommendation before meeting the prospective attorney, you also know something about this person's experience. Winning a lot of lawsuits isn't

necessary, but it's nice to have a big stick in reserve. The average lawyer will advise you to make every attempt possible to reach a settlement, so you should seek someone who can negotiate and debate successfully. Lawyers should be good salesmen, just like you, because they have to sell opposing sides and judges on the merits of their clients. Look for this sales quality in your lawyer.

Your Attorney. Once an attorney is your attorney, they need to know everything about your business. Provide them total honesty if you expect the same in return. Lawyers will, and legally must, keep all of your secrets. More important, they base advice on what you tell them, so don't hold back something that may change your liability and limit their ability. Let them do their job while you do yours.

Do Your Legal Part. Photographers often overlook their responsibility in providing liability protection to themselves and their clients in the making and use of images. You should make sure your paperwork is solid and in order, in the event of any legal question. Model and property releases are the first area of concern. The client expects the photographer to obtain or have releases, while the photographer may think that the client's employees don't need to sign releases. For the record, a company doesn't automatically have the right to use an employee's images or likeness—even if they think so. Some employment applications include generic marketing and photo releases. Take no chances with releases and get them for everyone and everything.

Copyrights and image usage transfer is another area in which you and your lawyer must pay close attention. This is a place where you can kill two birds with one piece of paperwork. Every invoice I send out has the exact use rights and copyright ownership listed in the same size and same area as the photo fees. They also include specific mention of exactly what rights transfer to the client, and that they transfer only upon payment in full of the invoice. It also says that any additional use, including electronic publication, is available and considered separate and requires compensation. They have to pay if they want to play.

Foreign Legal Problems. I do a lot of work in foreign countries for foreign clients. It's my policy to get everything up front for a new or unknown client. This eliminates nonpaying clients that are all but impossible to collect from in their home court. If you work in foreign locations, there may be times when legal help is necessary beyond money. Have a local lawyer's name to call should any problem arise. Your regular lawyer may have an affiliation with an international lawyers association. The U.S. Embassy can make recommendations about lawyers and doctors as well. ASMP and PPA have members in many lands, and their legal counsels may be of some help. A foreign lawyer can help with official

reports on lost or stolen equipment, payment disputes, customs, local taxes, permits, and crimes that you may encounter. They can also be a lot of help should the current government of a country fall. Anyone with a camera is often considered fair game when such things happen.

AGREEMENTS AND CONTRACTS

Anytime you agree to make photography for a client, that's basically a contract. From that point on, things can get more complicated when it comes to determining what really constitutes a legal and binding contract. Oral agreements for more than $500 are expensive to enforce under the Uniform Commercial Code. They are not impossible to enforce but are generally a waste of time.

Get It in Writing. Always, always get your agreement in writing. Even if it's a simple letter exchange with the client, along with their advance payment, of course. Read, understand, and agree with every written communication between yourself and every client. If you don't agree with something, make a change on the document and initial it. Never leave anything to chance; the client certainly won't. If possible, have your attorney take a look at anything that seems complicated or beyond your usual scope of business agreements.

Purchase Orders. My lawyer suggests that a client's signed purchase order and check for advance expenses constitute a written agreement—especially if you cash the check and do the job without any other written communications. Cashing the check is your client's best indication that you have entered into the agreement. Read the fine print on purchase orders before cashing the check. If you agree with the terms, return a signed copy, and head to the bank to see if the check clears. If you don't agree, cross out and initial objectionable items and type "purchase order accepted subject to changes and agreement with art director so and so," above your signature. It might be best to send purchase orders with such changes to the person who negotiated the job, rather than to the accounting department. Money people may not agree to your changes in their fine print. I always hold the check until these changes have been approved.

Work for Hire. Your client, through purchase order or other written communications, may expect to own all the rights to the work you complete for them. They may think you are "sort of" their employee. It may be written into one of the documents that change hands in slightly different terms, but it means the same thing. The client wants to own all rights to the work. Period. However, they won't treat you as an employee, meeting all the federal and state tax, unemployment, social security, insurance, vacation, and similar requirements. They want you to cover all these expenses, plus provide equipment, materials, and creative knowledge, and

then give them the images and go home. Make sure you can live with all the terms of an agreement before signing. Make sure you know all the terms, as well, before signing. Your lawyer can help with this fine print stuff.

State Job. I once bid on a job to shoot an entire state's travel attractions. The client wanted all rights to a hundred images of a hundred specific subjects. There were some nice benefits, which included shooting unlimited stock, keeping all images beyond the one hundred, VIP treatment at many events and properties, and the potential for other work with their agency. All of this included a high photo fee and liberal expenses. I spent a great deal of time bidding, with the understanding that being a state resident wasn't required. The agency sent me a note saying I had the job. A few days later, after I had purchased a lot of materials, the state client called and said they were sorry but the job had to be awarded to a state resident. It took a while, but they ended up paying for all the materials—which I kept. What goes around comes around. After several weeks of shooting the job, the contracted photographer saw an article on work for hire. He met with the agency and refused to continue shooting under their signed agreement or give them any images. The agency eventually kicked his rear end in court, and the state now employs full-time photographers to make their images.

Governmental bodies, just as other clients, often change their minds or have regulations even they don't know about, so ask for a letter of confirmation and cash up front before spending any time and money. Also, if you accept a job, do it as agreed. Every time a photographer backs out of a job, fails to meet an agreement, or creates a similar problem, the business of photography suffers. I'm not suggesting that you accept any and all conditions, such as work for hire. I am saying you must meet all the conditions you do accept.

Work for Hire, Part Two. Should you or shouldn't you accept work-for-hire jobs, in which the client owns some or all of the images? Look at all aspects of the potential job. Are there stock possibilities? Can you share copyright ownership? Do they really mean all rights? Is this a blockbuster fee or job, and is this a great client? After careful consideration, make the best-possible deal and then live by it to the letter. Otherwise, try to negotiate a better deal, or say thanks but no thanks and make an exit. If you give up something, like unlimited rights, make sure there's something gained—like the right to shoot unlimited stock with the client's models.

Cover Your Assets. Once a basic agreement to produce photography is reached, I immediately send the client a letter of confirmation with my interpretation of the job's terms. This gives me the opportunity to cover any areas of concern before, or instead of, issuing a written contract. The following items should be covered in confirmation letters:

- Specify exactly what will be photographed, when, and where—perhaps with the client's shot list attached.
- Establish who has the responsibility for approving changes in the job and resulting cost adjustments.
- Include the expense estimate and requirement for up-front payment.
- Establish the exact rights and uses the client will receive upon payment in full for the job. State that future rights, including electronic publication, are separate and require compensation.
- Send a thank-you note for the job, along with a pledge to provide your best-possible efforts.

These letters need not be in legalese in order to make their point. It makes sense, however, to have your lawyer help with some of the non-legal language. Personally, I like to keep things simple and informal, as follows:

Dear Super Client:

I am pleased to have been selected to produce photography of the New Widget for a one-year advertising campaign on behalf of the Same Old Widget Company of Mill Town, USA.

According to your advertising agency's creative director, Mary Pleasant, shooting will begin at 9:00AM on July 1, at the Same Old Widget plant in Mill Town. I have received Miss Pleasant's layouts for the principal shots and expect her to supervise at the site. The photo team, myself, and production assistant have scheduled three working days on location to complete this project. We will be staying at the Mill Holiday Hotel.

We understand that a purchase order and check in the amount of $0,000, for one-half the photo fees and all estimated materials, travel, and related expenses, will be forthcoming before we purchase materials or begin work. A complete invoice will be presented along with our selection of images. In the event of a cancellation or postponement on your part less than 00 days prior to the photo team's departure, the photo fees paid to date will be forfeited.

The Same Old Widget Company will receive written two-year unlimited-use rights to the selected images upon payment of the final invoice. Additional rights, including electronic publication, are available and negotiable.

Thank you for choosing my photography for this project. I am looking forward to working with the professionals at So-and-So Advertising.

Sincerely,
Tory Smith
Smith Photography

Business is business. The letters of confirmation, agreements, purchase orders, and contracts you sign may come back to haunt you in a court of law. Large corporations, small ones as well, do not like entering into bogus deals with flaky suppliers, which is how they may perceive your failure to complete any part of the project. On the other hand, they may feel it's perfectly okay to ignore many parts of an agreement they signed. This leaves you with the option to pursue other means of getting the client to meet the agreement.

This is an imperfect business trying to make its way in an imperfect business world. Do your best to complete every effort exactly as promised.

RATES, RIGHTS, AND FIGHTS

Basic Copyrights. You own the copyright to a photograph the second you push the shutter release, which is called the moment of creation, unless you sign a written agreement to the contrary. That's the federal copyright law.

This looks good in big type but doesn't always ring true in small type. The argument is rarely a question of who owned a copyright at the moment of creation. More than likely it's going to hinge on the later transfer of that copyright, or some other understanding to the contrary. Quite often you will find a transfer of copyright clause on such things as purchase orders, letters of agreement, contracts, payment vouchers, and on the backs of checks. By the way, crossing out fine-print claims on the back of checks is legal. Such wording has nothing to do with your contract with the company.

To avoid any questions, read, understand, and agree with every written communication between you and the client. If you don't agree with something, such as one of these copyright transfers, make a change and send them a note in advance. Never leave anything to chance, or to be settled at a later date. Some photographers ignore the fine print until a lawyer, usually someone else's lawyer, has it enlarged and included in a threatening letter. Don't transfer your copyrights away simply because you have been too lazy to read the fine print.

THE COPYRIGHT
Always include a copyright symbol in front of your name with every image.

Do not take your copyright for granted. Make sure everyone who sees your images knows they are copyrighted. Copyright *every* image, be it headed for a client use, stock agency, your file, or wherever. The copyright symbol (©) and your name should be attached wherever and whenever pos-

sible. This isn't required for you, the image creator and owner, to legally retain copyright ownership, but it shows others not to consider the images fair game (unless you've signed those rights away). The lack of the copyright symbol (©) or your name, may cause photo users, buyers, and potential copyright infringers to think otherwise about your copyright ownership. The lack of the copyright symbol is also the sure sign of a beginner who may be an easy target.

Delivery memos, estimate forms, and invoices should include a little fine print of your own, which states that clients are responsible for your copyright protection at no cost to you, for all images they have used. Very few professional agencies, magazines, corporations, and the like fail to include overall copyright restrictions on their materials, which also helps cover your images.

Public Domain. Some people, including smart photo users, think because an image appears somewhere in public use without a copyright notice that it's in the public domain. This is especially prevalent with images on the Internet, but some think books, magazines, advertisements, brochures, and similar print items also put pictures into the public domain. Not true. Very few images fall into public domain, which is well covered by copyright law, and none of yours will until long after your untimely passing. We're not concerned with public domain in this book. Your images do not fall into that category.

Stolen Images. My images have been "stolen" from all the print places just mentioned. Once a Mexican restaurant used one of my images right off the cover of a major airline brochure—design logos and all—on the front of their menus. Looked great. As fate would have it, the president of that airline had lunch there and kept a copy. He called me to ask if I was in the practice of selling images made for them so quickly and so widely. I had sold the airline exclusive rights for a two-year period. This was easy to take care of, although the restaurant chain thought the brochure was in the public domain. I sent them an immediate invoice and letter. It cost them quite a few tacos to pay for that misunderstanding.

Sometimes a copyrighted image seems to go into the public domain simply because it has been handed around and used by dozens of people. While it isn't really in the public domain, it's a difficult and expensive proposition to go after all the users. The image, however, may be lost forever, and you can bet that a good lawyer will try to prove public domain when his client uses it. It isn't public domain, though, and you should send invoices and letters to each and every person who improperly uses your image. You might entice a lawyer to send these letters for a share of the income.

Multilayer Ownership. When your images are used to create some new multilayer conglomerate image, you still own your original image and its copyright, unless you have transferred that ownership away in writing. I know I keep saying that little bit, but it's important. Pay attention to the fine print in shooting and stock contracts, and make sure you retain the copyright to your images in all cases and in all types of uses. Don't be fooled by fancy talk about major changes in your images being owned by the organization that theoretically "enhanced" your image.

Register Your Images. For the best protection, you should register the copyright to images with the federal government. This can be done easily, and I'll tell you how to do it in a moment. Complete information on this process is available, along with a single application, from the Copyright Office. You can also download any copyright form and instructions from their web site:

Copyright Office
Library of Congress
101 Independence Ave. SE
Washington, DC 20559-600
www.copyright.gov

Should You Register Copyrights? Absolutely. You do not need to register a photo's copyright in order to own the copyright, as I've already mentioned. However, simply owning a copyright may not be enough when it's improperly used by someone.

If you have a copyright infringement, where a person or organization uses your photo without your knowledge, permission, or payment, as owner of the copyright you have the right to take legal action to collect payment. Having the image registered will ease or eliminate the need for such legal action. In many cases, like my restaurant chain, you may be able to show the copyright paperwork or a copy of the copyright law (available at www.copyright.gov) and get an immediate settlement. The invoice and attached letter of copyright ownership you've sent should let them know you mean business and how much you expect to get paid.

The Feds. If the above doesn't work, your legal recourse is in a federal court, because copyright law is federal law. This also means it crosses all state lines and you need not take action in the state where the infringement has taken place. Your lawyer, who must have experience in federal court, will tell you the particulars. If you prevail in a federal legal copyright action, and almost every registered copyright owner does, it can mean being awarded payment for the photo use, legal expenses, and a damages award. An attorney experienced in copyright infringement cases, where the infringement is obvious and the image is registered, generally pursues and obtains a settlement. In such cases, the infringer finds that

defending a legal action in federal court isn't worth all the time, headaches, trouble, and potential liability.

Another Reason to Register Copyrights. At a recent Getty Images workshop for artists, their lawyer talked about the importance of copyright registration. She said, in so many words, that one of Getty's most profitable areas of income was collecting payments for copyright infringements. She didn't call them infringements, rather she called them improper use of images without permission or payment. In most cases, a call from one of that giant agent's attorneys, explaining the improper use and potential liability should a federal legal action be taken, resulted in the client paying double the normal image use fee. These calls are made in a friendly manner that usually results in both a payment and a future customer that has been educated about the proper use and ownership of images.

COPYRIGHT REGISTRATION
Registering your copyright for images is a simple process. As I've said, it's also a very necessary process.

How I Register Copyrights. I register one hundred images at a time with the U.S. Copyright Office. Their official visual arts registration forms can be downloaded from their web site or obtained by writing to their offices (see address on page 61). Instructions for completing the form are also available through the same resource. They do not, however, tell you how to make multiple image registrations on a single form.

I make a computer document file of one-hundred images in any format. Each has an individual name and number. These images are copied into a single Photoshop contact sheet, which is saved as a JPEG file. That sheet is printed in color and the JPEG file is saved to a well-labeled disc. I fill out the copyright form listing the attached contact sheet and CD as the images to be registered. I include this with a check and the form, and send it by registered mail to the copyright people. I keep a backup copy of the registration contact sheet, disc, and the return receipt from the post office.

The lawyers of some infringers have argued that the value of a single image, when registered as I've described, is thus reduced by the number of other images that have been included in the same registration. Mind you, they aren't denying that their client stole the images in the first place. While the Supreme Court will eventually settle this dispute, infringers are also aware that fines and damages have never been reduced by the number of other images included in a registration. A copyright registered image is more valuable, period, just as a model- or property-released image is more valuable. Take the time to do the paperwork.

The Reality of Copyrights. I know that many clients want to own all the rights (often called a buyout) to a certain image or images. For a multitude of logical reasons, often called money and future work, many photographers find themselves transferring away copyrights. If you're selling all rights to images, make sure of two basic things: know what the client really wants and what they are willing to pay for all rights to the images. Normally, we sell certain usage rights, such as one-time-use rights, to our images.

Additional uses, electronic uses, unlimited uses for a certain period of time and all ownership rights are all different situations and should be valued accordingly. That generally means a certain percentage fee increase for each new or additional use. Of course you can, and should, negotiate these terms to the satisfaction of all involved parties.

In the exchange of any use rights, you should also determine what rights you will retain to the images being sold and used by the client, no matter which rights they are purchasing. For example, you should retain the right to use images in your own promotion, not just your portfolio, and all rights to any and all third-party uses and sales. Remember when selling all ownership rights, that unless specifically stated otherwise in the written agreement, the client may in turn sell the images to others, perhaps even placing them with a stock photo agency who will compete against your sales.

In the sale of any image use rights, be specific about what is being offered and what is being purchased. In the case of an all-rights sale, the clients may feel they are purchasing every photo made in the shooting. They could mount that argument if it isn't spelled out in the agreement. The same goes for second printings and electronic publications. I always recommend that a written agreement be initiated when you are selling anything more than simple one-time or one-campaign photo rights. Even then, it's a good idea to spell out exactly what is and isn't being purchased.

No matter what rights you've sold for a given image, the improper, illegal, or outrageous use of that image may cause you to be named in a future legal action. Add a clause to your delivery memo, letter of agreement, confirmation letter, and other transfer-of-use rights that makes the client responsible and liable for their use—*any* use, especially those not approved by you in advance.

The ASMP has done a great deal of research, lobbying, client negotiation, and photographer education in the area of photography copyright ownership and work-for-hire situations. The organization has published excellent information on copyrights and negotiating with clients for photo rights.

Shooters Beware. Freelance writers, illustrators, and photographers who do contract work for daily newspapers and magazines often find that these organizations attempt to co-

erce the freelancers into signing a contract demanding all rights to everything shot for their publications. This means everything shot on the job and the rights to future publication in any and all forms and mediums, present and future. The photographer hands over everything and usually for the single job rate fee of compensation. Freelancers not agreeing to these demands are generally never to be hired again. Do not be surprised or offended when you receive such a contract or requirement from a prospective or active client. To them it's just business.

Large corporations, including mega stock agencies, consider photography to be nothing more than a product and photographers to be nothing more than inconvenient suppliers. They want to own what they pay for and not have open-ended deals hanging around their neck for the next ten years. This is especially prevalent with the creation of electronic images. Again, be sure you understand and can live with the terms of every contract.

Show clients that you are a "creative" product and they will appreciate your efforts with future jobs.

Not long ago one of our former stock agents invited us to a group dinner of her current agency colleagues, in a loud Italian restaurant. Only first names were exchanged, and for some reason everyone except our friend thought we were stock agents as well.

At one point in the lively conversation, someone said their business was great except for the photographers. Seems he was unhappy that photographers wanted any say about their work, how it was sold, and especially how much they received. "Why should the photographers get any more than a small percentage?" he said, "We do all the work." Keep this conversation in the back of your mind, because most of our clients do not think much of our creative abilities—unless those abilities turn out not to be so creative.

HOW MUCH $$$ DO YOU RATE?

What's your day rate? Do you even work by the day? "Is this going to cost a small fortune?" your client asks, even before you begin to discuss the project. What do you tell the client when asked how much an image or job is going to cost? Even a casual mention of a certain rate may be construed as an offer. We know that verbal contracts may not be binding for larger amounts, but do you want to pay a legal fee to find out? Do you want to lose the job because you made an offhand guess at a price or rate?

Quote Contracts. Problems in quoting prices up front usually arise when you're on the job and additional work must be done immediately—beyond the original quote. Log-

ically, you should have covered this obvious possibility in a confirmation letter, shooting agreement, or pricing memo to the client. Conversations such as these often take place in a distant location when the client's local representative, who may not represent the client in financial matters, wants some additional shooting. I say make your best deal and drop everyone involved a brief e-mail or note stating that the job has expanded, as has the expenditure of materials, manpower, and the photo fee. Always carry extra copies of your letterhead for this purpose.

THE PHOTO RELEASE
A photo release is a basic and important tool of the business. Just like your camera, don't leave home without a book or two of photo releases for people and property.

Not Released. A photographer, on assignment in French Polynesia for a cruise line, shot a couple sunbathing on the beach with the ship in the background. It was a great image that was used many times on brochure covers, posters, and in advertising. This professional often ridiculed others about the need for releases in a foreign land and when people were not the primary subject of a composition. The advertising agency assumed there was a release, until the client was served legal papers. Guess what? The couple was married, but not to each other, and they were both trial lawyers. The cruise line settled for well into six figures. The photographer never understood why no future work was offered to him. The image did, after all, bring in a lot of business.

The fact that you have a photo release, for property or person, makes an image infinitely more valuable. It also establishes your intent to sell the photos in a commercial manner with the person who signed the release—no matter how short or extensive the terminology. It establishes this intent beyond any reasonable doubt. Sounds like legal talk, doesn't it? With today's litigious society, using a person's photo or similar likeness commercially, without a signed release, is risky and foolish—and as I've mentioned, it can also be expensive for the user.

There have been some not unreasonable claims made that a magazine cover is in fact advertising to sell the magazine, not editorial reporting. The same goes for spectacular images of news events being used over and over to advertise the medium itself, long after the event has ceased to be news. This is especially prevalent in television sports. A photo release eliminates any concern as to whether or not these are legitimate claims.

Obtaining a signed release can and will quickly eliminate the potential for legal action.

Common Sense. Just for your information, a signed photo release does not allow any outrageous, lewd, or irresponsible use of your photos. You cannot use the image of a family at a picnic to illustrate an AIDS article or advertisement without a specific release. In fact, a release may be obtained from the models but will probably cost more money for this kind of use. Nor can you so substantially change an image that it conveys something entirely different than the original scene and subject.

There are many areas that require a special or specific release. For example, my Los Angeles agent had a client who wished to consider the photo of a brother and sister in jogging clothing, she sitting on his shoulders, for a promotional poster for a movie titled *Getting It On*. Even the client said that the standard release didn't cover this type of situation. Always call your models in the event of an unusual use request, and ask for their specific written permission. Run a couple having fun at the beach in an article about divorce, incest, rape, battered wives, and the like, and you may be in court, release or not. This may also be the case when an image is manipulated into something it isn't, such as pasting one person's head on another's body, removing a model's clothing or placing someone in a compromising position. Common sense should prevail in these situations.

You may also need a more detailed release in shooting certain subjects in which the models or people may even approve, such as poverty, valuable objects, private property, celebrities, police activities, military operations, and so forth. If you think society or the local community might frown upon a certain activity portrayed in specific images you create, get a release for that specific shoot and attach a proof, or don't shoot the subject in the first place. This is especially important with nude and erotic photography, editorial coverage of real or simulated criminal activity, medical procedures, legal procedures, and politically sensitive subjects. I know that in today's media everything seems politically sensitive, but you get the idea. Don't shoot without first getting a specific release for the situation.

Sued Anyway. No release will completely eliminate the possibility of a legal claim or guarantee your winning in the event of such an action. People can always find a lawyer who will file a lawsuit for just about any reason, so long as they are paid for such actions. But having a release is a very strong defense that the subject agreed with your release and intent to sell the images at the time of signing (unless they didn't understand). Make sure you take a minute to explain what you do with photos, what they can expect, and what the release means.

Foreign Releases. My basic photo releases and minor releases (children under eighteen years old) are translated and printed in the language of any country in which I'm working. I also get detailed language coaching on the proper pronunciation of the release contents so that I can read it to potential signers and models and they will understand. This has come in handy a number of times with potential models, clients, and police authorities. "No hablo Español" simply doesn't cut it.

Imagine photographing a quaint flower vendor and his donkey on a small Greek island. The image is used by an international cruise company in their next brochure. The flower man's cousin visits Athens and sees a copy of the brochure in a travel agency. He shows his cousin, who sees the opportunity to be paid by this big, rich company. Next time the ship is in port they approach the captain, brochure in hand, and raise hell. The captain tells the company's marketing manager, who calls the advertising agency representative, who yells at the photographer, who immediately sends the agency a copy of the model release—which is in Greek. I was that photographer, by the way, and I had paid the flower man. Play it safe by getting a release.

Employee Releases. Get a simple model release from every person, employee or otherwise, who appears in a commercial shoot. Doing so protects both the client and yourself. As mentioned earlier, just because someone works for a resort or airline doesn't give them the right to use an employee's photograph for commercial gain. This has been upheld in more than one court.

I have obtained a blanket employee and property release to use images for stock sales. Even so, when photographing their employees I show the company release and ask for an individual release as well.

Get Everyone Released. What do you do about photos taken at crowded events, say the Boston Marathon, or New Year's Eve in Times Square? At times like these, it's impossible to get everyone in the photo released. Can you use these images for a commercial advertisement? Nope. If even one person can identify themselves in the photo, and that's the court test, you may be held liable.

It's pretty obvious that some photographers, and ultimately their wealthier clients, often take chances and use images of crowded events in commercial ads. They assume, probably correctly, that no one is going to sue when they advertise around the Boston Marathon using a picture of the huge starting line, especially if it's a community service use. In such cases, your delivery form and agreement, which states that no photos are released unless accompanied by a release, should provide some personal protection in the unlikely event of litigation.

Minor Releases. Courts and juries are particularly interested in the protection of underage children, and justly so.

Never shoot a minor child in any situation without the express permission of their parent or a supervising adult who is in attendance when you do the shooting. Minors cannot sign their own releases, which means that a parent or legal guardian must sign. The age at which a person may sign a contract or release varies from state to state and country to country. Under eighteen is always a good rule of thumb for minor releases. Don't take any chances; use a release written for minors. And never shoot any minor in a compromising position. Don't even shoot your own kids naked in their play pool in the privacy of your own backyard.

Editorial Photo Releases. There are many photographers who shoot nothing but news events. These photojournalists may never need a release to sell a news photo to *Time, National Geographic,* or a major news association, because they are protected by the First Amendment. It's possible, however, that photographers would face legal action if that same news image were used by those same organizations, to promote their publications, without a release. In such cases courts might agree that it constitutes advertising the publication, not reporting the news.

Obviously, it's difficult to get a release when shooting in the middle of a war, drug bust, presidential campaign, and other fast-moving news events. That doesn't mean editorial photographers shouldn't carry a booklet of photo releases and use them as often as possible. Think about it. Advertising agencies are always using simulated news events in their campaigns, often at great expense, just to obtain proper model releases after the fact. If you have releases, news photos are more valuable. In fact, if you have released news images send them to a stock agency in a timely fashion. This assumes that you are a freelancer who owns the rights to your images. Sales of news related events is one of the Getty Images' prime income makers.

I know it may spoil the moment of making candid photos to get a release, news or otherwise. But, if you haven't been served legal papers or appeared in court, then you don't know what a spoiled moment is all about.

Think I'm Kidding? Think all this release stuff is overrated and overstated? A royalty-free photo library disc company purchased images made of a couple and their child. The family shot was used extensively in commercial advertising. However, the couple didn't want photos of their child used commercially and signed releases only for themselves. The group photo, they said, was made as part payment for the shoot. When all the dust had settled, the disc company settled for a cool million bucks. Doubt if they got any of it from the photographer, but you can bet he's on their hit list for legal action and off their hit list for future work. It wasn't me; I don't shoot for photo disc agents.

This proves a point about royalty-free and web site electronic photo libraries. Just because the fine print says photos are released doesn't always mean it's so. Smart photo buyers are asking for copies of the actual releases when images are used in expensive campaigns. I get calls every week asking for copies of a specific release before a client will make a big purchase from my stock agent. I don't mind because if my image says it is released, then I have the release. Such an example was that Greek flower man. I had the release in my hand two minutes after the ad agency called.

How Important Are Releases? The major stock agencies no longer accept image submissions that are not adequately model-, talent-, and/or property released, using the agency's approved release. If you are a regular shooter for any agency, this usually means they have supplied their release in advance, available in a variety of languages, which must be used and submitted with images. The Getty Images release, for example, is an extensive and very well-written release that protects the photographer, client, and mostly Getty Images, from any legal questions of the photo's use.

Short-Form Picture Release. My working short form photo release provided in the back of this book and doesn't always satisfy the legal departments of large agencies. If you are with one of these agencies, ask for their release and save a lot of discussion on the matter. When reading the agency release, which often contains more than a thousand words of legal jargon that protect and release the agency, you'll soon see why my release is called the short form. My form is simple and has never failed in the few challenges that have arisen. As always, check with your lawyer before using any form or release.

With an adequate photo release, your image is simply more valuable and less susceptible to a legal challenge by a person or property owner. Take the time to get a release in advance of shooting; that way, you'll know the person's name. I've found that having a release allows me to send copies of photos or reproductions of the photos in printed materials to the person. This makes new friends and begets future shoots. By the way, I also share a little of the income from any nice photo sales of people photographed along the way. The cover of my Mexico book is an excellent example. We met a young dancer at a fiesta show and photographed her for the book. After publication we brought her a copy of the book, a gift, and some hard cash. Now, fifteen years later, we're shooting her daughter and a lot of her dancer friends. They love the novelty and the fact we gave something in return. We did all this without speaking a work of English as well (which raises another point).

The Lingo. Learn to understand and speak the language in whatever arena you are currently situated. This means un-

derstanding what your lawyer and CPA are saying. Same goes for the corporate, marketing, and sales worlds. This is especially true of the medical world, if you have any problems in that area. You need to know the proper names and manufacturing methods and idiosyncrasies of your client's business. In my case, it means learning and making the effort to speak with the local people in every foreign location I get assignments. I don't need to be fluent in these countries, and you don't need to be fluent inside the lawyer's office or court room. Also, I don't want to be an ugly American who can't be bothered to say please and thank you in the local language. Whatever the arena, you had better educate yourself on the general scope of what's being said, or something may happen to you that isn't at all what you expected.

Learning the Lingo. You can learn some of the basics of any language, no matter if it's foreign, corporate, legal, or whatever. There are several ways to do this, and you should use them all at first. The easiest is to visit amazon.com and search for an introductory book and audio program. After that, you can find someone that speaks the language for a little one-on-one tutoring. Students in the area of your interest are always looking for a little extra cash and can teach you the current basics. Call a local school and see if there are basic classes. I visit restaurants featuring foods of countries where my assignments are located. There is always someone from the old country who wants to make a few bucks teaching a gringo how to say a few pleasantries in his language. Who knows—you may end up writing an operetta in Italian, like I've done.

WHEN ALL ELSE FAILS

No matter how serious a problem, disagreement, or legal threat, even by the giants of commerce, things are never so desperate that a settlement isn't possible. Always attempt, in a calm discussion or brief letter, to settle a dispute quickly and by yourself. This should be done directly with the people involved and doesn't require a lawyer. Most likely, your lawyer will have advised you to pursue this course of action first.

I once negotiated directly with a corporate counsel for a major credit-card travel publisher. They claimed that a copyright violation occurred when I used the cover of their brochure, which featured an image of mine, in a promotion flyer. Even though the company had provided me with color separations, which contained the image and their copyrighted materials for the promotion, and had corresponded favorably regarding the matter, the lawyers didn't agree that I had permission. Fight in court or negotiate were my choices. We agreed that I would send a simple letter to my client mailing list, allowing that while the company worked with me they did not endorse my work or the promotional flyer. It was this or pay $10,000.00 for the use of their materials. This letter turned out to be one of my best promotions ever, with many positive business responses. It was better than the promotion that caused all the trouble in the first place.

When Things Heat Up. Okay, so things have heated up and a client no longer wants to negotiate. This usually means their legal shark is circling around you, with blood in his eye. Of course, this is the time to call your lawyer and give a brief outline of what's happening, followed with copies of relevant documents and your evaluation of everything. Your daily log may be of value in providing dates, calls, and appointments with the client regarding the matter.

Once your lawyer is in the picture, it's time for you to get out of the picture. Your further involvement here is typically eliminated through a letter, furnished by your attorney, that states: "I represent So and So Photographer in the matter of such and such. All future contact regarding this matter should be made with me and not my client." At this point, it's time for you to get back to the business of photography and stay out of the legal proceedings.

I can name no fewer than a dozen photographers who have become so obsessed with legal actions that they literally quit working in photography. All of their time, energy, and emotions were put into the legal actions. Very few of them knew as much about litigation as they did about photography. As a result, their businesses started to falter, and they began to live for a possible income from the legal settlement—any settlement.

No legal settlement, unless it's a multimillion-dollar deal, is going to replace your career and photography business—or your sanity, for that matter. Placing yourself in the middle of a legal action will tear your heart and soul out. Don't do it. The funny thing about these kind of actions is that lawyers thrive on them; however, they are educated in the business of fighting legal sharks. Let them do it.

If your administration, records, standard practices, professional photo organization membership, and other business standards are in place and functioning, legal actions should not overwhelm or be allowed to overwhelm your life. I know that some organizations can be very aggressive in their discovery motions, which means they can ask you to tell them everything about every image involved, and everything else in your business. Take some comfort in knowing that your lawyer will attack them in the same detailed manner. Relax and let the professionals do their job to each other and not you.

Take-It-or-Leave-It Deal. Listen closely to your lawyer's advice. He or she will suggest what your options are, what

each will cost, and will give an educated guess regarding the eventual outcomes. Weigh these carefully, make your best deal, and live with it. Then let your lawyer take care of the details and negotiate the outcome you and he think best and possible.

Know what legal costs can be to fight a major company? Over $200,000.00 was spent by a single photographer answering a thousand discovery motions, attending hearings, gathering documents, and switching attorneys—all before his case went to court. This photographer is one of those who was forced, by the legal actions, to practically give up a thriving travel photography business to stage his fight. This photographer was part of a major stock photo loss by a publisher that also involved several other photographers and stock agencies, several years ago when original images were demanded by clients. Rather than accept a settlement, or even negotiate for a settlement, which was far less than the company-signed delivery memo, he chose to fight. The case was eventually settled—and for a lot less than he could have made during the same period of time, had he stuck to the business of photography.

Frankly, in my experience with the legal system, I've found that a settlement is far less distracting and expensive than a court case. You're in business to make and sell images, not to sit around law offices and courtrooms.

Reasonable Settlements. No matter how big the company, how tough their lawyers, or how many dollars are involved, there will come a time when a "reasonable settlement" is offered. The reasonable part is their choice of words, with which you may not agree. The fact is that no one can predict what a court will decide, and even a settlement for less than face value may save face. In some cases, this will be a take-it-or-leave-it offer; in others it may be a starting point for negotiations. This is where lawyers do their best work. They want to make more money, as much as you want to make more money. Let them negotiate. It may be a lot more profitable than the cost of discovery motions—certainly a lot less than losing and paying for your legal services anyway.

Collecting Debts. Slow and nonpaying clients can lead you to a new career in the collection business. If you followed my suggestions in an earlier chapter, the estimated expenses and a portion of the photo fee were paid in advance. Collecting the balance, probably your profit, from these slow-paying organizations is a financial art. Remember, you hope to do future business with this client, so don't send Bruno the Enforcer, or your lawyer, over to their offices to make collections until all else has failed. Instead, ask your

lawyer to write a friendly pay-up-or-deal-with-me letter as your first serious attempt to make difficult collections. The cost for this letter is about $100 and may be all that's necessary. The next step, which is the point where you probably lose future business from this client, is to completely turn the matter over to your lawyer or a collection agency. This generally means either a serious letter or litigation for your former client.

Goods Are Not Services. If you are forced to take legal action to collect from a nonpaying client, call your work *goods* or *products* rather than a *service*. It is important to have the judge rule on this point if necessary. Under the commercial codes of most states, if a photographer produces a product at the direction of a buyer and delivers that product, the buyer can accept or not accept the goods. If the product is accepted, it must be accepted at the contracted price. Trying to collect for services is much easier for your client to defend against.

All of my paperwork, estimates, agreements, delivery memos, and invoices carry the phrase, "Use rights or copyrights transfer to purchaser/client upon payment of the invoice in full." This means that you have the option to take copyright infringement action against a nonpaying client. This action involves a federal court, carries per-use penalties and, interestingly, is not a difficult legal action for an experienced lawyer to take. It can also be a long shot that costs you lawyer money. Such potential action is, however, a very good threat.

COPYRIGHT INFRINGEMENT

Aside from the nonpayment invoice copyright clauses, infringement cases aren't that uncommon. The potential infringer must first get their hands on your images. This is easy with the proliferation of images today. Some sources include: copies of portfolio drop-offs, scans and discs taken from printing houses; knock-off copies made by unscrupulous lab technicians; outright theft by clients, visitors, and employees; and unintentional second uses by even the best of clients.

Lately, the most blatant copyright infringers have come from the many arms of state governments, such as universities and even some travel divisions. These people feel that the Eleventh Amendment of the U.S. Constitution grants them immunity against lawsuits for the recovery of money damages. Several courts have agreed in cases involving unauthorized use of copyrighted materials. At the same time, these courts have also allowed photographers' injunctions stopping further infringements.

When dealing with a government-related organization, cover yourself in writing before handing out images that may be copied or used widely beyond what the contract allows.

This protection may be available in your delivery memo, invoices, or an enclosed letter saying that the agency agrees not to make any unauthorized or uncompensated use of the specific images being created. The ASMP has been active in trying to correct this problem, and their legal counsel suggests the following language for your documents:

> (The Organization) hereby expressly consents to the jurisdiction of the federal courts with respect to claims under the U.S. Copyright Act by (Your Name) and his/her legal heirs, legal representatives, and assigns.

The Big Boys. If your images are used by the big boys, with names everyone in the business immediately recognizes, then you need someone who speaks their language. I'm talking about the biggest of publishers, advertising agencies with multi-billions in billings, and corporations that eat other corporations for breakfast. People in these organizations are used to getting their way, even when they're not in the right. If you get into a contract dispute or other legal hassle with these big organizations, you'll find that they have a whole floor of legal sharks just waiting to get their teeth into your south end, and you will be dead meat before the water even clears.

In such cases you need a great white shark of your own. Do not rely on your hometown attorney, good or friendly as this person may be. Get one of the big boy attorneys on your side. These type attorneys are generally in New York or Los Angeles, sitting in an office suite in one of the skyscraper penthouses. They earned this lofty resting place.

You can find such an attorney through one of the professional photo organizations, a recommendation from one of the superstar shooters of our times (many of whom are happy giving references in such cases) or using Google. Just search the *PDN* reports of major court cases being won against the big boys and see who is doing the litigation. Most of the time it's New York attorney Joel Hecker, who participated in several of the cases I've mentioned earlier. He's my choice as the best shark in these deep waters. He is a master at quickly cutting through all the emotional problems that are created when there is a major problem. The first thing he does is establish the potential liability an organization faces should the matter reach litigation. He then establishes that his client is successful, that his work has a high lifetime sales value, has impeccable paperwork and, most importantly, that he is ready to play hardball in court.

Big Boy, Big Bucks. If you have big legal problems related to big contracts or copyrights, it may require one of those big boy lawyers experienced in this area. Expect to pay a good-sized retainer fee and let them handle the problem without your participation. Expect them to give you an honest and accurate analysis of the possibilities, probabilities, and costs of any legal action or course they may take. This is for those times when you really, really, need legal help.

BUSINESS FORMATS

Setting up or changing the format of your business is the first thing you should talk about with a lawyer and a CPA. Initially, this means listening to advice and deciding to be a sole proprietor, partnership, corporation, or other type of business. In making this decision, it means taking a look at your liability in administrative paperwork, documents, assignments, and related business activities—but this is only the tip of the iceberg, so to speak, when it comes to legal advice and protection.

Anytime you are considering major moves or changes in business, be sure to include both your lawyer and CPA. There are always legal and tax liabilities involved in business changes and developments. Your lawyer can often simplify the paperwork and will always have your best interests in mind.

Real estate changes, drawing up wills, estate planning, insurance protection, sales contracts, copyright transfers, marriages and divorces, deaths and births, major new clients, audits, an accident, a fire, winning the lottery, and other major events should also be discussed with your lawyer. While many of these occurrences are of a personal nature, they will directly affect your business posture, legal liability, and tax liability. Play it safe and talk with your business advisors when such developments take place. Following their advice could ensure that the developments are of a positive nature.

BUSINESS ETHICS

Remember that the way you operate your business will affect the next photographer to come along, just as yours has benefited from the goodwill of previous photographers.

Free Pictures. Take the name, address, and brief description, perhaps on a release form, of the people to whom you promise to send pictures, and then follow up on your promise. I'll probably be the next photographer who wants to shoot the quaint little market lady in Puerto Vallarta, Mexico. If you forgot to send her photo she'll be sure to let me, and all the other photographers who happen along, know about this oversight and not let future photos be made.

The promise of a free picture, in return for modeling in your stock, assignment, or other commercial photos, especially if a release is signed, constitutes a contract. Say one of these people sees a brochure with their photo on its cover. You can bet they will want compensation. Sending the free

print helps cover your right to use the image commercially. It also makes sure you can shoot the subject again, on future visits. Also, remember these aren't free photos you are sending. They are payment for the persons kindness in letting you photograph them in the first place.

Credentials. There are a few photographers who claim to be shooting on assignment for well-known publications or corporations, who aren't shooting for these people. Many of these fake photographers take advantages, as a result, that could result in legal action.

One such photographer claimed to be shooting for *National Geographic* in the small fishing village where my parents retired. This person had talked his way into free room and board, unlimited use of local transportation and fishing boats, plus VIP treatment from the mayor and restaurants along the way. In meeting him, my father asked if he carried a letter of introduction from the magazine. He also mentioned that his son, who sold images regularly to NGS Books, would be visiting that weekend. The impostor fled town within the hour.

Few major corporations, publishers, or agencies with names everyone recognizes send any contractor into a location without proper credentials. This usually includes a letter of introduction or a press card and expense account so their photographers won't have to beg for freebies. Also, such assignments always include advance local introductions with a name and number to call if there are any questions or problems.

There can be serious legal repercussions for photographers who claim to be shooting for an organization but are not.

Dirtbag Claims. If you don't have credentials, don't make claims that could get you arrested. When someone provides a photographer with a free anything, thinking this shooter will get their town or business in *Time* magazine, it's cause for attention. Sooner or later, someone will tell the local deputy, who may call the magazine. This is especially true when a dirtbag says he's shooting for *Playboy* magazine and isn't. Not only will the editors be unhappy about someone using their name under false pretenses, but the local deputy and the pretty girl's big brother will too.

Working with the Law. Lawyers and the law can be confusing, intimidating, and infuriating to the unsuspecting, uninformed, and uninterested photographer. The legal system is there to protect and assist you in business and life. While it may be difficult to live with, the alternative is unthinkable. Pay attention, take your time to understand what's going on, and work within the system. Also, always ask for help before you need help. Most of the difficult things I've described in this chapter are rare and will never happen to you—if you follow this simple advice.

8. LIFE AND DEATH AFTER TAXES

The one thing you can always count on in life is taxes. For a variety of reasons, this has always been perplexing to photographers. If you think the tax maze is a problem, then it's going to be a problem.

TAXES

Every business day of your life is tax day. Taxes affect every monetary transaction in every business. When we meet clients to discuss a job, purchase materials, complete a shoot, invoice the client and deposit the check, the tax man plays a not-so-silent role. How and when you choose to deal with the tax-related portion of these transactions will determine whether they are a problem or not. For the most part, tax problems are the result of not paying attention to organization and record keeping and, obviously, not filing tax returns.

As a business, you are legally obligated to secure and file the proper tax forms, be they city, state, federal, or otherwise. Fail to meet any taxing body's rules and regulations and you will be spending a great deal of time and money on unprofitable activities such as audits. Of course, you are also expected to promptly pay any taxes due.

Pay your taxes on time, in full, and before any other expenses. The IRS has little patience or humor for those who ignore this basic rule of business.

The more you understand about the various tax regulations and the complexities of their accompanying forms, the fewer potential problems will develop. This knowledge doesn't require that you yourself become a CPA, but it does mean retaining a good one.

CERTIFIED PUBLIC ACCOUNTANTS

Certified public accountants (CPAs) are people whose job it is to know everything about taxes. Find a good one before starting a new business or at least before filing your next tax return. On the basis of the data received from you, CPAs provide information and advice on all financial aspects of your business. For instance, they will advise you on how and when to properly expense the purchase of photo equipment. They will help you separate business and personal expenses. CPAs can also prepare and interpret your monthly or quar-

terly profit-and-loss statement and help you plan future cash flow needs. It's important to be comprehensive, giving your CPA all the financial and operational information that is unique to photography and your business.

Is This Legal? The primary question most independent businesspeople ask a CPA is usually, "Is this a legal deduction?" Or they may want to know what to do in the event of an audit. While such questions are natural, they are not aggressive enough for a freelancer. You should be asking, "Can you get this accepted in the event of an audit? Will including this deduction, or other information, trigger an audit? Will you be there to take the heat for me in the event of an audit?" Obviously, you want to prevent audits first and survive them second.

In considering your deductions, remember that most CPAs will not prepare materials that are in direct violation of regulations or law. They face even tougher penalties than you do for breaking tax regulations. There is a fine line between being aggressive with deductions and breaking the law. If your CPA will sign the year's return, you can bet that everything has been done properly. Trust him.

I am fortunate to have an astute CPA. In addition to being very knowledgeable in accounting and tax matters, his interests, like my own, include travel, photography, and beautiful models—not necessarily in that order. He was a major partner in one of the West Coast's largest retail camera stores, sole owner of a photofinishing store, operates a charter boat company, assists a famous travel photographer on tropical swimsuit shoots, and is himself a talented and avid photographer. In other words, he has practical knowledge of the financial operations of photography-related independent businesses. I don't have to spend any time educating him on the uniqueness of a location photographer because he's been on several shoots. Try to find a CPA who is interested in you as well as your business.

CPAs Aren't Bean Counters (Bookkeepers). It's my opinion that the independent businessperson with no more than four employees is their own best bookkeeper. They should control the flow of money and keep track of basic financial operations, up to and including initial preparation of tax forms for CPA examination and approval. If you expect to provide an accurate budget or job quote to a client, you

must have a working knowledge of financial matters anyway, including how much cash you need to make a profit on each job. For me, this includes signing all but the small account checks, reviewing incoming bills, and originating client invoices. Seeing a list of accounts payable just isn't the same as reviewing the bills you must pay. You can delegate the basic gathering of invoices, collections, small check writing, and invoice writing to an office manager, but you should take an active hand in the overall financial operations.

If you're neither interested in, nor capable of, keeping basic financial books and records, a CPA's office will be able to provide someone to help with these services.

CPAs Are Not Lawyers, Either. CPAs have an extensive knowledge of the legalities related to financial, business, and tax matters. Often, they are retained by lawyers to answer complicated accounting and tax questions. Especially if there is a high profile audit or tax court trial. However, if you've done something illegal, such as defrauding the government out of taxes or writing lots of checks on someone else's business account, a CPA will most likely advise you to get a good lawyer. So would I.

CPAs are not lawyers and, unlike lawyers, have no bounds of confidentiality when it comes to information, records, or materials you've provided. That means they must and will answer questions about your financial matters if so ordered by the IRS or a court. These orders must be in writing, so you at least have a little notice to make other plans.

All of this legal business leaves you with several choices on making those plans. You can never tell or show a CPA anything that might expose you to legal action. It's best, however, not to do anything that will expose you or your business to legal action. If that happens, upon getting the bad news immediately have your lawyer retain your CPA to his firm to assist with the case. That way any information about your business that they are privy to falls under the lawyer–client confidentiality agreement.

I suggest discussing any financial legal maneuvering or any potential problems with your lawyer and CPA before they arise. Even better, don't do anything stupid enough to get yourself into such a legal predicament in the first place.

FIGURING COSTS AND TAXES

Everyone knows that personal federal taxes must be filed and paid by April 15th of following each taxable year (corporate taxes are due about a month earlier, by the way). This is only the half of it. Many independent businesses are required to figure and pay estimated taxes on a more frequent basis. Most states, counties, and cities have some type of tax that must also be figured, filed, and paid on a monthly or quarterly basis, in addition to the year's end tax. Whew. Good thing we don't get everything we pay for.

It's almost un-American not to take advantage of every possible legal deduction available to your business. In doing so, it's almost un-American not to expect an audit.

The successful photographer should always know exactly what it costs to be in business, which includes any and all tax liabilities. At the end of every month, or quarter, subtract from your gross income the fixed overhead costs, job expenses, and probable taxes, and the result is profit. Having this information on hand eliminates potential financial surprises. Figuring taxes on a regular basis is just another part of business administration.

Overhead costs generally include rent, full-time employees, utilities, debt service on business loans, and similar monthly costs. Most of these items are tax-deductible and remain the same throughout the year.

Job expenses are determined, obviously, by and on each particular job and include such things as materials, props, equipment rental, models, assistants, transportation, and a lot more. This is an area where photographers may be vulnerable to tax problems. In an audit, which generally takes place three years from the job, it might be difficult to assign a specific expense to a specific project. Eliminate this potential problem by assigning an individual job number to each project and marking it on every receipt, check, and invoice.

Job Accounting. My own job accounting method is to use a large envelope for each shooting project. As receipts come in, the amount and job number are noted on the envelope, and the receipt is placed in the envelope. They are kept there forever, which makes it really easy to find a specific charge or to apply an expense for the tax people.

Problem-area expenses include such things as entertainment, marketing materials, petty cash expenditures, non–job related auto expenses, long-distance telephone sales calls, expensive meals, and the like. These are areas where money can stray from business purposes, into your own pocket, while being deducted as business expenses. Taxing organizations such as the IRS do not like money to go astray for any reason. Your best bet here is to commit to good record keeping that shows the business use for each expense and deduction. Assign each purchase to a numbered budget account and mark receipts accordingly. Back this up, when appropriate, with notations in your daily log. This may take a little time, but the alternative will be expensive.

In determining income on a monthly or quarterly basis, a general pattern and break-even point will eventually develop,

by which you can compare similar periods' expenses and income. If there is a major discrepancy in expenses or income, you should track down the cause. Financial problems, including business failure, occur just as frequently through uncontrolled spending and growth as they do from a lack of income.

Cash May Talk. Photographers often pay cash for their services and materials, especially in distant locations, which is hard to track in an audit. Try to keep cash payments for any business expense under $25.00. When you make any cash expenditures, always attempt to get a receipt. If this isn't possible, write yourself a cash-payment receipt that describes the business expense, with job number attached, plus the name and location of the recipient.

In my own business, which often involves foreign locations and language barriers, larger cash payments are the only option that locals will accept. For instance, a driver, interpreter, or guide may require immediate payment in the local currency. I cover these situations with the best-possible written records. This includes writing a cash payment receipt, getting a signed receipt from the vendor if possible, and making a daily log entry. The IRS will judge these expenses along with other records. The better your overall organization, the less probability of a denied deduction. Of course, I always have the photos to prove the activity really took place.

Cash Accounting. Your business and tax financial system should be done on a cash basis. This term has nothing to do with accepting or spending cash. It means you count income on the date a check is received and deduct an expense when the money is spent. It's a simple and straightforward way of doing business.

On the cash basis, you may not receive a check in the same year that it was written. For example, let's say that you receive a large check on January 10th, dated December 10th of the previous year. Do you count this as income for the year in which it's received or the year the check was written? Keep in mind that your client will be sending a Form 1099 to you and the IRS, listing the amount in the year the check was written. In similar cases, I count the income in the year it is received, as it can be established that the money was not available until the date you received the check. This might cause an audit if your tax return shows an income amount substantially lower than the total of Form 1099s received. You must have a copy of the check, deposit slip, and related information to back up the transaction. It might also be a good idea to attach to these records the stamp-dated envelope it came in as proof of the date received.

Now, on the other hand, you may need a few last-minute deductions this year, so you can write checks for business expenses on December 31st for immediate deduction. Just make sure the deductions are not for things that are really next year's expenses. Pay off your assistant's invoice for the last job, models and talent, buy a few memory cards for your digital cameras and similar small items. You cannot deduct magazine subscriptions, early rent payments, or association memberships for the next year. A credit card charge made for a business expense this year, even though paid off next year, is a deduction this year. Remember that credit card interest is very high when you make minimum payments.

Take a look at your business in December to see if you have an excess of cash or profit sitting in the checking account. This is the time to consider making a few of those smaller material purchases, which may benefit your current year's deductions. Of course, you may already have plenty of deductions, which makes this exercise unnecessary.

TAX RECORDS

Good record keeping is the basis of business administration. This is especially true when it comes to taxes, and more so when it comes to the IRS and potential audits. Good records mean good organization. The place to start your complete and accurate record keeping is with the business checking account. Many smaller businesses like to utilize a one-write check system, which enters each check into those tax deduction and budget categories mentioned. This can be kept in a simple computer program with check-writing capabilities.

The toughest IRS auditor will be much easier to deal with if you present them with complete, accurate records of your business transactions.

The IRS Schedule C lists the basic items most independent businesses utilize for deductions. It follows that if the IRS has made provision for deducting certain items in their tax forms, they must be acceptable deductions. Again, let me stress that you must be able to show that expenses and deductions are normal and necessary for your business.

Checkbook Listings. The following deduction categories are similar to the budget items listed in chapter 4 and are pretty much taken from the IRS Schedule C tax-return form. Most one-write check systems and computer accounting programs can be adapted to these listings. I've included a few comments on each as it may relate to your tax deducting.

Advertising. The cost of advertising in creative books, magazines, on the Internet and through other marketing media. You can include the costs for creating and producing these materials under this category.

Bank Charges. The charges your bank imposes on business accounts. To simplify accounting, include the cost of checks provided by the bank. This is generally included with

office expenses. Remember that your credit card is a bank card, which makes charges and fees applicable for deduction in this category.

Capital Expenses and Improvements. All office equipment, furniture, photo equipment, and major improvements made to business property. Even though you must pay the full amount this year, the cost for these items will have to be depreciated over their useful life in your tax return. We'll cover that in more detail in the section on depreciation.

Car and Truck Expenses. Gas, oil, car wash, parking, and simple maintenance. Major repairs should be listed under Repairs. Lease payments for business cars should be included.

Commissions. Sales commissions you pay to agents and others. Don't include your stock agent's commission, unless you issue them a check. And don't include payments to employees, which are included in their salary checks. If they are separate payments, they do belong in commissions.

Dues and Publications. Professional associations and publications, such as yearly directories. A reference book that is used in more than a single year is not a publication, rather a business expense. This is generally included with office expenses. Smaller amounts can generally be deducted immediately, but an extensive professional library is a capital asset that may require expensing over its useful life.

Employee Benefits. Health, vacation benefits, retirement, and other non-salary/non-commission items paid to or for your employee, but not for yourself or spouse.

Entertainment. Expenses for a client, potential client, assistant, supplier, employee, and similar person, for a working business meeting over breakfast, lunch, or dinner. You will only be allowed to deduct a percentage of such items. Good records are important in this category. You should record meetings in a daily log and make pertinent notations on a credit card receipt, such as the business being conducted at the lunch. Other entertainment can include the theater, concerts, movies, and similar events that you can argue are ordinary and necessary to your present and future business. As mentioned earlier, expensive wines, lavish catering, tropical golf trips, fancy yachting events, and other similar items, even though necessary to business, may be a little more difficult to get past the tax people.

Freight. Air expressing of images to your clients and shipping of supplies to your location shoot or studio. This is generally included with Office Expenses.

Goods and Materials to Be Sold. Discs, hard drives, props, materials, and other items necessary to produce your products or services. Include any sales taxes you must pay since they are a deductible business expense.

Insurance. All insurance you need for the business, employees, contractors, and rentals, as well as auto insurance on a vehicle used for business (or a percentage of the insurance equal to the percentage of business use) is deductible. You may generally deduct employee medical, equipment, liability, and property insurance. Your own health and life insurance, although necessary for business, fall under special requirements for deductions. Check the current deductibility of any insurance with your CPA or consult a tax publication before filing a return.

Labor (Wages). This includes your employee salaries, including yourself, but does not include contracted help. Be sure to issue a year-end 1040 to yourself, and employees, for salary payments and tax withholding.

Office Expense. In addition to the other items mentioned earlier: postage, petty cash items, window washers, stationery, office supplies, sodas for visiting clients, paint for existing walls, temporary displays, small Christmas gifts (under $25.00 each), and the like. Keep accurate and complete written records and receipts for these items—especially petty cash expenditures.

Rents. Your office rent, equipment rental, studio rental, business equipment rentals, and business use car, van, and truck rentals.

Repairs. Business equipment cost that results from fixing something that is worn or broken. Do not include any equipment improvements. For example, patching a hole in your office roof is a repair. Adding a new roof is a capital expense, or improvement, and must be capitalized. Your deductions for real estate property improvements must be capitalized over the life of the property, even though your lease may be far shorter, which seems unreasonable. I suggest you try to get the landlord to make all major improvements and raise your rent to cover the costs, which is immediately deductible.

Services (Professional). This heading includes the cost of any outside contracted service such as lawyers, CPAs, bookkeepers, assistants, or models who are not from corporations. These individuals must be in business and providing similar services to others. Ask them to furnish a copy of their business license and tax registration. You don't need to worry about this paperwork for your lawyer or CPA.

Supplies. Non-office supplies. Small items, such as expendable props necessary for business in general but not for a specific project. This is a very general area when it comes to photography, since we no longer use film and processing.

Taxes. Any tax you must pay to be in business. Retail taxes paid on materials or equipment should be included with the cost of those items and not listed in this category.

Travel and Transportation. Costs of getting to and around a job (other than your business auto expense). Car rental, gas, air transportation, taxis, cars with drivers—even sailboats and helicopters, if they are a normal and necessary trans-

portation items related to the job. You cannot deduct the cost of commuting from home to your studio or office.

Tax Files. You should have an individual file folder established for each of the above expenses, along with similar files for income. When making payments, note the date and check number on vendors' invoices. Should any questions regarding a specific receipt come up, you will be able to easily locate both the receipt and canceled check. These files will also be easy to whip into shape for tax filing purposes.

Daily Log. Your daily log of appointments, meetings, calls, assignments, and other important events, such as your wife or husband's birthday, is the place to make those notes that will affect your finances and taxes. For instance, list any money used in parking lots and meters when receipts aren't available. If you keep a regular log it will be invaluable in establishing your whereabouts, marketing efforts, and entertainment for business and meetings.

POTENTIAL DEDUCTION PROBLEMS

As mentioned earlier, you must ask yourself whether each deduction stems from an ordinary and necessary expense to your business. While this is the first and best test in determining an acceptable deduction and the most important yardstick for listing one, it is unfortunately not the only one.

Keep in mind that IRS agents aren't stupid, so don't play dumb when planning or making deductions. Always follow the advice of your CPA. After all, they will be there talking to the IRS when you get an audit.

There are a few areas that photographers have found immediately trigger IRS attention. While our expenses and deductions may be completely legitimate, the way we take care of requirements may not meet IRS standards. We also are involved in an unusual business with many unusual material and location needs. While we may hire a sailboat for photos, for instance, the IRS might assume it was rented for a pleasure cruise or outright vacation.

Travel and Entertainment. These are areas in which the IRS just loves to take a very close look at your business requirements and receipts. In the case of photographers, these are two separate categories and you should keep their receipts separate as well as their deduction entries.

Don't try to write off your vacation as a business expense by saying you're a travel photographer, unless you can produce travel-related invoices and printed pieces that result from such expenses. There are photographers who shoot studio subjects most of the year, then shoot location scenics for a few weeks in Hawaii during their family vacation, sending the results to a stock agency for potential sales. If you do this, make sure to generate some serious sales or the IRS may call it what it was: a vacation. Writing off thousands of dollars in travel expenses and showing only a few hundred dollars of related income is asking for trouble.

Entertainment-wise, be very careful just what entertainment for clients you deduct. Make sure you can at least claim future business as a result of taking your client to see the Rolling Stones, on a cruise through Hawaii, or 50-yard-line tickets at the Super Bowl.

Transportation. Transportation for a specific job, be it an aerial-photo plane or location-rental Jeep is a deduction. Just be ready to prove that it was normal and necessary. First-class air travel to a location shoot may or may not be accepted. Say the trip takes fifteen air-hours from your office to the shooting location, and you're expected to immediately start working. In this case, the deduction may be okay. More than likely the client must make this decision, pay the tab, and take the heat for the deductions.

First Class. In shooting a distant location or subject, you may want to travel and stay first class. This may be okay if you can provide a reasonable explanation. For example, traveling in business and first class usually includes an unlimited amount of excess baggage (no matter what the airline's official policy). This can make up for the additional cost of the fare. First-class air travel also allows more room for in-flight work, such as correspondence, location, and subject research, equipment checkouts, and simple relaxation. You may wish to accept what the client pays for coach fare and pay the difference yourself for first class, deducting the additional cost. Another good way to travel first class, without any questions from tax people or clients, is to upgrade with frequent flyer miles. If you use an airline bank card, which gives miles for all your office expenditures, it will cost you nothing.

Auto Expenses and Depreciation. Auto expenses and vehicle depreciation are among the many things examined in an audit; it's an area that may include personal expenses. The best way to eliminate any problems is to have a company car that is used only for business. That way, all the expenses, insurance, parking, and so on are much easier to track and deduct. There are some upper-end deduction limits for the use of luxury cars.

Keep a mileage and destination log in all of your cars and make an entry for every business use. At the year's end this log can be separated into business and personal miles traveled, making your deductions and depreciations for vehicles quick and easy. Note that commuting from home to the studio is not a business expense, nor is it business use of your car. If your sole office is in the home, driving to a shooting assignment is a business use and deduction. I make specific personal and commuting mileage entries in my daily log.

An auto burglar alarm, built-in security box, and secured parking expenses are both reasonable and deductible. Major

equipment losses are also deductible if you don't want to spring for the lower cost of an alarm or insurance.

Entertainment. Entertainment is an area that makes political and IRS hay in the press and in your audit. It's okay to entertain clients, potential clients, suppliers, models, and the like, so long as it relates to business. I've found that such entertainment, if well thought out, does result in better business. For example, I try to host a nice, not lavish, lunch or dinner in an expensive restaurant with plenty of atmosphere, for a client before or after a major photo shoot. This allows me to say thank you for the job, give them an overview of how things went, and make a sales call for future work. I know the deduction will be reduced by a percentage but feel it is a normal and necessary part of my business.

Some businesspeople like to entertain clients at football games, the opera, pool halls, Las Vegas, on expensive yachts, at the movies, and similar places. The more expensive and exotic your method of client entertainment appears, the more closely it will be examined. If the auditor smiles, you can probably get it past; if there's outright laughter, try looking them in the eye and offering a reasonable explanation; if they fall on the floor in hysterics and point it out to other nearby auditors, get ready for some serious negotiation. Your best bet is to have your CPA face the music on such deductions, instead of going to the audit yourself.

Depreciation of Equipment. Depreciation of equipment is also a sensitive area in the business of taxes. Photo gear, cars, and computers are the type of equipment abused in many tax deductions. While they are perfectly acceptable as deductions in a photographer's business, an auditor may desire a closer look to see that things are being handled correctly and that the items do not include any personal use.

The IRS has an equipment table that lists general types and the number of years over which items may be depreciated. I have found that this table doesn't always relate to my specific equipment use or longevity. For instance, I replace most of my daily working cameras much faster than the table allows for depreciation. Since my replacements fall into a regular pattern, I deduct these purchases over their real life. I can easily back up this area with paperwork and receipts. The auditors have accepted this depreciation because I have kept such excellent records and established continuity. On the other hand, many photographers make out because their equipment lasts years beyond the IRS table listings.

There is a current provision for depreciating a large amount of business equipment in a single year. You might wish to hold classification of all equipment depreciation until the Schedule C form has been figured the first time. You might need to adjust the depreciation schedules, which is acceptable, to fit a tax strategy.

Employees and Independent Contractors. This issue of status is a prime area of concern to the IRS. An independent contractor has a business license, tax registration or resale permit, business stationery, and invoices. Independent contractors also accept jobs with several clients.

If you utilize the contracted services of someone on a constant basis, say two or three times a week, they may actually be considered an employee in an audit. The same is true of anyone who makes most of their income from your business, whether they are full- or part-time. You'll need to seek a few other contractors or pony up with an employment position.

This is the position most governmental bodies take, and they will levy penalties and plenty of paperwork if you don't agree—even if the person has paid their taxes on the income. The IRS has a publication (Circular E) that explains the tests that must be met for employees and contractors.

I send a version of the letter that follows to independent contractors.

Dear Freelance Contractor:

I have accepted an agreement to produce photography for XYZ Corporation. As a second photographer (or production manager, location manager, etc. [Calling them an assistant may also be calling them an employee]), you will be working with me on this project as an independent contractor. Our immediate creative direction will be from the XYZ marketing manager.

As the prime contractor, I will have the overall responsibility for photography. You will be responsible for production [or lighting, logistics, backup photography, etc.]. Each of us will be expected to provide our own ideas, direction, insurance, and equipment for several situations to be specifically listed in the job memo.

To simplify the project, I will present an overall invoice to XYZ, which will contain your invoice to me for time, equipment, and related expenses. Because you are an independent contractor, I will not withhold any taxes nor provide insurance coverage. I will issue you a Form 1099 at year's end showing all payments. To meet strict state and federal requirements, I need a copy of your business license, tax registration, social security number, and proof that you provide similar services to other clients (i.e., business card, stationery, and promotional flyers). Please sign and return the enclosed copy of this letter along with these items.

I look forward to working with you on this project.

Sincerely,
Tory Smith
Smith Photography

Most contractors should already be aware of the problems associated with independent contractor status and will cooperate with your requests. No matter how good your letter of agreement, make sure they really are independent. If one of these people makes their entire income from your business, they will no doubt be considered an employee.

Many states consider models, stylists, and the like to be employees for insurance and unemployment coverage. If this is the case in your state, try to have the client billed directly for such outside services. Most of my clients have knowledgeable accounting departments and can deal quickly with the forms and requirements.

Several states, especially California and New York, have very strict requirements as to who is and who isn't an employee or contractor. This is such a hot tax topic and audit-causer that it's best not to guess. Talk with your CPA in advance.

Speculation *vs.* Inventory. In most normal businesses that make and sell their own products, the cost of such production cannot be expensed, or deducted, until the year in which those products are sold. Their products are inventory, which opens up a different tax situation. Imagine the potential problems this would cause stock shooters, whose images might sell over several years, sell many times in a single year, or never sell at all.

Thanks to a special act of Congress, photographers can speculate on shoots and do not generally have to consider their stock images as inventory. What this means, briefly, is that you can deduct the expenses of making images for sale as long as they are incurred in the normal course of business. This prevents doctors, retired pilots and teachers, and others with established incomes from spending giant amounts of money traveling around shooting photos for possible stock sales. The IRS is likely to call this type of activity a hobby rather than a profession, unless you show a profit.

Many financial people, including CPAs, don't know about this special act of congress that affects your shooting, speculation, and noninventory keeping. You may have to educate them, if such is the case. For the record it is:

Section 6026 of the Miscellaneous Revenue Act of 1988, consensus amendment, passed by Congress and signed by President Ronald Reagan. As a self-employed photographer, through a consensus amendment, this law exempts you from the Uniform Inventory Capitalization Rules of the tax reform Act of 1986, which required a horrendous amount of paperwork and inventory accounting and didn't allow deductions for photography made through your personal efforts as a working professional.

This ability to write off photo expenses is also extended to artists, the authoring (writing) of book manuscripts, and similar activities. It does not allow production costs for motion pictures, videos, magazines, and books, all of which must be capitalized. For example, you can deduct all the writing, photography, rough drafting, and selling of a book. The printing, binding, and storage, however, must be capitalized over the life of the book. That makes the books inventory, unless you use them strictly as a sales tool.

You can thank the people at the professional photo organizations for their campaigns on behalf of commonsense photography tax legislation. Their intensive lobbying efforts were largely responsible for the Tax Correction Act just described.

Homes with Offices. This is another area that tax auditors examine closely. Their first concern is that a business is established in your home, not just a hobby activity. Making a profit is the best way to eliminate an auditor's major concerns. If a home office is the sole office of your full-time profitable business, there should be no problem.

If you have a downtown studio and an office in the home, be ready to prove that the home office is necessary. In my own case, a home office was necessary for several reasons. My downtown office and studio is very busy with the sale of stock and the administration and production of assignments. This activity makes it impossible to work on things that demand quiet concentration, such as writing correspondence, completing complicated tax forms and filings, researching trade publications, and producing very detailed job proposals and bids. It also made it impossible to meet with visiting clients to privately discuss financial portions of a job. In the home office, I maintained a separate business telephone line as well as an answering machine, fax machine, computer, calculator, business library, furniture, and a working file system. I considered this home office a small business expense and took only a few reasonable deductions as a result. These are all the considerations which you must meet, should you have a home office separate from your away main office.

Do not depreciate any part of your home as a business expense, even though this is permissible. Doing so will have expensive tax consequences when the home is sold.

In my case, as I mentioned earlier, the sluggish commuter traffic, rising lease costs, expensive municipal utilities and taxes, and the limited parking drove us away from the big city. We bought a large house to replace our large office and haven't looked back. Our entire open-light basement is an office, as is a portion of the main floor. We have clients over to enjoy our view of the forest and comfortable atmosphere. We deduct all expenses associated with the business, except mortgage payments. We keep very close records of enter-

tainment costs for such things as client dinners, parties, and meetings. Our notes, grocery receipts, and the like are very important should an auditor want to check. Of course, our CPA would meet any auditor at their office, not our home, in our stead.

PROFIT PLANNING

If you want to make money in any business, it requires profit planning. This means paying attention to the costs of being in business. That's essentially everything we've been discussing in this chapter. Mostly it's knowing exactly what you need to gross in order to cover all expenses and make that profit, for every working day on every job.

Although the day-rate method of quoting jobs seems to be dying out, it's still one of the best ways to average out your expenses and income against profit and loss. If you aspire to make $200,000 per year, for instance, that means you must be making about $2,000 per paid working day. The average photographer will have an unpaid planning day and at least one postproduction day for every paid working day. With the advent of digital imaging and Photoshop, many of us spend more time making sure images are perfect than we do shooting. In a year this means one hundred planning days, one hundred postproduction days, and one hundred paid working days. The average year is rounded out by giving yourself sixty-five days off for holidays, weekends, and vacation time.

Profit means bringing in more money than you spend as a business.

The best way to start making a profit is to reduce the possibility of a loss. This means examining and controlling every possible activity. Try to eliminate lost materials, too much overhead, wasted person-power, unnecessary credit card interest, and unproductive non-assignment time. Establish a base price for all materials and a base rate for your time or stock images. Start high in setting prices; you can always come down.

Do not, however, spend all of your financial planning on the area of eliminating losses. Don't get so caught up in the minute costs of every item, strict time scheduling, and job planning that you forget what it takes to make money in the first place: sales. If you're going to take a few chances with spending, make sure it's in the area of marketing and sales. Send out an extra flyer or postcard, make a few more long-distance telephone calls to buyers, take more art directors to lunch, and update your mailing lists. Expenditures in marketing and sales should be considered an investment, not an expense to cut and reduce when things get tough.

If you don't sell, you don't shoot, which means you don't eat.

Speaking of profit, even the IRS allows that a business is a business, rather than a hobby, when a profit is made every three or four years. New businesses should project about three years of investment before they have repaid costs and show a profit. If you expect to make Big Bucks, things had better be looking pretty good in about two years, looking great in three years, and fantastic in five years. Otherwise, you should be looking for another line of work.

FILING TAXES

File your taxes on time and in full, before doing anything else.

If you've kept track of the various business transactions outlined earlier, tax filing periods should simply be a matter of compiling various receipts and invoices, perhaps via your computer, and filling in the forms. Of course, we know it's never that simple.

Tax Forms and Planning. If you really want a scare, drop by an IRS forms office around March 1st. This is the time most businesspeople start picking up the paperwork and publications for upcoming tax filings. If the jam of gloomy people isn't enough, the overwhelming number of forms will do the job. I doubt if anyone really knows how many tax-related forms, instructions, and publications exist. That may be a result of the illogical numbering and lettering system. Of course, the IRS doesn't have to show a profit to stay in business like we do.

There are many excellent guides covering tax forms and the planning and filing process. My first choice for information is the IRS. They have a publication or instruction sheet available for every form. If you follow their instructions, and of course, your CPA's counsel, things should go smoothly. Their yearly publication Tax Guide for Small Business is one of the most complete information sources available. It's free for the asking.

Only a few of these many forms are necessary to the photo business. In addition to the year-end forms, there are three or four areas and forms that photographers need to understand in advance. Tax planning includes knowing what happens and what is required for every business activity you undertake. Reading and researching the forms will show you how to plan and what to do in every transaction. Talking with a CPA is a must in this area.

Schedule C Form. Most of my basic budgeting and tax planning is centered around the Schedule C (form 1040), which is also a simple profit-or-loss form. While this isn't re-

quired for corporations, its use as a worksheet is handy for smaller businesses. I use each year's completed Schedule C as the basis of my next year's planning and budgeting.

The IRS looks carefully at your Schedule C for any unusual and high areas of deductions. For example, my own business involves extensive air travel, which clients often require me to include on their invoices so they can pay for everything with one check. This means both my expenses and income are artificially inflated. If there is an unusual amount listed under something like travel, I attach an explanation noting they are all business related, reimbursed by clients, and backed up by receipts. Even with all of this, an auditor may want a closer look.

My CPA advised me that a loss on the gross income line, which is called adjusted gross income, will generally draw an audit. This is the figure you get when the cost of goods is subtracted from all receipts and sales. This gross income comes before any business expenses have been deducted. In other words, the basic cost of materials to produce your images, excluding expenses, should not be higher than your income. Sometimes business expenses, which come after the gross income figure, do result in a loss.

Depreciation of Equipment. All businesses depreciate any major capital expenses on Form 4562 Depreciation and Amortization. This is the form where you list such purchases as an automobile, cameras, office machines, real estate property costs, and improvements. While the form is not too complicated, the information is important for future years' tax planning and deductions. The IRS provides separate instructions for this form.

Form 4562 is also where you must justify automobile use and related expenses. An advance examination of the requirements in this form will tell you exactly what's needed throughout the year. It's very difficult to reconstruct automobile expenses that took place three years ago when it comes time for an audit. Having the exact information available will significantly reduce the length of an audit.

Once an item has been completely depreciated and used in your business, it may still have enough value to be sold or traded. The income for this transaction must be reported on Form 4797 as the sale of business property, and on your 1040. Don't include the income with your photography income; otherwise, it may mean paying unnecessary self-employment and social security taxes on the amount.

Contractor's Income. You must report payments to any person or company that is not a corporation that total more than $600 in a given year. This is done using Form 1099. Assistants, models, processing labs, rents, repairs, and any other business expenses must each be issued separate forms, with a copy sent to the contractor and the IRS. If you fail to issue the form, it can mean a $50.00 fine for each contractor over this amount that you have omitted.

As an independent unincorporated businessperson, you should receive several 1099s around mid-February each year. These will include fair market value of any trades or bartered work. Make sure the forms accurately reflect your income from the issuing party and accurately reflect your reported income to the IRS. If they are incorrect, notify the issuing company immediately for a new one.

Royalty and 1099 Income. There are several boxes on the 1099 form, which lists freelancer money paid to you by clients. If income is listed as non-employee compensation, make sure it's listed as that and included with your Schedule C Income. If it's listed as royalty income, which some stock agencies and book publishers do, make sure it's listed with royalty income. This is a sticky area, because the income may or may not be what is reported on your forms. However, the IRS will look at your incomes in these different areas and match the amounts with the 1099 reports from the organizations issuing them to you—without paying any attention if the client has put your income in the right space. Your income numbers must match and be listed in the same category as the client, or you'll get a note from the IRS wanting to know why they don't.

Estimated Taxes. The IRS requires businesses and individuals to pay estimated taxes if income is more than $500.00 in a given year. Estimated taxes must be paid on all income that is not subject to withholding by an employer. You will be assessed a penalty for underpayment and overpayment; this seems unreasonable to me, but they don't ask for my opinion.

Personally, I find preparing my taxes three or four times a year, and paying any estimated taxes, more work than it's worth. There's an easy way to eliminate these estimated tax computations, forms, and payments. When I pay taxes on the 1040 form for a given year, usually around April 1st, I immediately file an estimated tax payment for the same amount paid, plus $10.00, on the same form. In other words, I have just made a double tax payment. The IRS accepts this "safe harbor" payment and will not assess any penalty if you make more in the coming year than the previous year. On the other hand, they will fine you for filing estimated returns that are too high or too low. Of course, this additional payment with my 1040 means not having the money to work with for a few months. It also means I can pay attention to the business of making money rather than wasting valuable time on multiple tax computations.

There is another way to avoid making estimated tax payments during a year. Complete your taxes and pay whatever you may owe and send it to the IRS before December 31st.

AUDITS

The best general advice I can offer on all tax matters, forms, and filings is to be on time, accurate, and complete. Elimination of these basics will almost certainly cause one of the least productive expenditures of time and money: the tax audit. No one enjoys an audit, not even the auditor, who must put up with unhappy, nervous, and sometimes abusive taxpayers.

The chances of an independent creative business being audited are better than most professions. Today, governments need tax dollars more than ever for the projects they think we need. The auditors for these bureaucracies always seem to find more money due than we have paid in taxes. And freelance photographers are an easy target. That's probably because we're in the unusual position of selling services, stock inventory, and products, wholesale and retail. That sounds like several businesses, which offer several opportunities for mistakes. And photographers make as many mistakes in their tax computations as any other business.

The best way to avoid an audit is to make a profit and pay taxes. The IRS is more interested in people who make a profit and don't pay taxes.

Photographers often pay little attention to the details of business expenses, good records, and receipts. Making photos of exotic places and subjects, like renting classical dancers for a Bangkok location photo, will cause tax people to have a hernia of the eyeballs. Plus, photographers often think they are cool and don't really have to explain trips to Tahiti for shooting stock photos. The IRS doesn't appreciate cool.

The Chosen Ones. Every tax return and information form is examined and compared to the average return. And on the average, photographers don't fit and seem to be among those frequently selected for audits. That's because our travel expenses are high, we deal with a great number of photo buyers who often make mistakes on our invoices and forms, and some of us choose to live and work in the same space.

Of course, we can be selected for an audit on a random basis too, which means a general look at one's entire business and personal financial life. These random audits make up those averages the IRS uses.

The profile audit is something that more specialty photographers face these days. These are conducted on unusual businesses—especially those doing something exotic—to establish a complete set of tax guidelines for others in the same specialty. For example, you may be an underwater photographer, a paparazzi (celebrity ambusher), a celebrity who is a photographer, an anthropological research photographer, or

a travel photographer. Any specialized field-within-a-field may trigger these audits. They are lengthy, difficult, and expensive in both time and money. I highly suggest letting a CPA handle the entire audit should you be unfortunate enough to be selected for a profile audit.

Audits Triggered. Audits are often triggered when there are major changes in a business. Let's say you have a great year and make twice as much as the previous year, which means twice as many deductions. Say you have a poor year with twice the deductions and the same income. Odds are, such fluctuations will trigger an audit. Fall out of the normal tax return, file late, fail to pay, fail to file proper unemployment insurance, have too many independent contractors and no employees, or do anything unusual, and it may become audit time.

A final word about what causes an audit. Make sure the income you report on a tax return matches the amount of deposits you've made in checking, savings, and other financial accounts. If your deposits are much higher than the reported income, you will get an immediate audit. The IRS won't wait three years. And make sure you claim all your income, no matter what the source. Failing to report income of any kind will not make the IRS happy, nor will you be happy with their options of handling such omissions.

The Audit. What to do in the event of an audit and during an audit has been the topic of countless articles, books, guides, seminars, and late-night prayers. There's really not much to worry about if you've kept proper records, filed returns on time, and paid the amount of taxes that a CPA thinks is correct. The IRS is looking for people who abuse the system, not photographers who play by the rules.

Even if you are well-organized and work within the established tax routine, the IRS may send its letter of greetings. Don't worry, thousands of audits arc conducted every year, and most come and go very quickly. Yours should be no different—but don't hold me to this.

In the event that you receive an audit notice, make an immediate appointment with your CPA. This is the time to retain a CPA if you haven't done so in the past, and let them take care of the audit.

Giving advice on and handling audits is what CPAs get paid to do, so let them do it. Let the CPA represent you in any meeting with the IRS, while you stay in the office and earn enough money to pay his bill. This is perfectly fine with the IRS, and it will relieve you of being put on the spot, having the cold sweats, missing important work, and facing any unpleasant questioning. At the very least, take a CPA with you to the audit for on-the-spot advice on procedure and

your obligations. I say this because IRS auditors tend to ask leading, aggressive, and adversarial questions that may make you may misinterpret their intentions or intimidate you. Your CPA is experienced in these matters and can help answer questions correctly and without the least bit of intimidation.

Your notice of audit should be specific as to what information and records are required. After talking with your CPA and before setting up the audit appointment, give yourself a quick audit. Examine all of your records for the item or year in question. Make absolutely sure you can back up every expense and deduction claimed and filed on the return. If you've found any business expenses or income not included in the return, perhaps lost in a job file, include them with your materials. At this point, let your CPA take over. In fact, let him or her go to the audit alone while you're taking care of your photo business. The IRS will grant as much time as is reasonable for you to get records ready, but don't expect more than a few weeks.

Trade-Outs. All tax auditors will look for income that is not contained in your returns. This will include such things as work for barter (trade or exchange), unusual numbers and amounts of cash transactions, or lots of foreign income, which may mean foreign bank accounts and tax shelters. Keep in mind that for some successful and retired people in other professions, freelance photography is a tax shelter or hobby income for themselves or their spouse.

If you accept anything other than a client's check for photography, such as a trade, cash, or a new car, claim the fair market value as income just as if it were money. Draw up your own cash receipt, with all the details, if necessary, and put it into your income file. The IRS will estimate their own fair market value, when they discover you have done a barter or trade transaction. This is true even if you make the exchange for business-related items or purposes. In my own work, there is a tendency for resorts to offer accommodations at some time in the future in return for shooting, especially when it's beyond a basic contract. I'm not crazy about the idea of doing any barter, as it causes potential tax and record keeping problems. I like the age-old tradition of cash and carry. Make that a cashier's check and carry.

Going Solo. If you are stupid enough to take on the IRS alone in an audit, follow the written requirements to the letter. Bring no more or no less information and records than they have requested. Offer short, simple, and complete answers to their questions. If you are unsure or unable to provide the correct answer, say so or ask for a later appointment to allow time to get the information. If you have any question about what's going on, say so. Auditors, contrary to popular belief, are human beings and have a job to do, which they want to complete quickly and efficiently. If this isn't the case, ask to see the auditor's supervisor or schedule a later meeting and send your CPA.

The Extras. If you're preparing for an audit and all the records are complete, there may be a few additional things that will help. While I don't recommend providing anything the IRS doesn't request, there will come a point in the audit when the CPA can't accurately describe your business. At times like this, it might be appropriate for the CPA to have a sample of your promotional flyers, a few of your clients' printed materials (with your photos), printed proof that exotic location photos were used by a client and—here's the clincher!—a photo of your sick grandmother.

The Penalty. In the event that your return is not accepted as filed, there may be some additional taxes due, perhaps a penalty as well. If you've made an error in calculations, forgotten to include information, or have made some other minor error, expect to pay the tax and interest. If you've done something a little more aggressive, like including your family vacation as a photo shoot, expect additional taxes and a penalty. If you've done something that the auditor considers a serious violation of law, expect serious trouble. You have the option to a tax court hearing to appeal any conclusion reached by an auditor. Your CPA and lawyer should be consulted in such cases, before making any sudden decisions or threats during an audit. Leave that for your lawyer and CPA.

Be advised that all governmental organizations have computers that talk to each other. If you've done something unacceptable to the IRS it's probably unacceptable to the other taxing authorities, and they will also be sending you an audit notice.

The IRS has plenty of time and people to check out every tiny detail of your business. The better your organization, records, and preparation, the less likely they will be to take advantage of this superior position.

9. WHY PHOTOGRAPHY SELLS

CREATIVITY vs. SUCCESS

Creativity is important to the art of photography, but don't allow it to consume your business and drive you out of business. Instead, make it your business. Try to apply some creativity to business and some business to creativity. Innovative ideas about the business of photography have provided more than one success story. Consider, for example, winner's circle photography at the local racetrack. A sharp businessperson realized that every horse in the winner's circle was a money winner at that moment. This was a while ago, of course. The horses' owners and their friends could be a quick sell for photos that commemorated the win. This was one of photography's more creative business ideas and one that requires little creativity in the production.

Why Photography Sells. Photographers often equate the degree of difficulty in making a picture with its value. A shot that takes hours to set up and shoot might only draw a yawn from potential buyers, but a quick snap of your cute girlfriend playing in the backyard mini-pool could have all the art directors in an ad agency calling you a genius. As my old grandpappy would say, go figure—which is exactly what you should do. Figure it out.

The snapshot that has all the art directors excited was exactly what they were looking for at that moment. At a later time, the more difficult shot could also become their perfect shot. You see, art directors, editors, and other photo buyers have a built-in need to change their minds at least once for any given project. Would you believe twice?

Mind Readers. There are photographers who can read a photo buyer's mind, and they are the ones who make the Big Bucks. Believe it. You see their work everywhere—in both ad campaigns and in magazine features.

You can learn this little mind-reading trick. Photographic clairvoyants do it in several ways. They know exactly how to make an image with a market value and what the market will be for that image. You read what's in the mind of the average photo buyer by first reading the materials produced in their agency and client's publications. This is too easy, right? Their own materials give away the very type of materials they buy. Of course, the minute you copy a style they already have available, they will bid you farewell. Your job is to create yet another link in their artistic quest for something new, differ-

ent, and exciting. Their job is a never-ending search for a new and exciting image. Some of them are also looking for a cheap image.

Your job is easy. Just read photo buyers' minds and be at the right place with the right shot at the right time. It works every time.

The best art directors create new images for their same old market. Seek out every possible opportunity to listen to these art directors and other photo users and buyers. This may be at a portfolio review, a job proposal, a seminar, or a lunch. These people will tell you what they need, what their market trends are, and what you should be shooting and selling. The trick is to listen to their wants rather than telling them what you think they need. Photographers who are really good at making salable images on their own are sought after by many sources, especially stock agencies. Just one of these good images will have several potential markets and several potential sales. Obviously, these photographers are also good at promoting such skills.

PHOTOGRAPHY IS A PRODUCT

Most image buyers consider photography a product. They have a marketing need and we supply images to fill that need. They pay for the product and use it to fill their need. Nothing more. This means we're dealing with photography on a money basis: so much product for so much payment. The client automatically categorizes us like so many shoes in a shoe store. If there were as many shoe stores in my area as there are photographers, people would be wearing shoes on their hands, too.

Much of this treatment as product suppliers comes from the stock agencies, which are selling a fixed and known product at a fixed and often negotiable price. We show them the goods and they either buy or look for other goods.

Producing a product for sale involves one of two things: creating something that is in demand or creating a demand for something you create. Until your market and reputation are so good that there is a constant demand for work, you must create a product for an existing or known market. Think of the many ways images are being sold right now

with photography outside the agency, magazine, and client sales. This might include art litho prints hanging in galleries, postcards, posters, photo books, web sites, and photo discs. Use your imagination.

By thinking in terms of product rather than creativity or, art, you are also forced to think about the business approach. This isn't as much fun as shooting pictures all morning, but knowing about markets means learning what's in the minds of photo buyers.

I set product-producing goals. That means shooting X number of images, strictly for their commercial value, each month. The subjects of these shoots are found in my agency and publication research, through talks with art buyers, and via my own wide range of interests. I keep an active list of potential photo subjects with my daily and weekly schedules. Whenever there's a gap in assignments or other work, I plan a shoot around one of these subjects.

While most of the images end up as stock, many clients are interested in seeing them, because I've already advised potential users that a special shoot is planned. Many of these potential buyers will provide suggestions for these speculation shoots, which always means a sale. This product production keeps me sharp (which the client demands) and busy (which my psyche demands).

PHOTOGRAPHY IS A SERVICE

Why are certain airlines such as Alaska, British Airways, or Singapore, regularly chosen over other airlines that fly the same aircraft on the same routes and for the same price? Why do they always get picked the best in their category by travelers? Service. Should it be any different for your photography product?

$ *Successful businesses are the result of three things: quality product, competitive price, and superlative service.*

If you want complete success, combine a quality product with the best service possible. You'll be surprised at the effect this has on both business and income.

The Basics of Service. If you always deliver top-quality photography at a competitive price and meet each deadline, preferably with a friendly smile, there will be food on your table. It doesn't take a marketing genius to figure out this philosophy, although many businesspeople are miserable failures at meeting even the most basic level of service.

$ *Service means delivering what you promised when the client needs it, at the price quoted—and in a professional manner.*

If you're going to call yourself a professional, then provide professional services. The following is my list of ten basic rules of professionalism:

1. Be on time for all appointments and meet all deadlines.
2. Dress and act better than the client might expect.
3. Be prepared for every client meeting.
4. Know something about the client's product.
5. Know something about the client's market.
6. Know something about the client.
7. Follow up when you promise something.
8. Confirm important details with a note.
9. Come in on or under budget.
10. Remember who writes the checks.

If these rules seem like little more than common sense, that's because they are common sense.

The Client's Marketing Goals. Every client to whom you hope to sell photography has, in turn, a market in which they hope to sell a product. Your photography is *one* of the tools they hope to use in these sales efforts; it's not the only tool and may not even be the best one, but it's the tool you are providing, and it's your job to make sure the photography they utilize does what's intended. Not an easy task.

The more you know about a client's market and sales efforts, the better your expectation in meeting their goals. Read about the company's goals in their public advertising and sales literature. Call their public relations or sales office and ask for information. Start a client file. Subscribe to their magazine. Buy a few shares of stock. Use your imagination.

Businesspeople like to deal with suppliers (which is what we are) who don't require a lot of time being brought up to speed on their company. If a potential client thinks you're a little too slow on the uptake about their business, they may also think you're a little too slow for the project at hand. Listen to what they're asking and telling, and show them a little savvy at the right time.

IDEAS SELL PICTURES

National Geographic magazine has always been a magnet for talented photographers, and as a result, the people who are on staff and under contract are among the best photojournalists in the world. Ever wonder how the editors determine who to hire for an assignment when there are so many good portfolios to sift through? Bill Garrett, a former editor and an outstanding photographer himself, says the photo editors at *National Geographic* are up to their necks in talented photographers but only ankle-deep in talented ideas.

Try to present some interesting ideas to a prospective photo buyer, especially if they're with one of the leading

magazines in the world. This means an intelligent approach that includes their editorial concept, product, or markets. Do this in a portfolio meeting, via letter, e-mail, your web site, at a social lunch, a workshop, or any time the client offers to participate. The ability to develop and share ideas may mean an opportunity to strut your stuff. And, as I've said before, opportunity is all we need.

Make sure you can outline ideas quickly, or the opportunity may be lost. Always say, "I'll follow up with a note on this project." This note will give you a chance to explain the idea in detail and retain its authorship. The latter usually means getting the shooting nod, if it's a great idea.

Coming up with ideas to sell a client's services and products is a basic part of selling to any client. Help a client sell their product and services using your photos, naturally. With an advertising agency, this may include speculating with the agency to gain them a client. With a magazine, it may include shooting a speculation idea to get their editor's attention. This goes right back to the concept of creating a demand or market for your work.

A recreational park once hired me to shoot a one-time consumer sales brochure. In the process of researching the client and making the images around the park, I found they played lots of rock-and-roll music because their customers were mostly teens. I suggested that a multi-image television spot, using lots of wild stills from the park, be produced with a hot rock song backup and advertised on MTV. While this was a new media and medium for the park, they loved the idea. It worked, too, and I got to direct the commercial and do a lot of additional work for them.

I know photographers who carry a portfolio of sample brochures, postcards, calendars, and similar printed materials around to small hotels, motels, restaurants, and tourist attractions. Their sales pitch is to collaborate with the client in shooting a special photo for something like a postcard. The card can be used for promotion, or for sale at the front counter, or can be sent out to commercial mailing lists. First, the photographer offers to share the profits from postcard or poster sales, but the idea is to sell the cost of the photo shoot. Sounds pretty small-time, right? How does making a profit of $150,000.00 sound for an average year of selling postcards?

Sooner or later, there will be an opportunity to discuss a client's marketing and sales goals. Usually, you will be given an outline while examining a proposal or portfolio. This is the time to offer ideas to help meet the client's marketing and sales goals with your photos. Even if the client has already tried everything you suggest, they will appreciate the educated interest in helping. Just make sure that it is interesting and educated.

BEST-SELLERS

The users of photography determine the best-selling images. You only have to look through one of the more popular magazines of our times to see what and where the best-selling photography is today. This type of research is the first step in producing your own best-sellers.

Best-selling images are created by the marketplace, not the photographer.

In reviewing top-selling images over the years, it's been my experience that the best images aren't always the best-sellers. These are images that sell over and over again, the ones with a continued commercial value, but generally not Pulitzer Prize winners, or any other prize winners for that matter. Often, they aren't even flashy images. Mostly, the best-sellers convey a feeling of warmth, welcome, contentment, and satisfaction, which is always successful in selling a product.

Your Photo Interests. My business of selling images related to travel isn't an accident. It was planned because I like to travel, explore cultures, meet people, and make photographs. The adventure of travel enhanced my love of photography.

There are a number of successful photographers who are not primarily in the business of photography. For example, Kenny Rogers, the singer and actor, is an excellent people photographer. Images of his friends are in several self-authored books and have become a successful business in themselves. This is a common practice for other not-so-famous professionals, including doctors, dentists, police officers, pilots, salespeople, and anyone else who has both the desire and access to interesting photo subjects. They have the shooting ability as well.

My point is that you should be making and selling photos of subjects in which you have an interest. There is no need to search the world for something exciting or exotic to photograph in order to earn a living in photography. The subjects are literally in your backyard.

If your images make people want to buy a product, the client will buy your images. It's just that simple and just that easy.

Your Personal Photography. Your personal photography, the making of family photos, the general recording of things that are important to you, and artistic experimentation and testing should always be part of your career.

Try to schedule a little time every so often to make personal images. Evaluate and compare these images with your

business of commercial shooting. Are you applying the same creative eye to your commercial work? Are you growing as an image maker? Are you still thinking and seeing images? Are you applying personal interests to the making of commercial images? Are you happy with your commercial work? Are you happy with photography as a business?

Your Best-Sellers. Every successful photographer has a number of images that seem to sell over and over again. The more you know about these best-sellers, the more of them you can produce.

Best-sellers beget more best-sellers. If you have ten images of different subjects or situations that seem to be continual sellers, they should be the basis of at least one portfolio.

At the end of each year I review the total number of images sold, the total number of clients sold to, and the number of times each top-selling image has sold. I separate stock from assignment, although both contribute to best-selling images. Overall, this research gives me an idea of what sells well and in what markets they sell the best. The number-one question is, of course, how much money does a best-selling image make? The second question is, how many times and places does it need to sell to become a best-seller? An even more important question is, can I plan and count on shooting more of these best-sellers?

Remember that an image sells for reasons that go far beyond quality and impact. It must be the right image, in front of the right photo buyer, at the right time. Repeat this process enough times and you can earn a great deal more income than is needed just to put food on the table.

10. SELLING IS THE MOST IMPORTANT ART

The art of a salesperson feeds the art of the photographer, rarely the opposite. You're not in business to make photography. You are in business to sell photography.

There are literally thousands upon thousands of markets available for good photography and good photographers. There are also thousands of photo buyers within those markets. In order to succeed in finding and reaching these markets, you must be as creative at selling images as you are in making them.

Nothing is more important to your success than persistent selling.

You must sell in order to get the assignments, which allows you to shoot great pictures, which allows you to eat regularly. Young photo businesses can expect to spend about 75 percent of their time selling and administrating in order to shoot 25 percent of the time. Eventually, sales efforts and images will build up your reputation. At this point, the time spent making images may become equal to the selling.

No matter what they may say now, the world's leading commercial photographers established their reputations by selling themselves and their images. Open any major magazine on the rack and examine the photography in its advertising and editorial pages. There will always be a few outstanding shots and a few that belong in the round file. How do those below-average pictures make it into print? Simple. Because the photographer was better at selling than at shooting *and* it filled the immediate need for an image. Some businesses, including a few photographers, have achieved huge successes by the skillful selling of average products.

The ability to make great, marketable images shows good sense in creativity and business.

Once again, don't get me wrong. I think quality images should be the basis of why you enter business in the first place. However, the ability to sell these quality images will ultimately determine your degree of financial success.

MARKETING IS NOT SELLING
Marketing is planning on which doors you should knock. Selling is knocking on those doors and asking for their business.

If your business is going to succeed, you must know and understand clients' markets, marketing goals, and priorities. In order to succeed in sales efforts, you must not only meet the client's needs but should also understand that their needs must come first.

Selling successfully means knowing where the most receptive markets for your work and style are located. Within those markets, you must be persistent in sales and offer the products and services they need. In other words, you must plan to be in the right place at the right time with the right photography and ideas. That planning is called market planning. Convincing those clients to buy is just plain old-fashioned selling.

PLAN FOR SUCCESS
I can't say it often enough: never call, e-mail, visit, or make a proposal to a client without knowing something about their products and their self-image. Research their business plans, financial growth, future markets, and product development. The informed photographer will be able to discuss relevant ideas during a portfolio or sales meeting with a prospective client.

You can easily find out about your client's business goals, products, and publications. Just ask them. That's right: call, e-mail, or write their offices and ask for copies of their most recent corporate annual report and company magazine. While you're at it, ask for copies of recent product sales brochures and special offer flyers. A lot of these materials will also be available on the web sites of better organizations.

In marketing, the better you plan before getting started, the greater your chance of making a sale.

With a few exceptions, most companies want to sell themselves to their stockholders. Their annual reports generally show photos of products, properties, and company leaders. The financial information will tell you where they spend their

marketing dollars. Read a little further and you'll see which products may require some new ideas and photography. Sales materials show the type of photography they use to promote their products.

If you're interested in selling editorial images to a certain magazine, read the last dozen issues. Most will have an established editorial format, style, and content. In order to sell to these magazines, you must understand their format and editorial goals. Of course, they will be looking for new ideas and ways to support their established policies while improving the overall look. Knock these editors out with exciting new images of the same old subjects they have been covering.

Marketing Strategy. Client research is as much common sense as it is planning. The real art of marketing comes in forming a strategy to determine what you hope to accomplish and how it will be done when the opportunity arises. This is a basic part of your business plan. Start thinking about your own strategy by writing down and answering the following questions. You may have done some of this in forming your business plan; if so, consider the questions a review.

- What am I selling?
- Where will I sell it?
- How will I sell it?
- What tools will I use to sell it?

The answers to these questions are both easy and complex, as is the making of great photography. Try to answer them as you read the remainder of this chapter.

MARKET SCOPE

Sooner or later, your style of photography will lead you toward certain markets. These might be in the areas of fashion, photojournalism, product still life, travel, corporate business, location portraiture, or one of several other areas of consumer interest. Your shooting and sales efforts will never be all things to all markets. In developing a market scope, concentrate on the organizations that use the type of work you produce.

The Markets. Where do you want to sell photography: locally, regionally, nationally, or internationally? Maybe you are interested in selling and shooting for markets in all of these areas. Stock agencies have found that a good image can be sold over and over again, throughout the world, for Big Bucks. Keep an open mind about the scope of your markets. The Internet has just about eliminated state, country, and language barriers.

Usually the city in which you choose to live and work determines the scope of your market. If you live in a smaller metropolitan area, your immediate market is mostly local, maybe regional, and smaller as a result. Of course, there are many hotshot photographers living away from the big city, but most came from the big city. That's where the action is.

New York City and Los Angeles aren't local or regional markets; these cities are the national market. Deciding to work in one of these cities means being in the national market, which includes competing with the best of the best in the local market as well. The cost of locating in these cities is high, for client and photographer alike, and generally prevents the smaller business from starting up and succeeding.

Of course, you don't have to live in a given market in order to sell in that market. Modern communications, agents, reps, direct mail, the Internet, and other factors make selling in national markets much easier today. In recent years, San Francisco, Miami, Seattle, Honolulu, Dallas, San Diego, and Chicago have drawn top businesses and photographers away from New York and Los Angeles, thus creating new major marketing areas.

Some travel photographers now live in the very areas they used to spend hours traveling to by air to photograph. Imagine stepping outside your villa in Tuscany to photograph the grape picking and crush. You can do this as well, living right next to your subjects and/or markets.

The question is, where do you want to sell your photography? The best approach may be to think regionally and to make a few moves toward national markets. This makes the overall planning easier, and the selling less expensive than in attempting to be all things to all locations. It also keeps your options open.

Who Buys in Your Markets? The first step in market planning is to find out who buys the images. When entering a new market, I establish a set of potential clients using following known photo-buying categories to compile work lists:

- Advertising agencies
- Design agencies
- General business corporations
- Marketing agencies
- Multimedia producers
- Public relations agencies
- Publishers
- Trade media
- Magazines

I use the following resources to develop initial listings for these categories:

- Internet search engines
- *Standard Directory of Advertisers*
- *Standard Directory of Advertising Agencies*
- *Photographer's Market*
- *Literary Market Place*
- City telephone books

These resources will help you find the major organizations that do business within most market areas. They also provide information on company size, financial strength, advertising budget, media direction, personnel, phone numbers, e-mails, addresses, and other related information.

The Internet. My first stop is always the Internet. Most of the better clients have their own web sites, which will provide all the information I've mentioned earlier. Just Google their corporate name and surf around their site.

Standard Directories. The *Standard Directory of Advertisers* is also a great place to learn about the main players and advertised products in corporations. The directory listings include the advertising and public relations agencies and their account representatives. Cross-reference these listings with the *Standard Directory of Advertising Agencies* (which includes public relations agencies). This should also provide the names of art and graphics department contacts. A polite call or e-mail to these people will often result in the names of specific designers, art directors, and other photo buyers who deal with the products you hope to shoot. Some major advertising and design agencies provide professional photographers with listings of the people in their creative departments for the asking. Bingo, your list is already starting to take shape for sales efforts.

In every region there should be several trade publications catering to the marketing and advertising fields. The local design associations, ASMP, and many commercial organizations within the business community usually have informative newsletters. A stop at the local library, Chamber of Commerce, or Better Business Bureau should produce sample copies. Subscribe to and read the most promising of these source materials for current information. Most publications make their mailing lists available, at a price.

Your sales and mailing lists are the basic tools to find and track clients. Keep them up to date and well organized. I recommend using a basic word processing program with mailing list capabilities to compile sales lists. This makes quick entry, maintenance, and printouts a snap. Just don't waste valuable time and list space on industries and organizations that simply aren't interested in the kind of photography you produce. Be generous in the number of listings you make at first. You can make eliminations as your shooting, marketing, and sales efforts take shape.

HOW TO SELL YOUR PHOTOS
Selling requires getting your work in front of the people who buy photography.

Many businesses feel it's enough to offer quality products, professional service, and competitive prices, but these are only the minimum expected from a creative business like photography. You're also in the business of selling ideas, through the use of photography, that will meet a client's marketing and sales goals. You must get these creative products in front of the people who buy creative products.

Sales Efforts. The best way to pitch sales is through direct personal contact with potential clients as a means to present your work and ideas. The opportunity for close contact requires informing potential clients about who you are in the hope of getting a portfolio interview. This can be done by sending out direct mail flyers that show off your work, via a web site, e-mailed samples, and advertising and promoting in the local trade publications and directories. Getting these photo buyers to your web site is often just as good as a personal portfolio review. If you've put together a dynamite web site, you'll get requests for proposals.

If you sit around waiting for the telephone to ring, it won't. The more calls you make, the more calls you will receive. The same goes for e-mails.

No single sales effort or method is enough to guarantee success. You must be persistent in all sales efforts. In the end, the persistent salesperson often lands the job as quickly as a less persistent but more qualified person.

Interviews. A portfolio presentation is a photographer's employment interview. Portfolio presentations are covered extensively in the next chapter. In any meeting, an experienced art director will be looking at you just as closely as he or she examines your work. Are you the kind of professional with whom their organization wishes to associate? Are the images presented a true representation of you and your current work?

Be positive about your work and be ready to suggest a few shooting and market-related ideas to the client. However, for the most part, let your images do the talking.

Proposals and Bids. If an art director or editor starts talking about shooting concepts and compares your work to their clients or publication, chances are an assignment is on the horizon. This is the best time to ask for the assignment. Always make at least one attempt to snare a job out of an interview, even if the client doesn't bring up the prospect. They can only say no, maybe, yes, or we'll call if something comes up.

In today's competitive world, a job discussion may mean making a bid or written proposal. In any event, always be ready to talk rates, because most photo buyers will want to know how much you charge to shoot. Relax. It's a natural question and you can provide a generic answer. By now, both you and the client should know what a photo assignment is

worth, so ask if they have a standard rate or budget in mind. Most established photo buyers will tell you their budget early in the meeting. Always make sure you understand exactly what they are buying and what you are selling.

Follow Up. Always send a thank-you note following every sales conversation, meeting, or portfolio review. Keep it brief and businesslike. Let clients know that you're interested in talking about new ideas and markets. This, too, is another reminder that lets potential clients know you want their business.

SALES TOOLS
Over the years I've relied on several basic sales tools to promote my work. Descriptions of each follow.

Your Image. Of all the sales tools available, your professional image is the best. The image and reputation you develop and earn through advertising, promotion, portfolio presentations, previous work, and awards is the ultimate sales tool. In fact, you'll find that nothing will sell like a reputation for high-quality photography and service. Do everything you can to earn and promote your own.

Advertising. Advertising allows you to create the image photo buyers see. There are a number of prime places for advertisements that will help sell your work. These include local trade publications, graphic art directories, national source books, the Internet, and art magazines. Follow these publications, even though you are not advertising at the moment, to keep yourself informed about developments within the market.

Photographers who can afford to produce and place quality advertisements should begin by looking at the professional photography sales publications and stock catalogs. Most of these are available in print and web site forms. If I were starting a new photo business today, these would be my first choices, along with my own web site. There are also some interesting specialty photo sales sites on the Internet, which are aimed at starting photographers. In the long run, this is the quickest and least expensive method of reaching the largest number of potential clients.

Advertisements should not only feature your images but should also allude to who you are. In other words, they should contain some of the personality and style that is found in your photography. Advertising may be the only opportunity you have to reach many potential clients. Make sure that your message and image come across loud and clear.

As with all forms of sales and promotion, the audience will be looking at the production just as much as they will your images. Hire the services of a good designer, perhaps someone you respect and hope to work for in the future. Make sure your ad is the best-possible representation of what you stand for and shoot.

I try to generate an immediate response from art buyers reading one of my advertisements by displaying a variety of images, relative to the market covered by the publication, that are available as stock. It's much easier for an art director to request and examine a selection of stock images than it is to set up a portfolio review and sales call. If they like your stock images, the next call will be for more shots or an assignment.

Web Advertising. There are a lot of sites that offer advertising links to your web site. There are also web services that will make your web site pop up first when searches are made for key words you provide. You can also pay sites like Google to pop a link to your site next to random searches for your kind of photography. In some cases you pay for every visit to your web site that is generated. In others you pay a monthly fee. If you have a great web site, some of these links can generate a lot of interest in your work.

Pictorial Books. Producing your own pictorial books is an excellent promotion that can also turn a profit. One noted Western-style photographer uses his latest coffee-table book as his portfolio, sending it to a few choice clients. I do this with potential major new clients as well. In reality, these coffee-table photo books have become an impressive portfolio that can generate high-end sales.

The best way to get a pictorial book of your work is to have a publisher create one for you. This means marketing publishers with ideas that are often ready to go, or very good. If you love classic cars, start working on a book today. Go to the car shows and see if you can make a deal to shoot the best cars . . . maybe giving some prints to the owner. Along the way you may meet a potential writer to help with the text, in the event you aren't able to write. Pitch the results to publishers until you get a hit.

An even better idea to pitch a publisher is a corporate profile book. This is where your client wants 10,000 copies of a promotional or historic book on their company. Your publisher does all the production work and you supply the images. Your name is on the cover.

Let's say you have a good idea, but no one wants to publish the book. You can do it yourself with today's creative software. There are several print-by-the-book sites available on the Internet. The folks who run them will be happy to give you information about self-publishing.

If your work is used to illustrate a book, get as many low-cost copies as possible and use them for promotions. See if you can get a clause in the book contract that allows you to get the first option to buy any publisher's overruns or fire-sale copies.

Follow-up Prints. Be sure to get a lot of reprints of your advertising page, magazine cover or other printed materials. Some printers and publishers offer these for a small fee. Alternatively, you can make your own copies. Send them to your new mailing list members along with a short letter offering an idea or two. Ask for a meeting to show more of your exciting images.

This is the very quickest and easiest follow-up for your advertisement. Make your lead item the letter introducing your services or a new flyer that is backed up by your reprints. A less expensive way of circulating your advertisements is having them reduced to a postcard size for mailing. These cards are also good for personal notes following sales calls and related meetings.

Web Site Disc. You can also put a web site or complete portfolio on a CD or DVD. Art directors like this system because it's something they understand and it's easy to view. Just make sure your site and the disc work easily and with every computer system they might encounter.

Art. If you've got the wall space, have your ad, magazine cover, or other great printed piece made into a large mounted photo print and use it as an office display. Don't bother having large posters made for client mailers. They're expensive to produce and ship, and very few art directors have the display space to spare in their offices. They might put up a very nice deluxe-size postcard. However, the poster wall space is reserved for their own work.

Public Relations and Promotion. Public relations and promotion are the companions of a good advertising campaign. Promoting yourself is more than just using some gimmick to get attention. It means getting information out about you and your work, just as in advertising, direct mail, and a web site.

Your Public Relations. Write a press release about any newsworthy item or event in which you have recently participated. Send it, along with a disc of photos of you and the event, to the trade and local news media. If the event and release are worthy, this can result in substantial media coverage. Get copies and send them to everyone on your mailing list.

Professional photography associations, through their local and national newsletters, often run items on the activities and writings of photographers. They aren't so fussy about the news value and will run articles about your latest client session. *PDN* runs very good feature and news articles on noteworthy photographers. However, they are strict about the news value and quality of materials accepted for publication, which are also posted on their web site.

The key to getting good media coverage revolves around the right timing, good journalistic writing, and the event's news value. Writing a release is easy for someone with even a basic knowledge of journalism. Editors just want the facts of who, what, when, where, how, and how much money is involved. If you can't produce an acceptable release, get acquainted with a writer at a local weekly newspaper or a freelance writer and strike a deal. Better yet, take a basic news writing class at your local community college. Learning to write a simple news release or news story will be one of the most valuable lessons you will ever learn.

Don't expect major publications to run every release and photo you send on their front page. This won't happen unless the event is of national importance, in which case, you don't have to call them, they'll call you.

Don't limit your news releases and ideas to the print media. Local television stations often run features about interesting photographers and their even more interesting subjects. Mail your release and proposed feature ideas to the station's assignment editor, call if it's a really hot idea or you know the editor personally. Some photographers, including myself, have hired television freelancers to shoot and produce short features on their work. This can revolve around an interesting assignment or location. Warning: it's expensive and difficult to get on the air, but well worth the effort when you do.

Promotion Subjects. The subjects and events about which you can produce interesting news releases are many. Listed below are a few potential news release topics:

- A new studio
- A major new client
- An unusual or exotic photo shoot
- A good cause
- A real news event
- A photo made with a one-hundred-year-old camera
- An award of any kind
- A special celebrity photo
- An exciting new product photo
- You in an unusual photo or situation
- You with a celebrity (model, actor, author)
- Your exposition or show
- Your new book
- Your new agent

Good Causes. One of the best promotions is to donate your images for a good cause. There are hundreds of nonprofit associations and causes that are desperate for quality photography. This might include shooting a poster for MADD (Mothers Against Drunk Driving), Greenpeace, or similar organizations. Get started with these causes by shooting a news or magazine feature story, a press release illustration, or

other project. Make sure you fully understand the goals and ideals of any organization before supporting it, because the marketing people who see your work will be associating you with these same ideals.

Politicians are always on the lookout for flattering photography of themselves. As with nonprofit organizations, they're always interested in having a good photographer photograph them in action for free. Remember, supporting any political cause, or person, will definitely label you as a supporter of that cause or party and their public positions.

Most advertising agencies donate their creative services to special causes and are on the lookout for photographers of a like mind. Ask around at the nonprofit organizations to learn who's helping whom. Drop a note to the person in charge and volunteer your time and services. Be ready to come through on a regular basis. While volunteering with a worthy cause should come from the heart, there is nothing wrong with letting your clients know, too.

Follow up all of these promotions with your own promotion. Have a photo of you, the event, and the principal players made for a news release. The organization's media people will probably help with mailing lists and production. Make copies of the best media use of such releases and send them to your potential clients. This type of promotion will let other companies know what kind of events and organizations you wish to be associated with.

Word of Mouth. When a happy client tells an associate how good your work is, that's the best form of advertising. You can only create this situation by performing well. Happy clients will also suggest places where you might want to make sales calls. When you call for an appointment, say that so-and-so suggested that you call. This simple action may just open a window of opportunity.

Some photographers run advertisements and send flyers based on the endorsements of clients. These promotions are good if you have the written approval of the client. This goes for reproducing magazine covers, client advertisements, and brochure covers that involve copyrighted materials and trademarks. Having your images used in one of these pieces does not mean it can be used in your promotion or portfolio without express written permission. I suggest having a line in your delivery memo, invoice, proposal, bid, and confirmation saying that the images and client-produced materials may be used in the photographer's own promotion. Don't just say portfolio, as this terminology is becoming dated and eliminates promotional advertising, direct-mail flyers, and web sites. Add these other uses to your terminology. Always discuss proposed promotional efforts that display client work with that client in advance. It might turn out to be a good sales call.

Sales Forces. These are the people and organizations that specialize in selling the services of creative people. They are your agents who are professionals at selling, just as you are at image making. In theory, these agents sell you and your work to their established contacts. The best of these people can make a significant difference in your gross income. Their commission can be as little as 10 percent for recommending a client who hires you or purchases a stock shot. The rates for full-time representation are generally 25 percent of the photography fee for negotiated assignments. Stock agents generally never get less than 50 percent of the image purchase price, often a lot more with some of the new royalty-free contracts. This percentage may be dropping even more, as the new mega agencies produce their own work-for-hire images, or as they retain so many photographers they can dictate a higher amount for themselves.

If you already have several major clients, there may be a reluctance to part with future photo fees from these sources. There is also the temptation, by some photographers and clients, to make sales directly and eliminate sales commissions. If you're going to have an agent as a business partner, then strike an equitable deal and live up to your end. These agreements may include sharing some of the income from established (house) accounts and possibly the right to sell stock to previously established clients. Above all, give your agents and representatives a chance to do their job without any interference.

Internal Sales Help. You may not be your own best salesperson. At the same time, you may not wish to share commissions with an outside agent. In this case, hire someone to do in-house sales tasks, especially concentrating sales time on client contacts. Employees can research mailing lists, deliver portfolios and stock, and often sell you better than you can sell yourself. Such people often become very knowledgeable about your work and valuable in their sales efforts. Sometimes a spouse is your best source of an internal salesperson . . . and you get to share the commissions.

The Internet. Next to the modern computer, and because of that remarkable invention, the Internet has become one of the most valuable sales tools ever conceived.

Portfolio Site. Most successful photographers have web sites that display their best work. While the initial cost can easily be as much as several hard-copy print portfolios, you only need one site to reach thousands of potential clients. Your site can also have several different shooting style sections available. For example, you could conceivably have fashion, travel, lifestyle, still life, aerial, underwater, and industrial image galleries. Obviously you don't want so many different topics available that it scares a client who may be searching for a specialist. But you get the idea.

Portfolio sites also allow you to present examples of your published work, personal work, stock library topics, biographical and historical information about you and your business, awards, references, and a host of similar topics that are valuable to potential clients. It's always easier to write this information in a web site than it is to tell a potential customer face to face. Most art directors like to surf around creative web sites. They may find something in one of your pages that will help you get new business.

Do not scrimp on the creation of a web site. Hire a good designer and give them an example of what you need—and some latitude. Like a hard copy of your portfolio, art directors will look just as closely at your presentation as they will your images.

Review the Competition. The first sentence of the above section says: Most successful photographers have web sites that display their best work. That means you can review portfolios of the best photographers in the business and within your specialty. This can be a good learning tool and will help you work toward improving your own shooting and web site.

Keep in mind that while imitation may be the most sincere form of flattery, it's not a good idea to copy the photography and web site designs of other photographers. Use your examination of their work as an inspiration to create something new within the parameters of your own style.

Research. The more you know about a prospective client, the better you can prepare a sales call or shooting proposal. Like successful photographers, successful business organizations, advertising agencies, and design and art directors have web sites. In addition to names, street and e-mail addresses, and the like, you can learn a great deal about a potential client's products, style of business, and previous image uses in marketing materials. You can also learn, from their financial reports, how much money they spend on various marketing programs and if they are solvent enough to pay for your work. Quite often an e-mail contact will be available for consumer requests, which should be used to request a copy of their current annual report and press kit. Use it to get ideas for your own materials, as well as researching the clients.

There are dozens of excellent search engines available on the Internet. If you have any experience on the Net, most of them have already sent you some sort of promotion. I like to search at www.google.com. Simply go to a search site, enter a company or person's name or another topic in their search box, and the site will do the basic research and present you with a host of options to consider. I print out the primary information on potential clients or post it to a file within my computer system for future reference.

You can also research equipment, materials, shoot locations, transportation, accommodations, assistants, talent, and just about anything else needed in a photography business. With today's secure online ordering and payment systems, you can also purchase many of these things on line. This little research tool gives you an easy and anonymous way to research prices and availability, as well.

Shoot Proofs. Wedding, portrait, and other photographers often post proofs from their shoots on sales web sites. This allows people with access to the site's address, and possibly a special password, to examine and order their own prints. Photographers simply hand out a business card with the event's special site address and password, which allows dozens of people to become compulsive shoppers. Remember to keep the images copy-blocked, or at low enough resolution to render them unusable if downloaded by shoppers.

Retail Sites. More than a few successful photographers have retail sales web sites. These sites sell such things as limited-edition signed prints, posters, professional workshops, books, library discs, and even used cameras and office equipment. While the sites can be very profitable to the general public, it's not a good idea to promote these sites with your normal assignment or stock image clients. Send clients to your portfolio and stock gallery web sites instead.

E-mail Tools. Undoubtedly the most valuable use of the Internet is for communication. Today's e-mail is easier, faster, smarter, and cheaper than all other forms of communication. With it you talk back and forth in real time with clients about proposals, bids, and jobs. Good quality layouts and photos can be sent each way during such conversations, no matter where in the world either party is located. Also, unlike a telephone call, an e-mail can be sent and received without going through operators, secretaries and assistants, or interrupting a client's busy day. They are also a lot cheaper than the a fax, telephone, air express, postal, and other more dated methods of communication.

With e-mail you can make electronic sales calls to current and prospective clients that have a good possibility of being seen. The cost to buy or create a good e-mail client list is low, as is the cost to scan and send a few choice images with a sales pitch. A word of warning, though: do not send long e-mails with huge attachments. Keep your note short and to the point. Enclose only one or two small images that will sell your capabilities. Tell the potential viewer what's inside the e-mail, so they don't suspect it's from a mortgage company, porno site, or other unwanted junk communications. If your prospective clients like what they see, they will ask for more images or a full copy of your portfolio.

There are also hundreds of sites that offer photography information and news, as well as various industry associa-

tions, information on legal decisions, new markets, talent agencies, and the like. Many of these web sites have chat rooms where you can talk with others who share your interests or who may answer questions.

PRICING YOUR PHOTOGRAPHY

Most photo buyers already know their budgets and the history of their companies' payments for photography used in various projects. Nevertheless, they will often ask you for a price to shoot a job or sell an existing image, largely because most photographers fear talking about money and will waffle down in price. Don't be a weenie. Ask what the budget is, and let the buyer know if you can work within their range.

Rates for photography are set by the market, your experience, reputation, and the client's budget.

You can't do every job for every client and fit into every budget. Be honest with your client and be honest with yourself. If the project isn't right for you, no matter what the reason, drop out gracefully. If the only difference is a small one, perhaps money, make an offer. Sometimes your ability to say no and to look for a project elsewhere is enough to sway the client in your direction.

One of the best sales tools is being open to negotiation. If you're asked for a day rate, offer to present a written proposal and quote for an assignment outline. Most working professionals want to see a layout or shooting outline in order to provide an accurate estimate or quote. The era of the day rate has just about passed, except for editorial and top commercial photographers.

One of the best ways to give a price quote is to base it on the client's use value. For example, imagine a major company wants to run your image in a full-page advertisement in a national publication. How much? If you've done your homework, the answer is easy. The average one-time, full-page color rate lets you know what the client will be investing to use your photo. The image you provide should be worth a percentage of the page rate.

Trades, Barter, and Trouble. Some clients have very attractive products, which they may offer in exchange for photography services. If your business is well established and putting plenty of food on the table, an occasional exchange or barter might be okay. Remember that barters must be treated as cash income for the full value in your income taxes.

SECRETS OF BIG BUCKS SALES
Everyone seems to think there are secrets to making big sales. They're right.

Yes, there are a few really well-kept secrets to making sales. I say well-kept because most photographers don't bother finding out what sales are all about. If you want to make Big Bucks selling, try remembering and following these secrets:

- Everything is negotiable.
- Pay attention to details.
- Listen to the client's needs.
- Study the client's market.
- Study your competition.
- Never quit trying.
- Take care of your client's needs first.
- Ask for referrals and introductions.
- Make a set number of new sales calls each week.
- Be patient.
- Follow up.
- Be persistent. Be persistent. Be persistent.
- Get started right now.

11. SUCCESSFUL PORTFOLIOS

You are known for the photography you show, not the photography you shoot. Show your best photography as often as possible.

THE PORTFOLIO

In the olden days of photography, before the digital age, portfolios were books or boxes of prints, transparencies and published tear sheets. Today those portfolio formats are still widely used but have been augmented by web sites, discs, pictorial books, public showings, and a few other innovative methods of presenting a photographer's best work to potential clients.

When I say *portfolio* in this chapter and throughout this book, I am including all of these methods of presenting your images. Everything that was important to the development of the original portfolio book is still important to any method you choose to show images.

WHAT A PORTFOLIO SHOULD SHOWCASE

Above all else, your portfolio should be filled with images that have impact and create excitement. Chances are the art directors and other photo buyers who examine your portfolio see dozens of portfolios every week. In order to be remembered, yours must be truly memorable.

Your Best Work. A portfolio should contain only your best work. Don't waste your time, or that of the reviewer, by showing pictures that need explaining. Your images must stand on their own. Remember, there is no excuse good enough to make up for poor quality, poor craftsmanship, or poor image selection.

What You Want to Shoot. A portfolio should contain examples of the subjects, style and ideas you want to shoot. Don't put still life images in the portfolio unless you are seeking that type of work. Be specific in your image selection and presentation. Don't include such a wide variety of subjects and styles that the reviewer will be confused.

Salable Work. Once the images that represent your desired specialty have been selected, think about the intended market. The images you create for clients will be used in selling their products. If your reviewer is the advertising agency for a shoe manufacturer, the art director isn't interested in seeing pictures of cars or women in bikinis.

Every photo buyer wants to know, beyond a shadow of a doubt, that you are capable of shooting exciting pictures of their client's products. Most assignments are given to photographers who instill confidence, so show images that will inspire the viewer to give you an assignment.

Your Unique Style. Throughout the process of image selection and portfolio production, try to maintain some of the individuality that brought you to photography in the first place. Art directors are creative people with an eye and respect for individuality. A shot or two of your personal work generally goes over quite well with these folks. Make sure these images also meet the basic requirements of quality.

Your portfolio should avoid cliché photography such as sunsets, flowers, travel scenics, and erotic subjects, unless they happen to be your specialty. No matter what your specialty, the portfolio should look like the photography of a working professional, not like that of a recent student or part-time shooter.

High-quality, unpublished prints are perfectly acceptable in a portfolio. Low-quality computer prints are not.

Tear Sheets *vs*. Photos. Tear sheets from brochures, annual reports, magazine features, and other published works that contain your images make for very good portfolio examples. Client-produced materials lend a great deal of credibility to your reputation. However, they must also be top-quality images and reproductions.

I know it's difficult to show tear sheets when you're just starting out, when clients reproduce your work in small sizes and on back pages, or when less-than-exciting images were selected for the publication. Don't fret. Prints are just fine in a portfolio. Even the best-selling pros include unpublished work in their portfolios. This is how they get new ideas across.

General *vs*. Specific. The working portfolio should reflect all of the things we've been talking about. It's your bread-and-butter display. It's your best work and represents the type of photography you are shooting and selling, or hope to shoot and sell. It also grows and changes with your career and clients.

$ Develop a different portfolio for every client and a style that's needed to sell that client.

Portfolio Viewings. All of your effort should be aimed at getting a personal one-on-one portfolio review. It will always be the very best opportunity to present your images in their best light. If you're a good salesperson, so much the better. It may take a little time, and some good sales efforts, to convince photo buyers to see you and your portfolio.

The working portfolio should contain a limited number of images. It's far better to show a dozen great images than to show a dozen great images and a dozen so-so images. Show your most exciting work and leave them anxious to see more.

When I first started showing a portfolio book to clients, it contained about a hundred pages. It was almost impossible for me to eliminate anything that had been published or printed. After putting several art directors to sleep, I started being more selective. Today, I show a maximum of fifteen or so images in a portfolio.

A general portfolio is used for casual showings that might include a banker, lawyer, CPA, businessperson, future assistant, stock agency, book publisher, old school chum, visiting relative, or lover. It's bigger and loaded with examples of your widest range of work. Don't bother scrimping; include three or four dozen shots. When pressed to show something at social occasions, this book does the job nicely.

The specific portfolio should be built around your personal work, a new style, or images in which you have a special interest. This should be shown to people who share your life interests and may also be potential buyers of such images. It can also be shown to art directors who are knocked out by your working portfolio. Limit the images to your personal shooting and try making it look like a sampler rather than a working portfolio.

$ Portfolio reviewers are busy people who are easily distracted. Show a portfolio that will knock the viewer out instead of putting them to sleep.

PORTFOLIO DEVELOPMENT AND SHOWING

Sequence. The sequence of your portfolio image presentation is just as important as the images themselves. Start with two or three eye-catching shots that relate to the intended client. Mellow down with something soft, interesting, or artistic. If you shoot editorial or annual reports, stick in a short sequence. Put in at least one personal image that shows an unusual approach or style. Lastly, hit them hard with your best of the best. After that let the reviewer do the talking.

The Client's Opinion. Hopefully, you'll get to meet with a client face to face, instead of being asked to drop a portfo-

lio off or have your work viewed online. After everything is said and done in a face-to-face portfolio review, ask the client for an honest opinion of the presentation and the development of your portfolio. Listen, evaluate, and plan to make adjustments for the next person. Tell them you appreciate their advice and that it will be followed. Don't make even one excuse for a critical comment or a disliked image. Always drop a thank-you note for both the review and their even more valuable advice.

Leave at least one promotional piece behind with a portfolio reviewer. $

Your Promos. Attach a business card to your "leave behind" items so potential buyers can easily reach you. I like to leave an interesting tear sheet, magazine cover, or other printed piece along with the promo. This reminds the client that I'm a working photographer. Some photographers like to mount or laminate their promotional work and include one or two pieces in a portfolio. This is okay, so long as it bolsters your case rather than your ego. I mount and laminate all of my portfolio images.

Ask the reviewer for one of their company's promotional pieces or a sample press proof that's related to the type of work you're after. This may open up a whole new discussion about shooting a specific job.

A word of warning: never, under any circumstances, badmouth another photographer, art director, graphic buyer, client, or anyone for that matter. It will only make you look bad. If you're asked for comments when shown someone else's work, talk about concepts and ideas, not the person or their personality. Remember that what goes around comes around, and nasty comments may come back to bite you on the butt one day.

GREAT PORTFOLIO IMAGES
A portfolio should represent your current capabilities and $ very best work.

Being a great photographer doesn't automatically mean it will be easy to select the right images for your portfolios. Few photographers can really be objective in their own editing process. I suggest you seek the advice and assistance of an experienced art director or photography counselor. This doesn't mean turning over the whole process, it just means having a second, unprejudiced, set of professional eyes.

Style and Subject. Your first job in selecting portfolio images is to pull all the best shots of each subject or shooting style. The more experienced professionals maintain a permanent working file of their best shots. Every time they edit

a new shoot, the best images are selected and duplicated for the hot file. This is where they turn for portfolio image candidates and special sales needs.

In my field there are about a dozen subject or style categories that cover most assignments. These are the areas into which every shoot is immediately sorted for editing, making it faster and easier to select the best images. This is the way to begin editing your best work for a portfolio.

Once you've selected a dozen or so images that fit into each category, it's time to call on that outside art director. Together, you should examine each image, selecting the agreed-upon best for final portfolio consideration.

Difficulty Factor. The degree of difficulty or amount of time expended in making a certain image has almost nothing to do with its portfolio impact—or value, for that matter. In other words, just because it took three days to set up and shoot doesn't mean the art director will look at it for more than three seconds.

Don't let any production factor, such as lens size, cost, exotic location, temperature, time, or distance influence your ability to see the real image for what it's worth. Concentrate on the end product. There will be times when something unusual, such as a really exotic location or rarely seen subject or very extreme temperature may influence an art director to become a photo buyer. This is more common in editorial sales than advertising. I know this might sound a little contradictory, but you should know when something is really interesting to add to a portfolio review and when it's not.

For the most part, your portfolio pictures should speak for themselves, because quite often you won't be there to help. Of course, this is also true of a web site, gallery display, or drop-off package. Either the images are your best efforts and belong in the portfolio or they do not. No degree of difficulty or love for certain images can change this fact.

Quality and Speed. I like to make my first major portfolio image selection, say a hundred or so shots, take a good overall look, and give it a rest for at least one working day. This affords me time to reflect on the selection, which often brings to mind another element for my consideration.

Never rush the process of selecting images for a portfolio presentation. The seed you sow today will be the food on your table tomorrow.

My semifinal image selection is done quickly. I give each subject or style an overall examination and then begin to pull the images with the least impact. In a short time, only the strongest images remain. I then move to another subject or style and repeat the process. This leaves me with approximately a dozen shots in each group.

The final image selection is done with the help of my wife, Nancy, who is an experienced creative director. It should be noted that she knows our files well and participated in the initial image selections. Your art director should also be involved in the semifinal selections if possible. We each select the single image or two we like the best and discard the rest. We constantly ask ourselves, "What is the purpose of this portfolio, and does this image suit that purpose?" From these final choices, we attempt to build a sequence that will compel the viewer to pull out the assignment book or, better yet, the checkbook.

YOUR MARKET

Your portfolio is an advertisement. It should be prepared for a specific market.

Your Market. When you show a portfolio, make sure it's prepared for the viewer's market. More importantly, make sure the market is one you are interested in and capable of handling. Often, an art director will ask if you have any additional materials available on a certain subject. This is to see if you are experienced in that type of shooting. It's a good idea to have available a backup series of different portfolio images, aimed at the same market. This is also a good reason to return for another interview, so set a date!

Marketing Realities. Most art directors are happy with the photographers who shoot for their clients. They look at new portfolios and surf web sites in search of ideas bright enough to make them willing to try out a new photographer. Your portfolio is a brief and potent opportunity to compete with the photographers already shooting for an agency, magazine, or client.

No matter how good your images and subjects, the art directors are looking for style and capability. Keep this in mind when selecting portfolio images. It should be a given that your images will be of high technical quality.

Art directors look at portfolios because they are interested in hot new styles, not because they are particularly interested in new shooters.

Sooner or later most photographers develop a recognizable style. Good photo buyers may be searching for your particular style to mold into their own projects. For this reason, your research into the current images used by a market should be done prior to your portfolio image selection. Don't try to imitate styles of the shooters already working for the client. Why should the art directors break in someone new for the same old shots? Show them that your style can be adapted in a whole new approach for their client.

Your portfolio should be built around an individual approach or style, so be sure to include some personal shooting, in addition to commercial images. Give the art director an opportunity to see there is more to you than commercial image-building. Show them a little excitement in your work and in your life.

At the risk of repeating myself, good art buyers will always look for an unusual spark of creativity in you and your portfolio. They are constantly searching for new ways to present products through exciting images. Make sure your images show the range of your style. No matter how good your shoe still-life shots are, the art director will be suitably impressed by a maximum of two or three examples. Ten similar shots of any subject are never as impressive. A flow of style through a range of subjects is the best way to keep your reviewer's attention and interest directed to your portfolio.

"Who Shot This?" While looking at a selection of my location advertising work, the art director for a major airline once asked if I had made the photographs. "Of course I made the photos," was my startled response. "Why do you ask?" He said that another photographer had been in earlier and presented a nice series of industrial product brochures as a portfolio. The art director, it seems, also moonlighted as a freelance photographer. In order not to conflict with his airline daytime job, he only shot industrial products. You've already guessed, I'm sure, that it was the art director who had made the brochure photos in that photographer's portfolio. Guess who got the job.

It's a very small world, and one in which using other photographers' images will soon be detected. Don't do it, or you may get to present that portfolio to a judge and jury.

PORTFOLIO FORMATS

During the early days of my career I didn't have many tear sheets to show potential clients. Instead, I would pull out a dozen or so of the best 11x14-inch Cibachrome prints money could buy. These prints would be full-framed images that included the black borders in the shape of a 35mm slide. In showing the prints, I would say they were just quick proofs from a recent shooting. Every client was impressed with the quality of my prints. That was a door opener to new business. This still works today, by the way, although I can now get great quality prints right off my desktop printer.

The images are more important than the portfolio package, or are they?

The Big Box. Jay Maisel sends prospective clients a huge box of his tear sheets, promotional flyers, and other printed pieces. There must be a hundred different examples of his published work in the box. While this violates my rule of keeping your portfolio short and to the point, it's impossible to argue with Jay's huge success as a shooter and an image seller. When you have a hundred great tear sheets, and his reputation, you can do the same thing. Until that time, keep it short, sweet, and high quality.

Packaging. Books have always been the most common portfolio format. They're easy to put together, moderate in cost, and a good way to view prints and tear sheets. Art directors will generally ask to see your book. If you elect to use a book, make sure the sheets that hold prints, etc., are always clean and scratch-free. The small cost to replace damaged sheets is more than made up for by a professional-looking book.

Boxes of mounted tear sheets, prints, and duplicate transparencies have evolved into the choice for many working portfolios. Images in these packages can be changed quickly to meet different client requirements. Each of the portfolio's mounted pieces must be removed and held to view, which gives a longer opportunity for consideration. Most photographers have their logos printed on the package and image mounts as a subtle sales effort.

For tear sheets and prints, I suggest using a lamination mounting process. They are available in high-gloss or matte finishes with felt backing. Borders of any color can be mounted under the images to enhance their effectiveness. Lamination will protect your tear sheets better than anything else. They also look very professional. I use such prints in my portfolio and in special slide-in frames on my office wall.

Printed pieces are generally produced for independent mailings and to accompany portfolios. This includes postcards, greeting cards, catalog sheets, tear sheet reprints, and similar items. They are best for "leave behinds," which may be held for future reference. Some photographers laminate a series of these pieces into a smaller accordion-style portfolio. Most photo buyers do not have room for large posters in their offices, so don't waste the money unless you are a fine-art shooter, and that's a whole other specialty.

Catalogs of images are the portfolio of choice for many photographers with extensive stock files and extensive financial resources. High-quality printed catalogs are expensive to produce and may become dated very quickly. But they sure do look good in the hands of an art buyer. Several Internet-based companies produce this type of portfolio for photographers.

High-tech image portfolios have become commonplace with the advent of computers, which allow you to create and burn portfolios on discs. Those same computers have programs that can create digital laser programs and mini-movies,

which can be transferred to disc, as well. This technology allows you to create and send out hundreds of high-quality DVD portfolios for the cost of three or four presentation folders or boxes of expensive, mounted photo prints and tear sheets (once the program has been produced, of course).

The best part of working with some of these digital-based portfolios is the ability to use video picture editing capabilities such as fade-ins, quick cuts, short stories, titles, voice-overs, and music. With most of the better computer systems and simple video or photo editing programs, you can create interesting presentations that both inform and entertain a potential buyer. It's probably best to have someone who has created a few of these types of programs help you with the first productions. Remember that with such high-tech portfolios, the format and operation of your portfolio will be looked at just as closely as your images.

Of course, much of this creative technology has been available for some time at motion picture film and video post-production houses in major cities. Many leading pros have created short documentary-type movies of themselves and their work for years. Now they can send those programs out on a disc that can be viewed on most modern computers. Using such postproduction facilities, and their experienced editors, will guarantee that you have a high-quality product to show clients. It will also guarantee a high price to create the master program, from which you duplicate copies to send potential clients. This is the way most serious and successful photographers choose to go.

A few words of warning about high-tech portfolios: don't let fancy technology tricks and music take the place of quality images. While art buyers, designers, and clients like to be entertained and sold, remember that they are looking for image makers and images that will help sell their product. Make sure that your portfolio creates that impression, no matter what the format.

Disc Packaging. Treat your disc portfolio packaging the same as a print portfolio folder or box. Have your name, contact information, and logo printed on the jewel case, slip cover, or insert. Again, this is a place where your interesting and colorful cover may be the reason someone takes the time to view the disc. I suggest using a professional disc duplication and packaging company. They usually have some interesting packaging products and ideas.

Materials. Portfolio reviewers will be considering both your images and their packaging. Always use the highest-quality materials and images possible. Have at least two duplicate portfolios available for simultaneous showings. Having two portfolios also guards against loss and theft.

Review your portfolio regularly and look for ways to improve its impact. Keep in mind that about the time you are tired of a portfolio, it may just be catching on with art directors. Also remember that your portfolio is a sales tool designed for and aimed at photo buyers, not other photographers. If the opportunity presents itself during a portfolio review, ask for an opinion on your packaging and presentation. These people see hundreds of portfolios each year and know what they like.

PRESENTATIONS

Interviews and Attitudes. Getting to see the right people for a portfolio review is often as difficult as getting an assignment from the review. Keep in mind that most of these people would rather see a drop-off or web site portfolio. However, when you do try for a personal review there are two basic approaches. One is to call the company, agency, or publication and simply ask, "Who's the right person to show my photography?" Many organizations have already established procedures for seeing suppliers, which is what you are, and will let you know what to do. Others may provide a name. Some may say so sorry. If you've done a good job in your market research, the mailing list resources will provide the names of people who should see your portfolio.

Your portfolio is meant to inspire sales.

You can also drop the prospective client a letter of introduction and request a personal portfolio review. I suggest including a self-addressed and stamped postcard to make their reply easy. Don't be put off by put offs.

As I've said, a portfolio presentation is an interview for prospective employment. You, the images, and the packaging are being considered for future work with the reviewer's company or client. This is the opportunity you've been seeking, don't blow it with a poor attitude or, even worse, poor images.

Their Commentary. The photo buyer looking at your portfolio hires photographers and purchases stock images. Give them a chance to view your images in peace and quiet. In other words, let your carefully prepared portfolio do its job without a running commentary by you. Remember that an experienced art director will be looking at you just as closely as your portfolio. Are you the kind of professional with whom their organization wishes to associate?

Art buyers know what they want and will share this information with you.

Your Commentary. Listen carefully before inserting a portfolio, or foot, in your mouth. I keep saying this, but it's important.

Very few images in a good portfolio require any explanation. If you've produced a good package, it will stand on its own. If you are asked about a given image or client, be positive and brief in your response. Let your images do most of the talking. Point out one or two interesting things in a maximum of three or four images, and say no more. An interesting point might include the casual dropping of the name of a major organization that hired you to make the shot. Everyone likes to work with a successful photographer. No one likes to work with a smart-ass, who constantly talks about every shot and client represented in their book.

Be positive about your work. Also be ready to suggest ideas for incorporating your work with the viewer's projects. Again, this means knowing something about the client's past projects before reaching the meeting. That's a lot better subject to talk about during a portfolio showing.

A Pulitzer Prize–winning photographer once approached a major oil company with an idea to publish a goodwill brochure. The photographer hoped to photograph people living around and associated with the various areas of this company's business, but not their employees. He hoped to show the community benefits derived from their business. The oil-company people loved the idea and started talking print costs, logistics, dates, and other related matters. During this process, the photographer began to point out some of the shortcomings of such a project. He went on about the poor conditions he had seen, the dirty garbage sitting in streets, and the constant traffic to and from the plant. You see, this photographer had always been a photojournalist, shooting in hostile environments. This was the first time the normally hostile environment had become cooperative. The photographer talked too much. In fact, he talked the company right out of doing the project. "We'll be in touch" were their parting words.

Remember, there are far fewer good ideas around than good photographers with good portfolios.

Time Is Money. Photo buyers are busy people who also have a short attention span. Be polite with a little small talk, but remember you're there to take care of business. Show your work, introduce a few ideas, ask for the sale, and say good-bye.

Leave a good sample behind with your business card attached. This sample should fit into the art director's prospec-
tive file, not be a huge poster that ends up as a fire starter. It can be a promotional flyer, advertising reprint, client's brochure, or any good, clean example of your work. Leave something that will make them call you.

Drop-Offs. Some photo buyers are just too busy for individual portfolio examinations. This is a fact of corporate life over which you have no control. Some magazines and advertising agencies schedule regular portfolio sessions for their photo users and buyers. While your portfolio may be included with several others, it will also be viewed by all of the organization's potential buyers. Have at least one duplicate portfolio, preferably two or three extras, for drop-offs. Your images should be able to speak for themselves anyway.

If you expect to do a lot of drop-off portfolio presentations or want to send them out unsolicited to a much wider market, it's probably best to spend the time and money putting your portfolio on a computer disc. If a disc is lost, destroyed, or not returned, you're out a few bucks—not a several-hundred-dollar print portfolio package.

Follow-Ups. Always send a thank-you note for a portfolio review, even if it's just a drop-off. This is considered common courtesy. Keep it brief and businesslike. Let the reviewer know you're interested in talking about new ideas and markets. After a month or so, send another note with a recent sample of your work. By this time, you might have another bright idea to share.

Don't be put off if the reviewer doesn't have an immediate job available or seems uninterested in your work. It doesn't mean that they don't like you or your work. No one said this was going to be easy. Be persistent in showing your portfolio, and sooner or later things will start to click.

Evaluate every person and organization reviewing your portfolio. Determine if you are interested in and capable of producing work for their use. If so, put them on your regular mailing list for promotional materials.

Try to show your portfolio at least once each week—more if you're not too busy shooting or taking care of other business. It will keep you alert and aware of the many changes of people and organizations that buy images. Also, always try to direct potential buyers to your web site.

Did I mention not talking too much during a portfolio review?

12. STOCK IMAGES ARE BIG BUSINESS

IMAGINE PHOTOGRAPHY THAT SELLS AND SELLS

Successful stock photography is just that—images that sell over and over again. You can sell stock images yourself directly or through a web site, or via a partnership with an agency. You, or through your agent, are licensing a specific use of an existing photograph that has been created for that purpose. Clients purchase a stock image because doing so is usually faster and less expensive than making their own images. This is especially true of the more generic subjects. Sooner or later, photography of every imaginable subject, including people, places, events, emotions, and just plain stuff, is needed by photo buyers somewhere. Needless to say, if either you or your agent have a large file of good stock images available, of the subjects that are needed, there is money to be made.

Most of the successful photographers, the ones who really make Big Bucks, sell stock images in the process.

THE GOOD NEWS ABOUT STOCK PHOTOGRAPHY

Best-Sellers. It's not uncommon for a top-selling stock image to have a lifetime income of over $100,000.00. That would be a very good image making very good sales. You need only look through current magazines to see that clients are looking for the right images to sell their products. It's those images, not the next Pulitzer Prize winners, that are the best-sellers.

Good Sellers. Imagine creating a library of 10,000 good product-related images, no matter what the product, and selling each one for just one-tenth of those big-time best-sellers. This library in itself would make you a nice living. How about doubling that library's size every year or two? Using this speculation, it's quite easy to understand why photographers and agencies consider stock images a serious business within the photography industry. You don't need to be a rocket scientist to figure out the potential profits.

Who Sells. Anyone can sell stock images. Create a good library of images, of practically any subject, and you create the opportunity to sell stock photography. *How* to sell the images in a stock library is an entirely different subject.

What Sells. Sooner or later there is a demand for every subject. If you have images of African tsetse flies, someone will buy them for a medical article on sleeping sickness or an advertisement for a new treatment. However, your chances of selling photos of a healthy family hiking or biking in the countryside are much better. There is also a high demand for portraits of successful ethnic people in all walks of life.

No matter what your photography specialty, the potential for stock sales from that work exists.

Why Stock Sells. Stock photography sells for the same reasons that all photography sells: it's the right image for the right client at the right time and at the right price. Achieving this means having a very efficient method of delivering that image in a format the client can use.

In general, stock images are more generic in order to make a wider number of sales, while assignments are more specific. Stock should be faster and easier to find, and often available at a lower cost than assignment work.

POTENTIAL SUBJECTS

Before jumping into the deep end of the stock photography business pool, you take a good look around and see what's happening subject wise. The more you know about this end of the business, the better you will be able to pick and choose potential shooting for your own stock library.

To get a good understanding of stock photography subjects that sell well, look at stock photography that sells well.

See Everything. You can get an overall look at the leading stock agencies by visiting www.punchstock.com. They are sort of a stock agency's stock agency web site. Punch-Stock supplies designers and creative professionals with a unique visual tool, according to their own promotions, which is a comprehensive collection of over one million rights-managed and royalty-free stock photos and illustrations from the world's top photographers and stock agencies. By visiting PunchStock you can surf through about two dozen of the leading stock agency collections.

See the Best. Of course, you can also go directly to most of the leading stock agency's web sites. I suggest taking a look at the biggest and the best:

Getty Images (www.gettyimages.com). Getty Images is the largest image collection stock agency in the world. They must have at least 10,000 creative suppliers of still photography, motion picture footage, news, entertainment library images, up-to-the-minute images, and assignments to produce all of those materials. This is the place to see what's happening in the world of image making and selling. They are the big boys on the block.

Corbis (www.pro.corbis.com). Corbis is one of the major players in stock photography library sales. It was the brain child of Bill Gates, who just wanted to buy rights to a few pretty pictures for his home. And being the brain that Bill Gates is, his interests grew into one of the leading collections of images in the world.

See the Rest. If you want to get an idea of how big and wide-ranging the world of stock photography has become, Google the words stock photography agency. You will be rewarded with thousands upon thousands of resources. Take a look at the right side of the opening screen and see who advertises their stock for sale in this manner. You can purchase this kind of Google advertising and have your name appear right next to the biggest names in the business.

The web sites, flyers, and catalogs produced by leading stock agencies make interesting reading and research for your own work. A word of caution: once a situation or subject has hit the agency sites and catalogs, or the royalty-free photo discs, it's very available to a lot of buyers, so don't treat these resources as shooting guides. Develop your own concepts and ideas so that others will copy you instead.

In looking through the materials of leading stock agencies, you will see that they generally fall into two categories. They portray a specific subject or they portray a concept or feeling. Both are necessary to meet the many needs of photo buyers and their markets.

Quite a bit of stock photography is shot, filed, advertised, and requested on a subject-by-subject basis. A sample subject list might include such things as the following:

- Aircraft
- Animals
- Boats
- Books
- Buildings
- Business machines
- Cars
- Cats
- Children
- Cities
- Clothing
- Computers
- Couples
- Crafts
- Destinations
- Doctors
- Dogs
- Equipment
- Families
- Flowers
- Food
- Horses
- Lovers
- Men
- Mountains
- Musical instruments
- Parents
- People
- Recreation
- Restaurants
- Senior citizens
- Sports
- Sunsets
- Teens
- Travel
- Water
- Women

I'm sure you can add a lot more under this brief subject list. While it's easy to shoot stock photo subjects such as those listed above, concepts and feelings are more difficult to portray. In every stock photo shoot, try to apply a feeling, or concept, to your subjects. Some of the more popular marketing concepts and terms include the following:

- American
- Antique
- Artistic
- Asian
- Beautiful
- Best
- Classic
- Cold
- Colorful
- Comfortable
- Cool
- Craftsmanship
- Danger
- Delightful
- Dry
- Economical
- Elegance
- Ethnic
- European
- Exciting
- Exotic
- Feeling
- Fresh
- Geographical
- Glamorous
- Happy
- Hateful
- Healthy
- High-tech
- Hispanic
- Honesty
- Hot
- Independent
- International
- Inviting
- Leadership
- Loser
- Lost
- Love
- Luxurious
- Loyalty
- Peace
- Pride
- Principles
- Quaint
- Sadness
- Safe
- Satisfaction
- Sexy
- Strong
- Tasty
- Teamwork
- Togetherness
- Trustworthy
- Unhappy
- Warmth
- Weak
- Wholesome
- Winner

Take a look at the annual award-winning advertisements in *Communication Arts* magazine, the Clio Award winners, the Magazine Photos of the Year, and similar image-conscious media. Most of these involve an effort to convey a distinct feeling to the viewer. This should be the primary goal in all of your stock and assignment photography.

In my travel photography, I try to instill a desire to see the place featured. Travel organizations want to put people on planes, on cruise ships, in resorts, in restaurants, in theme parks, and a host of other attractions. My work must convey such things as enjoyable, fun, safe, colorful, and so on.

Your stock images need to imply that a potential buyer's product or service is desirable, safe, the best, and other similar feelings. Do that and you can sell stock photography.

WHAT TO SHOOT
There are few limits regarding what can be included in a stock photography library.

Your Interests. Since there are so few limits regarding what can be included in a stock photography library, you can shoot pretty much anything you want. Shooting stock images allows photographers to cover *and* participate in just about

anything imaginable. If you enjoy hiking, swimming, jogging, camping, family sports, or gardening, there's a demand for good recreational images of people in all of these situations, in all types of geographic locations. If you enjoy horses, auto races, fashion, music, dancing, cooking, carpentry, inventing, exploring, native crafts, business, computers, manufacturing, wood carving, collecting, travel, television, stamps, coins, wigs, bugs, or similar things, somewhere someone needs photography on these subjects. Whew. Those are just a few of your opportunities to shoot and sell stock images.

Most stock photographers I've met shoot a particular type of subject for two reasons: because they love the subject and because they want to make money. Make sure you consider both reasons in making stock subject shooting choices.

No matter what your interests, shooting stock images for sale allows you to participate, to be around and to collect props toward building a library. It also allows professionals in specialized fields, say mountain climbers, divers, pilots, doctors, missionaries, soldiers, and the like to become stock photographers, as well.

Shooting speculation stock photography allows you to work any time and most any place. You don't need an assignment, because stock is a self-generated assignment. All you need is the desire to make images, a little knowledge on the intended subject, the business format and, of course, the money for materials, equipment, and production capability.

Be Careful. I know there is a proliferation of erotic and porno sites on the Internet, only because a friend told me, most of which probably buy stock images. My guess is you could shoot and sell such subjects to these places. If you do, I strongly advise staying well within the federal, state, and your local community laws. You will also need a good First Amendment rights attorney, as these sites, their suppliers, and their viewers are favorite targets for law enforcement. If you do enter this specialty, please don't tell anyone you read this book, even if you are a huge success.

TAXES AND INVENTORY
Shooting stock photography is an investment.

Every stock image you shoot is an investment toward your future sales. This is really an investment in putting food on your table, as well. Most business investments, especially production of products for sale, have very strict tax rules about depreciation and inventory. Professional stock photography creators have been given a break in this area.

Thanks to the congressional lobbying efforts of ASMP, PPA, and other artist-oriented associations, photographers can now immediately deduct the costs involved in making

stock images for sale. Previous tax regulations required the expenses for this type of shooting to be deducted when the images were sold. Talk about an accounting nightmare!

In order to meet tax requirements for speculation stock shooting (i.e., having the deductions accepted in an audit), you must be in the business of making and selling photography. This can be as simple as having an agency selling your work on a regular basis, even though you may also work in another field. If you do work in another field be very careful about writing off huge expenses to create stock photos, with very little income to show as a result. If you are an assignment photographer, no problem. If you are starting out in the business, make sure your intent and goals are aimed at making a profit. That's the basic IRS test, by the way—the intent to do business for profit, not as a hobby or vacation tax write-off. However, they may take another view if you continue to show losses for a number of years while building a photo file.

Selling the use of a stock image is a service. There is no transfer of tangible property and you keep originals for future sales. The sale of services has its own special tax category in many states. Some states consider any sales within their borders to be taxable. Some states also impose taxes on sales made outside their borders, even though the job, sale, and check may be outside their state. Remember that the hunger most governmental organizations have for tax money is far greater than your hunger for success. Make sure you work well within their rules and regulations.

Check with a knowledgeable CPA on tax regulations as they relate to the production and sale of stock images. The rules and regulations governing this business are constantly being considered and changed by well-meaning bureaucrats. A lot of this is also covered in chapter 8.

HOW TO SHOOT STOCK
There is only one way to shoot stock photography. Shoot as though your livelihood depends on it.

Creating Stock. Leading stock photographers plan stock shoots around subjects they know will have continuous markets and sales. This might be something simple like an Italian meal prepared and shot in your studio. It might be a little more complicated when shooting the same meal being prepared in the Tuscan countryside of Italy. Either way, though, you get to sample the food you shoot.

Producing stock photo shoots puts you in the position of both client and photographer. You must conceive the idea, procure the props and people, plan the shoot, schedule the logistics, create, file, and sell the photographs, and pay for everything along the way.

I plan recreational and travel-oriented shoots in popular tourism locations such as Hawaii, Mexico, Asia, French Polynesia, and Italy. As I just mentioned, this involves more than selecting good shooting locations. It also means hiring local and international models, scheduling accommodations, all sorts of transportation, planning the shoot list, establishing a budget, checking the market need for images, making the images, footing the bill, and selling the images.

Shoot, Shoot, Shoot. Whatever you choose to shoot, it means shooting a variety of concepts and angles around each situation. In making stock images, you should shoot double the normal assignment amount of frames in order to produce as wide a selection of salable images as possible. I try to create as much originality as possible in my images so they are attractive to buyers and my stock agent.

You can imagine how high the costs of a major stock photo shoot can be. Again, producing your own stock should be considered an investment in the future. The images you make today may sell next year and they may still be selling in ten years. Of course, they may never sell at all. You take the same risk all independent businesspeople share in committing hard cash to produce a product for sale. Make sure you have enough hard cash to cover speculation shoots, conduct normal photo business, and take care of the extras like food and rent.

Equipment. Stock photography is the same as assignment photography, and you need the best equipment available for the type of subjects being photographed. (General equipment is covered in an earlier chapter.)

Your images have to stand out in a sea of other stock images, so do everything you can to make the best-possible images. I suggest shooting with the highest-megapixel digital cameras possible. While your clients may rarely need a huge image document, if one does, you will be able to deliver. It may also mean selling the image for a higher fee.

Film. Not long ago all stock photography was created on real film. The bigger the format, the better the sales. As a result, many photographers and stock agencies have huge files of transparencies and slides. Many of these images are scanned into digital formats and sell very well as stock. If you have a big file of original film images, sort through them to see what might be salable as stock. Rent or buy a scanner and get those images into your digital stock library.

PHOTO RELEASES
Stock images are ten times more valuable with model and property releases.

I can't say this too often: a talent and/or property photo release is one of the most important tools available to your photography sales. A good stock photo of a pretty girl or handsome man may sell well. It can sell ten times as well with a model release. A photo release establishes, with the person who signed the release, your intent to sell the photos in a commercial manner. It establishes this intent beyond any reasonable doubt, and that is exactly what your clients need for their own legal protection.

As I've said earlier, there have been some not unreasonable claims made that a magazine cover is in fact advertising to sell the magazine, not editorial reporting. This problem won't arise with a photo release.

HOW TO FILE AND MAINTAIN A STOCK LIBRARY
Shooting stock photography is one thing; developing and maintaining an image library is an additional business altogether. It requires equipment, software, knowledge, and materials beyond the normal assignment photography business.

Even the smallest stock agency, owned and operated by a single supplier photographer, will have a large library of images. After twenty years of shooting travel stock, beyond the assignments, my files have grown to some 500,000 images. In talking with several of our colleagues in single owner stock agency photography businesses, no matter what the specialty, I haven't found this to be all that unusual.

If you are prolific enough to create and add 1000 new images per month to your stock file, that's 120,000 every year. In less than ten years you will have created a file that's over a million images strong. While these large numbers are probably twice what a productive shooter will create, they do give you an idea how quickly a library can expand.

Potential Problems. The number-one potential problem in creating a stock library isn't making the images. That's easy. Getting each image into the library can be an administrative nightmare, especially if you don't get started with the very first images. Therefore, each session you shoot to include in your stock library should be:

- Created
- Edited for keepers
- Identified
- Uniquely numbered
- Key-worded/categorized
- Corrected if necessary
- Manipulated if desired
- Converted to the required file format
- Assigned a copyright symbol (©)
- Filed in main library
- Copied into backup location
- Put into sales place (web site/agency/other)
- Delivered when sold

Stock Equipment. In addition to all the photography equipment you'll need to create a stock library, there are a few extras needed to complete those steps just listed. The stock shooter will need a good laptop computer to download images from the camera when shooting on location; a high-capacity, fast desktop computer and image-editing, business management, and storage software; a lot of good standalone storage capability; a quality color printer; and a high-speed Internet connection. The investment for this equipment and learning its proper use can be substantial, just as it can be for a basic shooting setup.

Editing Process. Obviously you shoot the best-possible images and edit shoots to remove the unusable shots. There are several programs available for editing images from a shoot. I like to keep it simple and use the Bridge software in my Adobe Creative Suite. This is an all-inclusive system that allows me to quickly sort through several images in small format, or individually in full-screen view; cull out the bad shots; do any corrections and manipulations in Photoshop; assign an individual number and file name to each image; and file each image into whatever folder I choose in whatever file format I choose. I do this as soon as possible after completing the shoot.

Image Identification. You should know the proper name and other identification characteristics of a subject being photographed for your library. I suggest getting this information down on paper, or in your laptop computer, as you shoot. While you may know exactly what, where and when something is at the moment an image is created, some of this information may be lost or jumbled a few days later when the file work begins.

I like to shoot a "slate" for identification of a particular subject (that's a movie term for the little clapper that is snapped in front of a camera at the beginning of every single shot). The slate can be a sheet of paper containing important information printed with a marking pen. I also shoot signs that identify locations, equipment, or other special information when they are available. By slating, you will have the information needed for subject identification in an adjacent frame.

The information you place with a new stock image will follow that image throughout its lifetime. The more specific and complete the identification is, the easier it will be to administer, search out, and sell the image. This is one of the most important administrative activities you will perform. An image without identification often becomes lost. An image without release and location information won't sell for Big Bucks.

Numbers Game. Every single image you save for the stock library must have an individual and unique number.

Some photographers like to use a brief code that immediately identifies the subject matter and its proper file location. Such information substantially reduces the amount of time required to find and duplicate images for sales. It also facilitates the tracking of sales, uses, age, ownership, cost, and other related information for a specific image. This is what I did for my original film stock, placing the individual number code on slide mounts and transparency covers.

I suggest you simply give every image its own unique number, because the other information will be listed in another way. You can start with the number one, if you like, but the number will have to be something like 0001 so a computer program can distinguish between 1, 10, 100, and so on. Let's say you hope to have 500,000 images in your ultimate library; this means starting with the number 000001. This system will also tell you how many images have been created for the system at any given time.

Typical File. I use the Excel program from my Microsoft Office Software Suite for numbering, categorizing, and assigning key words for your images. Any one of these listings can be searched when a set of photos are needed for a specific client use. My image listings have some other information that is important to my clients, as well. Use whatever additional categories you think necessary for the specific type of images you create. There can be as many different categories as you wish, within reason.

For example, a typical travel image entry would have the following categories across an Excel spread sheet:

- Unique number
- Country
- City
- Keywords
- Date made
- Time of day
- People in image (yes or no)
- Type rights
- Model/property release (yes, no, or n/a)
- Release number

Key Words. The real heart of every image is a set of four or five key words that tell you, and potential buyers, exactly what the subject is of that image. These are the primary words entered when searching for a stock image. For example, a typical travel image set of key words might include the following:

- Hawaii
- Oahu
- Waikiki
- Beach
- Surfer

You can have more key words if desired, although a maximum of ten is plenty. Some that might be added to the above key words might include:

- Woman
- Bikini
- Afternoon
- Fun
- Recreation
- . . . and so on

No matter what subjects you shoot, most of the images can easily be identified with five key words. Try not to be too general in selecting your key words. Things like sunset or dusk are fine. Words like *red, big,* and *bright* are so generic that a searcher may be flooded with red apples when they are looking for red cars.

Corrections. Make sure that your images are color correct and exhibit good contrast. Make sure there are no small dust spots in the images. Make sure your horizon is level. Always remove such things as discarded beer cans and cigarette butts from a scene, unless you are a photojournalist recording things as they are where they are. These are the very minimum corrections that should be done to every image you make and save for sale.

Manipulate When Necessary. You may recall when *National Geographic* magazine squeezed the pyramids of Egypt together to fit their cover's vertical format, without informing readers that such manipulation was done. Today they make and take great efforts to ensure that such manipulation hasn't been performed on any of their images.

There are a lot of good reasons to manipulate an image beyond simple corrections—but "just because you can" isn't one of them. These can be easy things like removing telephone poles to more difficult things like adding objects like sunglasses or a client's cruise ship to a scene. Sometimes, the more obvious and creative your manipulations are, the more desirable the image will be to a client.

Ultimately, I have no objection to manipulating images, so long as your potential buyers know when something major has been changed.

File Format. You need to convert from the RAW and/or Photoshop file format into a file format that is both safe and easy to work with in the future. TIFF is currently the most often used and acceptable format to save images in. However, technologies are ever changing, so it's important to stay on top of new developments. *PDN,* and especially *PDN Online,* is an excellent place to do this research.

Client Files. Though you may choose to save images in your stock library in TIFF or another format, keep in mind that most clients require that the images are delivered in the JPEG format. Because JPEG is a compression format, the image files are smaller and easier to send quickly over high-speed Internet connections. Because JPEG is a lossy compression format, image quality will be degraded if the images are opened and resaved over and over.

Copyright Symbol. Add your copyright information inside every photo's identification information, as well as on your various written communications. Make sure you review the legal section of this book and that you understand the role copyright laws play in photography.

Library File. Storing a lot of library images takes a lot of space. Though you may keep images on your system while you complete the initial identification, correction, and key word phase, this isn't the place to maintain even the smallest image library. There isn't enough room, and computer systems have a habit of bombing, dying, and eating stuff.

When an image is ready for my library system, I move it to a stand-alone hard drive. I have different drives for different types of images, at least 250GB each in size. Designate a separate drive for each category of images in your library. Of course, you can designate specific drives for storing other business-related files, too. The drives are inexpensive, easy to store, and portable. My drives are broken down into the following categories:

> **Working Files.** Just about everything on my desktop.
> **Stock General.** Smaller subjects that do not have their own drive.
> **Client Shoots.** In case a client loses their working images.
> **Location Drives.** A different hard drive for every major location I cover (e.g., Mexico, Hawaii, Alaska, etc.).
> **Backup Drives.** I back up everything on a separate drive. When that's full, I start a new backup drive.
> **Music.** I have a separate drive to hold my eclectic collection of music. Keeping a lot of this kind of stuff in a computer system is just asking for trouble.

Final Destination. How you sell images will determine their final destination. They may stay in-house or go on your web site, or they may go on to a stock agency. You can transfer images to an agency by simply providing them with a hard drive or burning images to a CD or DVD.

HOW TO SELL STOCK PHOTOGRAPHY

There are several ways to successfully sell your stock images. You can sell directly from your office, sell them via your web site, or place them with a stock agency. There are also some web sites that feature images from numerous photographers; when a viewer sees an image they are interested in, they can click on the image thumbnail and be directed to the photographer's website.

ON THE WEB

Most assignment photographers also sell a little stock directly to clients. It's not always because they want to be their own stock sellers, it's usually because they don't have much of a library and/or don't want to share any income. This is sort of a frosting-on-the-cake type of stock library.

After selling stock in small bits and pieces, most photographers see the light and establish their own internal agency or begin searching for an outside specialty agency.

Selling your own stock photos really isn't all that difficult. In fact, there are many photographers who are very successful at selling stock. I'm one of those photographers. However, it is a separate business function, which means you must sell and administer in addition to producing the images.

Web Site Design. The best way to sell your stock library images is to do it on a web site. You'll need to enlist the help of a web designer who has built sales sites for other businesses. It won't be cheap. Your site needs to be just like those operated by the big boys, Getty and Corbis. Take a look at their sites well in advance of planning your own. Here are some key elements of a well-designed, functional site:

Operation. Your site must work quickly and be easy to navigate. Clients should be able to find the image they want or surf around general topics to see your entire online library.

Selection. You need to have a lot of high-quality images on a stock web site—and a large enough selection of subjects and images to make it worthwhile for clients to visit more than once. This means you need to be out shooting, while an experienced person or company maintains your web site. You will be busy enough, after shooting, just getting images ready and uploaded to the site.

Be sure that you offer a range of image sizes, generally low and high resolution, and at prices competitive with other stock agency rates. Your site must have the storage space for these images to be immediately available for downloading when a client makes a purchase.

Payments. Clients should be able to quickly and easily purchase your images. I recommend offering a simple PayPal (www.paypal.com) or credit card payment system, which can be implemented by your web designer. You can also set up accounts with major clients so you can send invoices and they can pay by check or other method. I prefer the first option.

Image Delivery. Your clients must be able to immediately download the image they purchase. This is a design component, and it needs to work well. I also recommend setting up the capability of delivering images on disc via express or standard mail. Sometimes TIFF image files are so large that it's not feasible to send them via an e-mail attachment.

Web Sales. As if building a library of stock images and getting them on your web site isn't enough, you'll have a major job in selling the web site to clients. There are a number of ways to sell your own stock web site, most of which are similar to selling assignment photography. They include direct mail flyers and offers, advertisements in trade publications, in-house sales representatives, and e-mail campaigns.

Professional Sales Sources. The *Black Book* and *Workbook* (see page 115) specialize in high-end contacts with buyers of photography. These are among the best places to advertise your web site and your shooting services. This is where I suggest you start looking at sales options and prospects.

Art director magazines are also good places to promote your stock images. The best is *Communication Arts.* These magazines include interesting features and advertising from all sorts of suppliers, so you won't be bunched in with hundreds of other photographers and their web sites. The downside is the cost for a month or two of exposure.

The places that solicit advertising from photographers also offer mailing lists and web sites to help you sell. Take a few minutes every now and then to look over their materials to see if they are right for your own marketing growth plans.

Stock Lists. A comprehensive list of the images in your stock library should be included with any mailings or client call leave-behinds, including reprints from the photo books and your flyers. Keep your list on a computer so it can be updated as your library grows and changes. Don't list a subject, location, or topic unless you have a good file of images available on the web site for prospective clients.

Art buyers receive hundreds of promotional pieces each week and will spend about ten seconds examining each item. The best ones will be held aside for further examination and possibly the working file. The best promos often make their display wall. However, they will almost always file a stock list from an online agency for future reference. Make sure yours has good contact information on it.

E-mail Promos. There are some organizations that can promote your web site with a massive e-mail campaign. This usually means samples of your work and a link to your site will be sent to all known image buyers in the world. It's your hope, of course, that some of those photo buyers will open the e-mail in the first place, and take a look at your site. You can find a lot of these organizations with a quick Google search. I also recommend surfing around the photo sites and asking who is the best and most effective.

STOCK RATES AND RIGHTS
There are two types of stock photography for sale today: rights protected and royalty free.

Rights-protected images are generally sold for a specific one-time or single-campaign use. The rights for all uses remain

with the copyright owner, which in this case is you the photographer. There is no across-the-board price to use a rights-protected stock image. The pricing formula is a bit complicated for first-time sellers and buyers. Uses are categorized by the reproduction size, placement, media, number of imprints, geographical size of the audience, and whether it's for editorial, advertising, or commercial use. Advertising and commercial uses must have the appropriate model or property releases and command higher rates. Most editorial uses don't require releases or have other commercial value, which makes them lower in price.

For instance, a client may wish to buy your photo to illustrate the cover of a brochure that will be printed one hundred thousand times and distributed within a regional area. Or a publisher may desire to use your photo half page in a regional magazine article with a circulation of fifty thousand readers. An advertising agency may wish to use your image in a full-page ad that will run in ten national magazines with a total circulation of five million. Each of these uses has a different price, which you must be able to quote to prospective clients. You must also be able to rationalize with, or educate, some clients as to the reasoning for such pricing.

There are several stock and assignment photo pricing guides available at professional camera stores and at Amazon.com. I use the stock photography software pricing and selling guide called FotoQuote, developed by Cradoc Bradshaw. It's a simple geographic and specific-use-oriented guide to pricing most stock images. The software sells for less than your minimum-cost stock image should be priced. I suggest you evaluate these published rates and then establish general rates of your own.

Online Rates. Selling rights-protected images online is not easy. After reviewing all of the pricing options, mentioned above, you'll understand why. Most stock sites offer several choices of uses and prices that have been standardized to make purchases quick and easy. More complicated uses are negotiated via e-mail or telephone. This might include uses that require exclusivity, major international campaigns, multiple print runs and huge print run brochures.

Transfer of Rights. Clients purchase specific use rights, which is a license to use your copyright in a certain manner upon their payment of the invoice. The exact usage should be spelled out in clear terms, both on your web site and in your online invoice so that there is no question about what is being purchased. This is especially important with rights-protected images.

Royalty-Free Images. Royalty-free images are purchased before any use is permitted. After that, buyers of a royalty-free image are not required to specify how or where they use that image. In fact, they can use the image for almost any-

thing. They can also use the image over and over again, because a royalty-free license has no restrictions on time or reuse. About the only restriction of buying a royalty-free image, is in not sharing, selling, or storing the image in any way that makes it accessible to others.

On the other hand, royalty-free buyers have absolutely no exclusivity. The image they bought for unlimited use may also be purchased by other buyers. In fact, they may be purchased by hundreds of other image users—thousands, if you listen to stock agencies making their sales pitches to corporate managers, stock holders and potential image suppliers. That's the attraction of selling royalty-free images.

Having royalty-free images for sale on your site, or an entire web site of royalty-free images, is the most popular and easy method of selling stock. The better you sell your web site, the more sales you will make—over and over, without any use and price negotiation, complicated tracking of where an image has been sold, and what rights may still be available.

Royalty-Free Rates. Most royalty-free sales are made for either a small (5MB), medium (12MB), or large (40MB) TIFF files. Larger sizes may be available, although buyers are generally required to buy rights-protected images in these cases. Exact document sizes and prices vary from company to company, so you will need to surf around the main stock agency sites to figure out what yours will be.

Prolific shooters, who can create several thousand images in a short period of time, like the idea of royalty-free sales. They shoot a lot of subjects and hope most of them will sell a lot. Their income grows when a lot of buyers buy a lot of images a lot of times. Some of these shooters make a lot of money following this theory.

STOCK PHOTO AGENCIES
A stock agency is in business to sell many images from many photographers.

Photographers place their images with a stock agency for good reasons. Some shooters want to spend their time planning and shooting, not administrating and selling. Others feel that a stock agency is so much better connected to the markets and their income will be substantially higher. Also, all of those shooters with outside agencies benefit from the wide selection of images, services, products, and potential assignments that bring buyers to the agency.

Typically, stock agencies are responsible for image selection, marketing, sales, administration, and sales of the images in their libraries. Often this is accomplished in huge multilayered web sites. The better an agency is at accomplishing all of these tasks, the better the sales and the more money everyone makes. The agency is responsible for ac-

counting, billing, client research, market trends, photography trends, and other administrative efforts. The best thing about stock agency photography is that once you have images on file, they sell while you do something else, like shoot another batch of images or take a nap.

For this service and investment, the stock agency receives a percentage of each sale. This is similar to the way any agent represents an author, musician, artist, or other creative talent.

Working with a stock photo agency is a partnership from which both sides expect to profit. You shoot and the agency sells.

In working with an agency, it's your job to produce salable stock images, with proper captions and releases, in a timely and frequent manner. Your investment includes all the time and money it takes to make and deliver those images, and you hope the agency sells those images well enough to cover those costs and make a profit beyond what you would if you were making your own sales.

Some stock agencies produce or purchase their own work-for-hire stock photography. This means they hire a photographer to shoot certain subjects or locations, researched and selected by the agency, and they pay the expenses, a fee, and possibly a small royalty on the sales. The copyright to these images belongs to the agency. Though I'm not crazy about the practice, it has become prevalent as a means of earning short-term income for hungry photographers. In the long term, however, these photographers will make a great deal less, while the agency will make a great deal more.

Finding an Agency. Selecting an agency depends on a number of factors. You want a successful, aggressive agency, and they want a talented and prolific photographer. Stock photo agencies are a serious business aimed at making money. Their time is valuable, which means you must have more than a passing interest in being represented.

Finding the agency that is right for you takes the same kind of research as finding clients for your assignment photography. First, talk with photographers to see who they work with or recommend. Find out which agencies are seeking your style of photography. Second, ask art directors which agencies they call for your kind of images. Take a close look at the stock agency advertisements in leading graphic publications and talk with photographers represented by the agency. Their web sites are probably the best place to learn who is with an agency and the wide range of services and products they offer image buyers.

There are two basic types of agency. The general agencies cover just about every general subject. Specialty agencies represent only a single genre of images, such as wildlife, news events, travel, or historic images. The ideal agency is one that has a need for the kind of photography you produce.

Your List. As you research the various stock agencies, try to find out who the main contacts are for prospective photographers. If they don't have anyone listed, call their offices or send an e-mail and ask. Make a list of these people, along with their mailing addresses. Sell to this list of clients as you would assignment clients.

Agency Requirements. Most established agencies have basic requirements for prospective photographers. Print these out and save them.

SELLING YOURSELF TO POTENTIAL AGENCIES

Selling an Agency. Edit your very best portfolio work into about twenty images. Make this group of images into a Photoshop contact sheet and save that to a disc. Make a high-quality hard copy of the contact sheet. This will be the main piece in your agency sales effort, so make sure it's good.

Send these items, along with a letter stating your interest in placing work with the agency, to the people on your prospective agency list. I suggest limiting this effort to a single agency at a time. Many agencies are owned by larger corporations that talk to each other. Remember, they are the market, and it's a buyers' market. Set your sights on the best agency possible and be persistent in trying to attract their attention.

The following is a sample letter to an agency:

Dear Agency:

I am a successful professional photographer seeking to place my best images with a good stock agency. You come highly recommended by James Brown, an art director with XYZ Company in Your City.

I have enclosed a small sample of my photography for your consideration. If my work fits your established standards, perhaps we could meet to discuss the possibility of an agreement. I can supply additional images, should you wish to see a wider selection of my work. You can also see the scope of my assignment work and clients on my web site, www.coolphotos.com.

If we reach an agreement, I am ready to provide you with an immediate five thousand images for consideration and possible inclusion in your sales library. I am also able to provide an additional five hundred new images each quarter.

Your time and consideration of my work are greatly appreciated.

Sincerely,
Tory Smith
Smith Photography

Why Street Mail? All of the stock agency people are high-tech oriented, spending hours of their day in front of a computer. I know it would seem best just to send them an e-mail with your best images and a note. My guess is they probably receive a lot of these e-mails, most of which are deleted. Have your package hand-delivered if possible. Consider sending the package via FedEx. An air express package cannot be ignored. It will be opened and the recipient can view your contact sheet or use the photo disc. Either way, your work will be noticed.

$ *You will have to sell yourself to a potential stock agency. Treat them just like you would any assignment client, because that's exactly what they are—a client.*

Once you've attracted the attention of an agency, it's time to discuss the business side of things. All stock agencies have a standard photographers' contract. They will provide you with a copy, probably as a downloadable document. Read the contract. Make sure you understand the requirements, terms of representation, fees, income share, and related items.

$ *Make sure you can live up to all the agency contract terms before signing.*

Contracts. Agency contracts may or may not be negotiable. No matter which, your lawyer should give any contract you sign the once-over to advise you of any potential areas of uncertainty. Armed with this information, try to personally meet with the agency to discuss your relationship. If they are in a distant city, these discussions will have to be done via telephone or e-mail.

A good agency understands that you are a creative person and they will be open to your personal approach. However, you will probably be met by a brick wall if they are forced to deal with your lawyer, or you want to make any major changes to what they call a "standard contract."

When an agency wants you to sign a contract and join the ranks of their photographers, they are at their very best. Unless you become one of their highest-grossing photographers, you will become another numbered account from which they must accept images and to which they must make payments. In other words, make your needs known up front and in writing, because once the ink has dried on the contract, you have to go to work and they go back to work. There aren't many second chances to reconsider any of the terms. Don't be put off by this fact of business, because that's the way business is done. You will be dealing with a corporation that intends to make a profit.

The Fine Print. Every contract has a little fine print. Some agencies want exclusive representation. This means they're the only agency representing your work. It may also mean that you can't make direct stock sales to any one client. All agencies want exclusive images that are only with their library and no other agency's library.

There are a few smaller regional agencies that allow photographers to be represented by other distant regional agencies. However, today's small agency will eventually grow, sell nationally, and perhaps be purchased by a larger agency. This could mean that two agencies in the same city may have the same photographer's images. Agency legal types do not like these situations, so start with a single agency and see how that works. You'll be busy enough with one agency as it is.

Copyrights. This may seem obvious, but make sure you retain the copyright to the images you provide an agency. This should include the results of any manipulated and/or combined new images created from your images, and other changes they make in your images. Do not allow them to share or own the copyrights to your images, no matter what the format or what their standard practice. Your images are the only thing an agency wants from you. If they own your images, they don't need you. Read the fine print in your contract about copyrights. Of course, this may be a moot point if you have signed a work-for-hire shooting stock contract.

Contract Length. The Term of Representation is generally three years for the first contract. This gives you and the agency enough time to see if a mutual profit can be made. After that, contracts generally run five years. Many agency contracts have an automatic renewal, if neither you nor the agency objects in writing.

What happens if either you or the agency is unhappy? Can the agency quit accepting your images? Can you quit submitting? What if one party elects not to renew the agreement? There should be a procedure and fixed schedule covering all such contingencies. Most agencies have the right to market any images used in their catalogs, promotion, or web sites beyond contract termination. This is not an unreasonable request so long as a specific time period is agreed upon. Some contracts state that the agency has a certain number of years to market a given image. This means that each image has its own "expiration date" with the agency, regardless of the duration of the contract.

Payment and Accounting. How does the agency handle accounting of image sales? How often do they pay photographers, and what proof of sales accounting is provided? Do photographers have audit or inspection rights to their own accounts and submissions? What fees are they expected to pay or share with the agency? All of this should be well covered in your contract, and not an insider's secret.

Fees. Agencies generally consider photographers to be necessary suppliers rather than creative talents—after you have signed the contract, of course. Many impose fees for a variety of services, some of which might be aimed at making money before an image is even sold.

There may be a fee to accept and file an image into their library. The agency pays a staffer $10.00 an hour to accept, edit, record, and download one hundred images. They charge you five bucks per image to cover this cost. Figure it out. Imagine the agency fee for accepting your initial 5000 images! Again, these things are covered in your contract. Make sure you understand everything in that contract and can live with everything.

Agency Sales. Most stock agencies have extensive sales resources, using catalogs, advertising, flyers, promotions, e-mail, web sites, and an in-house sales force. Over the years, this has become the place for photo buyers and creative people to examine and select stock images. Rarely will you see an agency, magazine, designer, or other marketing-oriented business that doesn't employ most of these resources.

Photographers are generally not required to participate in agency sales programs. A few smaller agencies have photographer-based catalogs in which you can purchase pages. You get to determine which images appear in the publication, which is sent to known photo buyers. Make sure their fees aren't substantially more than it would cost you to print and mail a flyer to the same people.

Don't misunderstand my questioning of agency fees. Stock photo agencies are in business to make money. I know many agency principals and respect their profit and business motivations, especially when it includes photographers. There are, however, agencies that charge you an image filing fee, a file duplication fee, a catalog fee, and a pull fee to leave the agency. Some of these agencies also intend to profit from the handling of your images rather than the selling of those images. Don't let that happen to you.

Your Role with a Stock Agency. You can be either an asset or a pain in the asset to a stock photo agency. One makes money for both parties, the other costs both parties money. The single ingredient to making money with your agency is communication. This doesn't mean calling every week to see if they have sold your latest submission. It also doesn't mean calling to see where your check is for the past quarter. It means letting the agency know what you are doing work-wise and paying attention to the information they send you regarding agency image needs.

You need to know what the agency is selling, what's hot in new photo uses, and how you can improve submissions, quality, ideas, caption information, pre-submission editing and, yes, sales ideas for the agency.

Better stock agencies send newsletters and lists of photo needs to their photographers on a regular basis. These reports often relate the agency's best sales, new photo-buying trends, marketing opportunities, photographer and agency news, and other information aimed at the common goal of selling images. The better photographers read the reports and adjust their shooting and submissions accordingly. This doesn't mean you have to change styles or quit being a creative shooter because the market is slow. It means that photo buyers are requesting certain images, which you can produce and submit.

Submissions. Your agency may require a certain number of submissions and acceptances each year. Their big stick might be a reduction in your share of the income from any sales if this minimum isn't met. This isn't a way to make more money from you; it's a way to get submissions. Photographers who constantly produce and submit new work to an agency are profitable—to that agency and to themselves.

The more quality images you submit to this agency, the more money you will make. These are the welcoming words you will receive from a stock photo agency. The more images an agency has, the greater their potential for sales. The greater your agency sales, the greater your share. It's a simple process.

How many images should you submit each month? I suggest you submit the best images made during the past month, be they ten or ten thousand. Even though a large number of images on file with an agency can lead to greater sales, the quality of your work is the basis of all sales and agency selections. Your job is to consistently make and submit high-quality images.

Too many photographers sign on with stock agencies just to find a home for their excess or outtake images. What the photographer can't sell, they hope the agency will sell. This is not the path to greater riches, and you can bet your next commission check that the other photographers will be submitting their best first-takes to the agency.

Agency Clients. The world's leading users of photography, the clients who spend the Big Bucks on images, know all about stock photo agencies and their various products. As often as not, the agencies are among the first places that are called when there's an immediate need for good photography. By making two or three calls, a client can have hundreds, if not thousands, of top-quality images on their computer screen within a matter of hours.

In the world of assignment photography, reputation and experience are often the prerequisites for getting choice jobs. Stock photography, on the other hand, is purchased because it's the right image at the right time, not because it's the right photographer. Your images have the same opportunity

to sell as the best hotshot's in the same agency. The client rarely knows or cares who made the image.

Selling Around Your Agency. Sometimes a client of your stock agency will call you directly, seeking a better deal. This is a tough but not uncommon position to find yourself in. It can be tempting to sell around your stock photo agency, especially if you have occasionally sold stock directly. It's also easy and tempting to make direct calls to clients who have purchased your images through an agency. While this may make a few sales, some clients have no loyalties and only want to save a buck. It may also damage the relationship with your agency. It may void your contract. Worse, it may bring on a legal action. No matter which, it isn't the right thing to do with a business partner, and that's exactly what a stock agency is—your partner.

In signing an agreement with a stock agency, you promise to produce and provide images, which they promise to sell. This is a great combination that can lead to even greater profits. I suggest you spend as much time as possible making images for the agency to sell, rather than seeking ways to make sales around their efforts.

When a stock agency and photographer click well so do sales and profits—no matter what the agency.

THE BAD NEWS ABOUT STOCK PHOTOGRAPHY

If you haven't already gotten a feeling for the business of stock photography, I need to say it a little more directly. Stock photography is a business, and for the two or three major players it's a very big business. And in case you haven't noticed, in the real business world the individual doesn't play much of a role. I know that some CEOs make a lot of money these days, but not much trickles down to the people who create their products.

We photographers are included in that last category of people who produce a corporation's products. You may have gotten the impression that it's easy to sign up with a stock photo agency. Unless you're a very good and prolific shooter, however, it's going to take a lot of persistence. That's okay, because we covered that in chapter 1.

The two largest agencies aren't accepting many new shooters or images, unless their work is already in demand.

That means you need to find and shoot what they need, or create a demand for your work. At the moment they are very interested in news, entertainment, celebrities, bizarre events, impossible-to-get subjects, and the like. Some of their freelancers and work-for-hire shooters are doing very well, as a result.

Even if you are with one of those giants of the photo industry, to them images are simply a numbers game. They have signed lots of photographers and only need to make a few sales from each of them every month in order to make a lot of money. In order to make any money yourself, as I've said earlier, you need to make sure you have lots of good images with your agency. If you are able to do that, you will survive very well. If not, signing with them may be counterproductive. Take a close look at the agency you hope to be with, and talk with some of their average photographers before signing anything.

Something else I haven't mentioned is the percentage of an image sale you will receive from a large agency. Very few new contracts are signed for anything more than 20 percent to the photographer, so 80 percent to the agency. It's often lower for the photographer with royalty-free sales contracts. You and your agency must both be very prolific for you to make serious money.

What to Do. Take a lot of great shots and get them in front of the people who buy those kind of images. Same as an assignment shooter, same as those mega agencies. How do you think those agencies got to be "mega" in the first place?

No matter how big and prolific the mega agencies are, there will always be people who simply don't like dealing with huge business concerns, no matter what price and selection advantages they may offer. Some photographers feel this way, as well.

If this is the case, I suggest you start with the smaller agencies. It will be easier to get your work accepted, and you may be able to establish a reputation. This rarely happens in the very large agencies, where they want to establish their own reputation. By gaining a reputation, you will create a greater demand for your work. That may be enough to make a very good living photographing the things you love.

$ *Learn from the mistakes of others. You won't live long enough to make them all yourself.*

These words greet trainees at the Navy's Special Warfare School, which trains Special Forces SEAL teams. These are the guys who do underwater demolition, parachute behind enemy lines, blow up missile sites, and make life very difficult for our enemies. Both the Navy and I know that Eleanor Roosevelt said those words first. So how does this macho military business relate to photography? Just like those Navy's SEALs, you won't live long enough to make all the mistakes that our profession will throw your way.

Want to find out all about the potential problems and opportunities in the worlds of business and photography? Visit the local library, a bookstore, or the World Wide Web. Seek out and study the work and words of people you admire and respect. Do the same thing for the people who have already made the Big Bucks, no matter what their business. You can read about and learn from what they have already accomplished and taken the time to put down on paper. Following the directions in these resources generally helps things in your own business. Doing things by feel is almost always more expensive in time and money.

There's a good how-to book available on just about everything, including all aspects of photography. A well-read photographer knows what's going on and how to be ahead of the competition when things start moving fast in his business. You can find all the information necessary to develop a very successful business just by reading. You already know this, or you wouldn't be reading my book in the first place!

Recommended Resources. I've provided several resources in the following pages that have helped me make successful business and creative decisions. Even a brief study of these suggested references will give you an idea of the information that's available. These resources should only be the starting point in your continuing education and decision making. Some of the most useful of these are www.amazon.com and www.google.com

Amherst Media Inc. (www.amherstmedia.com) is my longtime publisher. They have some of the best publications available today, on a wide range of photography subjects. Several Amherst Media books are included in my resources.

The resource information provided in this chapter was accurate at the time this book was written. However, with time and today's very mobile businesses, some of the locations may have changed and some of the organizations may be out of business. You can find just about anything on related subjects by searching the following web sites.

PHOTOGRAPHY BUSINESS BOOKS

The Photographer's Guide to Marketing and Self-Promotion, by Maria Piscopo
www.mpiscopo.com; www.allworth.com

Maria has examined the businesses and sales practices of more photographers than any other single person. As a result, she knows what she's talking about, and has put down some of her suggestions in this excellent guide. Her ideas and suggestions should be considered the standard by which you work. She has also created a series of interesting and informative video programs, which are directly related to making Big Bucks, including: *How to Get Paid What You Are Worth, How to Find and Keep New Clients, How to Create More Time and Less Stress,* and *How to Get Clients to Call You.*

Professional Business Practices in Photography
American Society of Media Photographers (ASMP)
www.asmp.com

This is one of the very best references about the business requirements of commercial photography. It is an informative and practical manual on subjects including assignment work, stock, pricing, estimating, negotiating fees, agreements, rights, releases, copyright, electronic technology, and marketing strategies. ASMP is a leading membership organization in modern photography.

Sellphotos.com, by Rohn Engh
www.photosource.com

The premier guide to establishing a successful stock photography business on the Internet. Rohn is a leader in the world of direct marketing, and this book is only one of his many publications. See his PhotoSource listing later in this chapter.

How to Grow as a Photographer, by Tony Luna
www.allworth.com

This is an inspirational guide for established photographers who have become a little bored producing the same old work, are having trouble keeping up with the digital revolution, or want to make some changes

in their business and life. Tony has been around the block, working as an artist's representative and executive film producer. His clients are among the leaders in editorial and advertising products.

Negotiating Stock Photo Prices, by Jim Pickerell
www.pickphoto.com

A prolific stock photography shooter shares some of his extensive information and experience. This book includes good, solid information on pricing and negotiation in the world of stock. His web site is loaded with good information and links to other excellent resources about photography in general, as well.

The Perfect Portfolio, by Henrietta Brackman
www.amazon.com

The best guide to developing an image, market, and career portfolio. Many of Brackman's secrets of selection, editing, and presentation are shared, all from over twenty-five years of working with such greats as Pete Turner, W. Eugene Smith, and Larry Dale Gordon. While this book is aimed primarily at print portfolios, it is the single best resource around for the philosophy of any portfolio development.

Legal Handbook for Photographers (2nd ed.),
by Bert P. Krages, Esq.
www.amherstmedia.com

There are many legal considerations in the world of freelance commercial photography. The better informed you are on legal matters, the fewer problems you will face. This book is loaded with legal information you'll need to navigate the maze of rights, liabilities, and similar legal topics in the photo business. This book was written by an attorney who specializes in intellectual property matters and is nationally recognized as a public advocate for the rights of photographers.

How to Create a High-Profit Photography Business in Any Market, by James Williams
www.amherstmedia.com

The book you need to build a successful photography business in any market and avoid common pitfalls. Covers setting your goals, attracting new business, and creating an image that appeals to clients. Provides a lot of information on selling and client interaction, with tips on creative marketing campaigns and networking with other professionals.

The Photojournalist's Guide to Making Money and *Marketing Strategies for Writers,* by Michael Sedge
www.allworth.com

Provides useful information for beginners and professionals interested in photojournalism and selling to world markets. Living and working from the west coast of Italy, Michael knows what's happening in international marketing and sales. This inside information will show you how to establish a photojournalism business, implement the latest research tactics, network with editors and other photo buyers, pitch to television producers, and expand business through lectures and teaching.

Professional Marketing & Selling Techniques for Digital Wedding Photographers (2nd ed.), by Jeff and Kathleen Hawkins
www.amherstmedia.com

Wedding photography is its own art form. However, successful shooters know there's more to it cameras and creativity. The Hawkins team shares a lot of business and marketing strategies, teaching photographers how to begin a successful, profitable, and well-regarded studio or improve upon an existing business. It is a valuable and comprehensive guide that no wedding photographer should be without.

Marketing & Selling Techniques for Digital Portrait Photography, by Kathleen Hawkins
www.amherstmedia.com

Kathleen provides a look at the way ever-changing digital technologies impact portrait photography and suggests a new set of marketing skills better suited to digital photography. You'll learn to identify your market, find a specialty niche, and will get tips for conducting sales-boosting sessions. The book is chock full of practical marketing and sales techniques, sample forms and letters, and beautiful images.

Master's Guide to Wedding Photography, Marcus Bell
www.amherstmedia.com

A compelling combination of gorgeous images and hard-won advice on everything from perfecting your wedding shot list to flawlessly capturing each crucial shot, to creating a lifelong photographer–client relationship. Marcus is one of the leading photographers in the business.

The Best of Adobe® Photoshop®, by Bill Hurter
www.amherstmedia.com

Using Photoshop, photographers have the power to refine and enhance their images after the shoot. Bill takes you through some common effects with Photoshop, then looks at images from some of today's top pros, showing how they were created. This is a great resource for learning what's possible with the powerful software.

The Best of Professional Digital Photography, by Bill Hurter
www.amherstmedia.com

This book provides a behind-the-scenes look at how the world's finest photographers craft their images, work with clients, and set the bar for other photographers in the digital world. Bill covers a wide array of topics related to all aspects of digital capture, including ideas for fine-tuning your capture, correcting images in postcapture, and much more.

Digital Capture and Workflow for Professional Photographers, by Tom Lee
www.amherstmedia.com

Workflow can be a complicated part of digital photography. Tom guides readers through the techniques needs to ensure the best-possible capture, fine-tune sharpness, exposure, and consistently good color. He also covers Photoshop retouching and a wide variety of plug-ins.

BUSINESS AND MARKETING BOOKS

Standard Directory of Advertisers
The Red Book of Advertisers
www.amazon.com

The very best and most complete listing of regional and national advertisers. Includes detailed information such as names, addresses, phones, e-mails, web sites, fax numbers, gross sales, advertising budgets, and their advertising agency contacts. This is the first step toward researching and building a solid and accurate mailing list. It's expensive, but it's the best resource in the business.

Standard Directory of Advertising Agencies
The Red Book of Advertising Agencies
www.amazon.com

An extensive listing of advertising and public relations agencies. Once you find the clients in *The Red Book of Advertisers,* this publication will help you find their agency people to contact. Provides detailed information, such as names, addresses, phones, e-mails, web sites, fax numbers, gross income, and their other client contacts. It's expensive, but it's the best resource in the business.

Literary Market Place
www.literarymarketplace.com

This is the most comprehensive listing of book publishers, and their related suppliers, available. It contains names, addresses, phones, e-mails, web sites, fax numbers, and their other important information about the publishing world.

How to Sell Anything to Anybody and
How to Sell Yourself, by Joe Girard
www.amazon.com

Joe is the world's best salesman. Check it out in the *Guiness Book of World Records.* Through his books, he can teach everyone something about sales, ideas, promotions, and making Big Buck in any business. After all, selling is how we put food on the table. I suggest reading his books at least once every year.

Advertising Your Way to Success, by Cort Sutton
www.prenhall.com

The easy and understandable approach to advertising for the independent and small business owner. It will help you treat photography as a product and advertise it to your best advantage. Excellent examples of promotional ideas and advertisements.

How to Get Control of Your Time and Life, by Alan Larken
www.amazon.com

Read this book today and you will be organized tomorrow. This is one of the corporate world's most popular books. It's designed to help you gain control of time, planning, priority-setting, and organization. In a business as erratic as photography, having command of these things means having control of your life. Our time is what we sell.

In Search of Excellence: Lessons from America's Best-Run Companies, by Thomas J. Peters and Robert H. Waterman, Jr.
www.amazon.com

The information in this book is the result of an extensive survey of the world's best corporations, what we hope will be our future clients. Among other things, the authors report that successful people are brilliant on business basics and don't let tools substitute for thinking and creativity.

On Writing Well, by William K. Zinsser
www.amazon.com

The photographer who can get thoughts down on paper will be successful. This is a well-written guide on writing well. It will help you create better correspondence, proposals, captions, and goals. It's also a continual best-seller with professional writers.

Swim with the Sharks without Being Eaten Alive, by Harvey MacKay
www.randomhouse.com

A very good pep talk book, full of helpful suggestions about selling. Aimed at beating the competition to the job and to the bank. Our clients have been reading this one for some time now, so it follows that we should be reading it too.

How to Prepare and Present a Business Plan, by Joseph Mancuso
www.amazon.com

A good business plan is the heart of a good business. This guide lays the ground rules for business plans that are acceptable to bankers and potential investors. It includes forms, checklists, and sample financial statements.

Go Rin No Sho: A Book of Five Rings, by Miyamoto Musashi
www.overlookpress.com

This is a subtle book on the war of life and business. It has long been a must read for Japanese businessmen, the guys who are kicking our butts all around the business world, as well as running sales campaigns like military operations. It was written by a samurai warrior in 1645. It's aimed at martial arts but applies to business. It's sort of a martial business guide.

Innovation and Entrepreneurship, by Peter Drucker
www.amazon.com

According to the *Wall Street Journal,* Peter is the dean of business and management philosophers. While this book has been out of print for some time now, you can still easily find copies on the Internet, and it's worth the effort. A very foundation for the businessperson interested in succeeding.

MEDIA

Photo District News (PDN)

www.pdnonline.com

Subscribe to this publication immediately. It's the best place to keep up with current changes and developments within the business of commercial photography. Features the work of the best pros in the world and the up-and-coming photographers of tomorrow.

Nikon World

www.nikonworld.com

Devoted to the art of photography and, of course, promotion of the fine Nikon line of equipment and its aficionados (that means *fanatics*). Features top portfolios, equipment reviews, and information. It's a good resource, no matter what camera system you use.

Communication Arts

www.commarts.com

The best in visual communications. Their annual photography and commercial award editions are good resources of current work. Their annuals on design and advertising are places to learn who's who in your potential client pool.

Rangefinder

www.rangefindermag.com

A first-class magazine for professional photographers in all specialties. Covers a huge range of subjects each month, including equipment reviews, technical information, how-to articles, marketing stories, computer technology, and lots of the current best work being created in today. Prolific Amherst Media author Bill Hurter is the editor.

PhotoMedia

www.photomediagroup.com

A beautiful tabloid-sized professional photography magazine and mainstay on the West Coast for some twenty years. *PhotoMedia* targets serious creators and users of photography, with educational and inspirational articles on all aspects of photography. Their editorial information encourages readers to consider new products, services, techniques, and opportunities, while including features about the foremost photographers of the day, industry trends, special locations to photograph, industry news, people, technical features, and new product reports, as well as a calendar listing of photo happenings throughout the region. Obviously, I've been a big fan since their first issue.

AfterCapture

www.AfterCapture.com

This is the premiere monthly publication for photographic postproduction work. Also provides online multimedia resources for the professional photographer. In addition to archives of *AfterCapture's* print articles, AfterCapture.com provides original online content, tutorials, blogs, and audio and video podcasts. Some very nice images and information. Prolific Amherst Media author Bill Hurter is the editor.

www.photolinks.com

One of the all-around best places to find out what's happening throughout the world of photography. It presents a wide variety of photography topics in over eighty categories with more than 25,000 unique listings.

www.dpreview.com

This is where you'll find all the latest in digital photography and imaging news, reviews of the latest digital cameras and accessories, and discussion forums. The site also features a large selection of sample images, an unbiased digital camera buyers' guide, side-by-side equipment comparisons, and the most comprehensive database of digital camera features and specifications.

SALES AND MATERIALS

Creative Services Counseling

Maria Piscopo

888-713-0705

www.mpiscopo.com

Established professionals swear by, and I'm sure on occasion at, this knowledgeable career counselor. Maria conducts seminars throughout the country, where she also offers private counseling. She has the ability to compliment, criticize, and stimulate photographers to new heights in business, sales, and success. You can get a good idea of her capabilities by reading *The Photographer's Guide to Marketing and Self-Promotion,* listed earlier in this chapter.

PhotoSource International

Rohn Engh

715-248-3800

www.photosource.com

Home of *PhotoDaily, Photo Stock Notes, PhotoBulletin, Photo-Market, PhotoLetter,* and a host of other valuable photography sales and information resources. Rohn is a leader in photography direct marketing. He's also the prolific author of several excellent books on selling photography. His web site is an excellent resource for learning about and keeping up with the ever-changing business side of photography.

Agency Access

www.agencyaccess.com

I use Agency Access for all of my direct mail lists. They specialize in developing custom lists of photography buyers, and their site allows you to create even more customized listings for a wide variety of buyers. It's a simple matter of selecting the specific publications or organizations and the type of buyer or user within that organization. They also provide phone and e-mail contact information. An excellent starting list can be created for around $100.00.

fotoQuote

Cradoc Bagshaw

www.fotoquote.com

Excellent software for quoting jobs and stock photo prices. Easy to use

right out of the box, prices in international currencies, licensing agreements, a huge magazine database for job and price quoting, and a simple graphic map for quoting in or to specific locations. This is a great investment if you are selling rights-protected images.

Pickerell Services
Stock Connection
www.pickphoto.com

An extensive online stock photography web site that's loaded with portfolio galleries, educational information, product resources, and links to other interesting photo sites. Jim has been in the stock business since it began and designed this site for others interested in learning from his many years of experience.

PunchStock
www.punchstock.com

A unique site containing a over a million rights-managed and royalty-free stock photos and illustrations from the world's top photographers and leading stock agencies' libraries. It's like a visit to Corbis, Getty, UpperCut, Index Stock, BananaStock, and a dozen other excellent stock agencies. You can surf through images from all of these agencies, but you are not connected to those agencies—and you don't need to be a member, know a password, or have a secret handshake to look around.

Getty Images
www.gettyimages.com

Getty Images has the largest collection of stock photography in the world. They must have at least 10,000 creative suppliers of still photography, motion picture footage, news, entertainment library images, and assignments to produce all of these materials. This is the place to see what's happening in the world of image making and selling.

Corbis
www.corbis.com

Corbis is one of the major players in stock photography library sales. It was the brain child of Bill Gates, who just wanted to buy rights to a few pretty pictures for his home. And being the brain that Bill Gates is, his interests grew into one of the leading collections of images in the world. Another good place to see the best in stock photography.

The Black Book
www.blackbook.com

The leading advertising and assignment resource for photographers. In addition to publishing a quality book, they also offer online portfolios and client resources. A very good place to display your work and to see the work of top professionals.

Workbook
www.workbook.com

A huge resource for selling your stock and assignment photography. In addition to publishing a large yearly collection of photographer's images, they also offer online portfolios, directories, and client resources. This is also an excellent place to display your work and to see the work of top professionals.

Planet Point
www.planetpoint.com

This is a great web site to present your portfolio, or find such creative services as copywriting, stylists, agents, and sales representatives.

Adobe Systems
www.adobe.com

These people create the software that makes our photos look so good.

Photoshop World
www.photoshopworld.com

These people teach us how to use the software that makes photographers look good. Visit this site to see what's next in this great world of image-editing software.

Microsoft
www.microsoft.com

These people create the software that makes our offices run efficiently.

Apple
www.apple.com

This is the place to research all that great Apple computer equipment. The site often offers some nice sale prices and also sells Apple's reconditioned guaranteed equipment. Look here before buying on any cut-rate web site.

Amazon.com
www.amazon.com

Home of every book you can ever hope to read, not to mention many other valuable products.

B&H Photo
www.bhphotovideo.com

Home of B&H Photo, these people carry and sell just about anything and everything you'll ever need in the world of professional photography. A good place to price check and learn the specifics about equipment, as well.

PayPal
www.paypal.com

PayPal is one of the leading banks, so to speak, that's online. Many leading product suppliers (like eBay and B&H Photo) accept payments from PayPal; your web site should too.

PROFESSIONAL ASSOCIATIONS

Membership in professional associations is an excellent way of keeping current on business developments, new products, promotions, and what your competition is doing. These associations represent us in legal matters, survey markets, offer many group buying opportunities, and are a good resource for helping members prosper in business. Best of all, in meeting the membership and ethical requirements you gain excellent credibility.

American Society of Media Photographers (ASMP)
 www.asmp.org
National Press Photographers Association (NPPA)
 www.nppa.org
Nikon Professional Services (NPS)
 www.nikonpro.com
Professional Photographers of America (PPA)
 www.ppa.com
Society of American Travel Writers (SATW)
 www.satw.org

EDUCATION
PDN PhotoPlus Expos

www.photoplusexpo.com; www.pdnonline.com

The best major photo information and product conferences. A very reasonable way to see the latest in equipment, materials, and photography ideas. Conferences are offered each year in several major metropolitan areas. Seminars and workshops are also conducted by leading professionals in the photography business. Get on their mailing list for information.

Maine Photographic Workshops

David Lyman, Director
www.theworkshops.com

This is an excellent place to see leading photographers and their work up close. The classes and workshops are also great places to learn about the real world of photography, from those same people. An extensive seminar and course catalog is available. The location alone makes their workshops worthwhile.

Brooks Institute

School of Photo Art and Science
www.brooks.edu

The leading school of professional commercial photography and a beautiful place to shoot. Brooks offers a quality education and degree in the technique and art of photography.

FEDERAL HELP
The Internal Revenue Service (IRS)

www.irs.gov

The IRS is one of the most extensive resources of tax and business information available, which often comes as a great surprise. The funny thing is, however, many small business owners do not take advantage of this free service. There's no doubt that the business of freelance photography can often pose interesting tax questions. If you are unable to answer such unusual questions, drop the IRS a brief note. Asking for information will not trigger an audit. Not asking and making a mistake in your taxes, however, just might pull that audit trigger.

IRS Forms Distribution Center

www.irs.gov/formspubs

The has a multitude of publications and forms available, which you should at least review. Sometimes the name of a specific publication may change, but others will take their place. I suggest taking a look at the following subjects: Your Rights as a Taxpayer; The ABCs of Income Tax; Tax Guide for Small Business; Travel, Entertainment, and Gift Expenses; Exemptions, Standard Deductions and Filing Info; Tax Withholding and Estimated Tax; Educational Expenses; Miscellaneous Deductions; Guide to Free Tax Services, and Business Use of a Car.

Small Business Administration

Office of Business Development
www.sba.gov

This is another organization with numerous business publications. Local offices also offer workshops, seminars, and counseling by retired and very successful businesspeople. Take advantage of this excellent resource.

U.S. Library of Congress

Copyright Office
www.copyright.gov

This is the place to learn everything you ever wanted to know about copyrights. It's the place to get forms, as well, and instructions on proper filing of those forms.

BASIC FORMS

Forms appearing in this section may be copied or duplicated for your own business use. For your convenience, the forms are available online for download from the publisher's website. To access these PDF files (which can be opened with Adobe Acrobat), go to www.amherstmedia.com/downloads.htm. Click on the title of this book and enter the password H1856.

YOUR LOGO

A logo is the identifying mark of your business and should be placed on every piece of business paperwork. This includes all of the forms provided in this chapter, as well as your letterhead, business card, and all promotional materials.

Your logo should look professional, so consider having it created by a graphic designer or print shop. It should also say something about the photography, service, or product you produce and deliver. It can be as simple or complicated a graphic design as your creative desires and pocketbook will allow. I use images from my shooting, different in each piece, as a logo. Some photographers use a camera or other item unique to the type of subjects they cover.

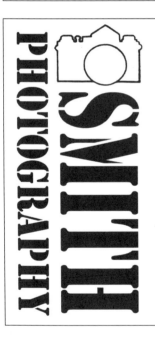

ABOVE—Sample logo.
LEFT—Sample business card.

TORY SMITH
2223 SECOND AVENUE
PHOTOTOWN USA 12345
TORY@SMITHPHOTO.COM
WWW.SMITHPHOTOS.COM

Mr. James James
Vice President
James Advertising
1000 Madison Ave.
New York, NY 10000

Date

Dear Mr. James:
One photograph may be worth a thousand words, but if it's the right image, it can be worth a hundred times that to the clients of James Advertising.

I make exciting photographic images that will help your clients sell their products in the widest possible range of markets. If you like the enclosed sample, you'll like what we can create together.

Allow me fifteen minutes of your time, and I'll share more of my images and some interesting ideas.

Sincerely,
Tory Smith
Smith Photography

Mr. James James
Vice President
James Advertising
1000 Madison Ave.
New York, NY 10000

Date

Dear Mr. James:
It was a pleasure meeting you yesterday. Thanks for taking the time to view my photography and for considering it for future projects with James Advertising.

I was most interested in the extent to which your company plans to utilize visual images for future campaigns. I'm sure the addition of Creative Director Mary Pleasant to your staff is in part responsible for this exciting direction. Her many media awards from So-and-So Magazine are well deserved.

During our meeting you mentioned a potential location photography project with the Same Old Widget Company of Mill Town, USA. I am most interested in presenting an estimate to produce this location photography. Please let me know if you would like to see a comprehensive proposal to complete that project.

Thank you for considering my photography and visual marketing ideas. Should you desire to see any additional images, please call. I look forward to the possibility of working with the professionals at James Advertising.

Sincerely,
Tory Smith
Smith Photography

SALES CALL/PORTFOLIO FOLLOW-UP LETTER

Tory Smith
2223 Second Avenue
Phototown, USA 12345
www.smithphtos.com

ESTIMATE

Shooting Date:	Today's Date:

Agency:	Client:
PO#:	PO#:
Art director:	Representative:
Phone:	Phone:
E-mail:	E-mail:

Billing address:	
Job description:	Shoot location:
Usage:	Rights:
Image format:	Equipment:

EXPENSE	DESCRIPTION	ESTIMATED	ACTUAL
Photo Fees			
Materials			
Telephone			
Assistants			
Props			
Transportation			
Insurance			
Special Equipment			
Accommodations/Per Diem			
Miscellaneous			
TOTAL:			

THE NOT-SO-FINE-PRINT TERMS OF ESTIMATE

(This form should be printed on the reverse side of your estimate form.)

1. THIS IS AN ESTIMATE, not a bid or firm quote, to provide services and other items necessary to produce photography for the client and the proposed use stated on the front of this form. It's good for the next thirty (30) days and then subject to reconsideration.

2. The estimates for fees and expenses are based on your original layouts, job descriptions, and requested reproduction rights. We expect payment for all estimated expenses in advance of the job. They are subject to actual costs, which will be reported in the final invoice.

3. We understand budgets, approvals, and changes in creative needs. Please inform us should there be any changes, additions, or variations in your requirements, as they may affect the project's actual costs. The client for whom this work is ultimately made is also ultimately responsible for payment of fees and expenses incurred by the photographer in this project.

4. If you wish to accept our estimate and tie us into a firm quote for the service/fee portion of this estimate, do so by entering into a simple letter of agreement. Such an agreement is the place to cover cancellations, postponements, re-shoots, and other related items that may affect the project.

5. Your use rights are stated on both the estimate and the final invoice, which are granted upon payment. Nonpayment is an infringement of our copyright. We own the copyright to these images unless otherwise stated in writing on the final invoice. You are expected to provide copyright protection for us, at no charge, for each use.

6. You accept full liability for all uses and indemnify us against all claims for any improper, illegal, or outrageous uses. We maintain the right to use these photos in our own promotions and to resell any generic images.

7. WE WANT TO DO BUSINESS WITH YOU. If there are any questions, please call or e-mail us immediately. Should any legal disagreement arise from this project, let's attempt to settle it together. Should that fail, we reserve the right to arbitration or other legal action.

Tory Smith
2223 Second Avenue
Phototown, USA 12345
www.smithphtos.com

Mr. James James
Vice President
James Advertising
1000 Madison Ave.
New York, NY 10000

Date

Dear Mr. James:

I am pleased to have been selected to produce photography of "The New Widget" for a two-year advertising campaign you are conducting on behalf of the Same Old Widget Company of Mill Town USA.

According to your creative director, Mary Pleasant, our shooting will begin at 9:00am on July 1st, at the Same Old Widget plant in Mill Town. I have received Ms. Pleasant's layouts for the principal shots and expect her to supervise at the site. The photo team, myself, and my production assistant have scheduled three days' working time at the Mill Town plant.

We understand that a purchase order and check in the amount of $0000, for one-half the photo fees and all estimated materials, travel, and related expenses, will be forthcoming. A complete invoice will be presented along with our final selection of images. In the event of a cancellation or postponement on your part less than three days prior to the photo team departure, the photo fees paid to date will be forfeited.

James Advertising and their client, the Same Old Widget Company, will receive written two-year unlimited use rights to the selected images upon payment of the final invoice. Additional rights are available and negotiable.

Thank you for using my photography for this project. I am looking forward to working with the professionals at James Advertising.

Sincerely,
Tory Smith
Smith Photography

LETTER OF AGREEMENT

This LETTER OF AGREEMENT sets forth the terms under which John Q. Photographer will provide services necessary to produce photographic images for James Advertising and their client, Same Old Widget Company.

1. Tory Smith and assistant will provide three days' location photography of the New Widget, at the Same Old Widget Company in Mill Town, starting July 1st at 9:00am.

2. Tory Smith will provide all of the normal and necessary photo and lighting equipment to complete this project. In addition, he will procure and provide the necessary materials and client proofs.

3. James Advertising has provided a production memo, a copy of which is attached, stating the type and size of digital documents desired, composition parameters, and product placement needs. Mary Pleasant, Creative Director, will be present at the photo sessions to supervise and approve progress.

4. James Advertising will provide a check in the amount of $0000, as advance payment one-half the photo fees, estimated materials, transportation, and location costs. In the event of a cancellation on your part, less than three days prior to the photo team departure, the photo fees paid to date will be forfeited. A copy of the photographer's estimate for these items is attached.

5. Tory Smith will provide a final invoice for the balance of fees and any outstanding expenses, along with receipts for expenses. Rights to image use commence upon payment of this photographer's invoice.

6. James Advertising and their client, the Same Old Widget Company, but no third parties, will receive two years' unlimited use for the selected images. Additional uses or extensions are available and negotiable.

7. Tory Smith retains the right to use the images, in their final campaign form, for his own promotion and to resell generic images.

8. In the event of any disagreement or failure to complete this agreement, Tory Smith retains the right to arbitration.

_____ _____

Tory Smith James James
Photographer James Advertising

_____ _____

Date Date

Tory Smith
2223 Second Avenue
Phototown, USA 12345
www.smithphtos.com

PHOTO DELIVERY RECEIPT

Enclosed please find:

QUANTITY	FORMAT	SUBJECTS

Received by: _____

Please acknowledge receipt, item count, and terms by signing and returning top copy.

Holding or using images signifies your acceptance.

SUBJECT TO TERMS ON REVERSE SIDE

THE NOT-SO-FINE-PRINT TERMS OF PHOTO DELIVERY

(This form should be printed on the reverse side of your photo delivery receipt.)

1. The enclosed photos/discs are for your examination and consideration for future use. We expect this will take a reasonable length of time, up to thirty (30) days. Let us know if you need longer for consideration, otherwise we charge a weekly holding fee.

2. These images represent our best photos for your proposed use. Please treat the photos/discs as though handling valuable papers, cash, or similar items. They are worth a great deal over a lifetime of sales. Please use signed return receipts and insurance when shipping.

3. Our rates are based on each use, media placement, print quantity, market, and similar items. Let us know your planned uses, and we'll outline the costs. We understand budgets and value long-term business relationships.

4. We own the copyrights to these images, which remain with us unless negotiated and stated otherwise on our invoice. Your use rights are granted upon payment of our invoice. Nonpayment is an infringement of our copyright. You are expected to provide copyright protection for us, at no charge, for each use. You accept full liability for all uses and indemnify us against all claims for any improper, illegal, or outrageous uses. We maintain the right to use these photos in our own promotions and to resell generic and similar images.

5. Model- and property-released images say so on the accompanying paperwork and the final invoice.

6. We want to do business with you. If there are questions, please call or e-mail immediately. No matter how serious a problem, we'd like to discuss and settle it directly with you. Of course, if this doesn't work out, we retain the option of arbitration or other legal action.

YOUR CONSIDERATION OF MY WORK IS APPRECIATED!

Tory Smith
2223 Second Avenue
Phototown, USA 12345
www.smithphtos.com

INVOICE/GRANT OF RIGHTS

Mr. James James
Vice President
James Advertising
1000 Madison Ave.
New York, NY 10000

Date: _____

Description of Job:
As per attached shooting list and agreement.

Expenses:

_____ .$_____
_____ .$_____
_____ .$_____
_____ .$_____
_____ .$_____
_____ .$_____
_____ .$_____
_____ .$_____

Less Advance: .– $_____

Amount Due: .$_____

Unless otherwise indicated, payment of this invoice grants one-time, nonexclusive rights to the listed photography, and/or as per the written agreement with your company. A copy of that agreement is attached.

TERMS: Net 30 days. Monthly rebilling charge added to past due accounts.

THE NOT-SO-FINE-PRINT TERMS OF INVOICE/GRANT OF RIGHTS

(This form should be printed on the reverse side of your invoice/grant of rights form.)

1. THANK YOU FOR DOING BUSINESS WITH US. This invoice is only for the services, fees, and use rights stated on the front. You are purchasing the one-time, nonexclusive rights to the photography listed, or such rights that are stated in our agreement, a copy of which is attached. We own the copyrights to these images unless negotiated and stated otherwise on this invoice. Any electronic publishing, storage, or major manipulation requires additional compensation and written authorization by the photographer.

2. Terms are payment in 30 days, after which monthly rebilling charges will be added. Your use rights are granted upon payment in full of this invoice. Nonpayment is an infringement of our copyright. The client for whom this work is made is responsible for payment of fees and expenses incurred by the photographer in this project.

3. Our rates are based on each use, media placement, print quantity, market, and similar items. Please let us know if you have additional uses, and we'll negotiate costs. WE UNDERSTAND BUDGETS AND VALUE LONG-TERM BUSINESS.

4. We maintain the right to use these photos in our own promotions and to resell generic and similar images.

5. Model- and property-released images are noted as such in the accompanying paperwork and on the invoice.

6. WE WANT TO DO BUSINESS WITH YOU. If there are questions, please call or e-mail immediately. No matter how serious a problem, we'd like to discuss and settle it directly with you. Of course, if this doesn't work out, we retain the option of arbitration or other legal action.

WE APPRECIATE YOUR BUSINESS.

SMITH
PHOTOGRAPHY

Mr. James James
Vice President
James Advertising
1000 Madison Ave.
New York, NY 10000

Date

Dear Mr. James:
Thank you for the press proof copies of the Same Old Widget Company's new national advertising campaign, which utilizes my photography. I am very pleased with the overall look of this campaign.

In looking through our receivables for July, I note that our invoice for the balance of this photography project is still outstanding. I'm sure this is an oversight by your busy accounting department. Your attention in this matter will be greatly appreciated.

Sincerely,
Tory Smith
Smith Photography

Mr. James James
Vice President
James Advertising
1000 Madison Ave.
New York, NY 10000
Date

Dear Mr. James:
My bookkeeper has informed me that James Advertising is now 120 days outstanding in payment of our invoice for the Same Old Widget Company's photography project. A copy of the invoice, which now includes several monthly re-billing charges, is enclosed. I have called to discuss this matter with your accounting department, to no avail.

Our invoice requires payment in thirty (30) days and states that your client's use rights are granted only upon payment. Nonpayment is an infringement of our copyright. The client for whom this work was made is also ultimately responsible for payment. Unless payment is received within ten (10) days, we will have no alternative but to take action to protect our copyright, and to seek payment directly from the Same Old Widget Company.

Your immediate attention to this matter would be appreciated.

Sincerely,
Tory Smith
Smith Photography

COLLECTION LETTER

ASSIGNMENT CHECKLIST

FORMS AND PAPERS

❏ Job layouts or descriptions
❏ Photo releases
❏ Purchase order

❏ Agency names/phone numbers/payment addresses
❏ Client names/phone numbers/addresses
❏ Materials estimate advance

MATERIALS AND EQUIPMENT

❏ Laptop computer
❏ Location cell phone
❏ Backup hard drive
❏ Walkie-talkies
❏ Memory cards
❏ Camera bodies
❏ Lenses
❏ Filters
❏ Strobe system
❏ Stands
❏ Clamps
❏ Sync cords
❏ Remote triggering device
❏ Reflectors
❏ Grids, filters, gels

❏ Power cords
❏ Tripods
❏ Plastic freezer bags
❏ Gaffer's tape
❏ Marking pens
❏ Garbage bags
❏ Tool kit
❏ First-aid kit
❏ Batteries for everything
❏ Flashlight
❏ Bug repellent
❏ Swiss Army knife
❏ Scissors
❏ Notebook
❏ Travel checklist

DOCUMENTS

❏ Passport (with extra photos and copies)
❏ Airline tickets (and copies)
❏ ATA Carnet (foreign customs guarantee)
❏ Customs regulations (copies)
❏ Equipment registration forms (U.S. Customs)
❏ Letter of credit

❏ Credentials (letter of introduction and press card)
❏ Emergency medical information
❏ Medical prescriptions
❏ Insurance papers
❏ Equipment list (copies)
❏ Personal (copies)

CONTACT INFORMATION (NAMES, ADDRESSES, PHONE/FAX NUMBERS)

❏ Tourist organizations, visitors and convention bureaus
❏ At home contacts
❏ Client
❏ Agency
❏ Family
❏ Business associates
❏ Airline(s)
❏ Hotels

❏ Family doctor
❏ Business lawyer
❏ On-location contacts
❏ Client and agency contracts
❏ Model agencies
❏ ASMP and PPA
❏ U. S. Information agency
❏ U. S. Embassy

PHOTO RELEASE

I give (Photographer's Name) permission to photograph myself and/or property, and to use or sell the materials in any manner he wishes.

Signed: _____

Name (Print): _____

Address: _____

City: _____ State: _____ Zip Code: _____

Date: _____ E-Mail: _____

MINOR PHOTO RELEASE

I give (Photographer's Name) permission to photograph the below-named minor and to use or sell the materials in any manner he wishes.

Signed (Parent or Guardian): _____

Minor's Name: _____ Age: _____

Address: _____

City: _____ State: _____ Zip Code: _____

Date: _____ E-Mail: _____

PROPERTY PHOTO RELEASE

I give (Photographer's Name) permission to photograph the below named property, to which I have ownership and/or legal control, and to use or sell the photos in any manner he wishes.

Description of Property:

Signed: _____

Name (print): _____

Address: _____

City: _____ State: _____ Zip Code: _____

Date: _____ E-Mail: _____

SMITH PHOTOGRAPHY

Tory Smith
2223 Second Avenue
Phototown, USA 12345
www.smithphtos.com

CASTING SHEET

Name: _____

Mailing Address: _____

Phone: _____

E-Mail: _____

Web site: _____

Social Security #: _____

Birth Date: _____

Height: _____

—PHOTO—

Weight: _____

Eyes: _____

Hair color: _____ Length: _____

Sizes

Suit: _____ Dress: _____ Shoes: _____

Shirt: _____ Pants: _____ Hat: _____

Bust: _____ Waist: _____ Hips: _____

Agency: _____

Phone: _____ E-Mail: _____ Web site: _____

Representative: _____

SAG AFTRA SEG AFM AGVA WORK PERMIT

Tory Smith
2223 Second Avenue
Phototown, USA 12345
www.smithphtos.com

LOCATION EXPENSES COVER PAGE

(ITEMIZED ON NEXT PAGE)

Location:

Subject:

Client:

Job Number:

Date:

Total Expenses:

Tory Smith
2223 Second Avenue
Phototown, USA 12345
www.smithphtos.com

ITEMIZED LOCATION EXPENSES

(SEE COVER PAGE FOR TOTAL)

DATE	ITEM/LOCATION	AMOUNT

MAKING CASH PAYMENTS

A statement of cash payment form should be used when buying services or products for which no receipt is provided and cash is the only accepted method of payment. Examples might include hiring an on-the-spot model, a fisherman's boat, paying someone to carry heavy equipment, or, most commonly, for payments made to taxi drivers when traveling abroad. By using this form, you are creating a written record of what was purchased, the amount paid, the date, and other particulars. The IRS will accept such paperwork for business expense deductions so long as your purchase is normal and necessary for the job at hand.

PHOTOGRAPHY

Tory Smith
2223 Second Avenue
Phototown, USA 12345
www.smithphtos.com

STATEMENT OF CASH PAYMENT

Date:

Vendor:

Address:

City:

Country:

DESCRIPTION OF ITEM/SERVICE	AMOUNT

TOTAL PAYMENT:

Comments:

RECEIVING CASH PAYMENTS

A statement of cash receipt form should be used when a company or person pays you in cash. On occasion, a client might wish to get a better price by paying cash at the time you photograph their product. This happens in foreign countries now and then. Another example might be a person who sees you make a scenic photo and wants to purchase a print. When they pay you in cash, you should provide a receipt (and a copy for your files), which will have an address to which you can ship the print. The IRS requires that you use a method such as this to keep track of all cash income.

Tory Smith
2223 Second Avenue
Phototown, USA 12345
www.smithphtos.com

STATEMENT OF CASH RECEIPT

Date:

Received from:

Address:

City:

Country:

DESCRIPTION OF ITEM/SERVICE	AMOUNT

TOTAL PAYMENT:

Comments:

Tory Smith
2223 Second Avenue
Phototown, USA 12345
www.smithphtos.com

Mr. James James
Vice President
James Advertising
1000 Madison Ave.
New York, NY 10000

Date

Dear Mr. James:

It has been a pleasure working with the professionals at James Advertising on the photography project for the Same Old Widget Company of Mill Town. I was especially impressed with the capabilities of Creative Director Mary Pleasant.

Thank you for considering and using my photography for this project. We are interested in participating in any future photography programs that may arise with James Advertising. Please feel free to call any time to discuss ideas.

Sincerely,
Tory Smith
Smith Photography

INDEX

CREATING WORLD-CLASS PHOTOGRAPHY

Ernst Wildi

Learn how photographers can create technically flawless photos. Features techniques for eliminating technical flaws—from portraits to landscapes. Includes the Zone System, digital imaging, and much more. $29.95 list, 8.5x11, 128p, 120 color photos, index, order no. 1718.

PHOTOGRAPHER'S GUIDE TO POLAROID TRANSFER, 2nd Ed.

Christopher Grey

Step-by-step instructions make it easy to master Polaroid transfer and emulsion lift-off techniques and add new dimension to your photographic imaging. Fully illustrated to ensure great results the first time! $29.95 list, 8.5x11, 128p, 100 color photos, order no. 1653.

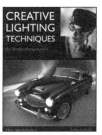

CREATIVE LIGHTING TECHNIQUES FOR STUDIO PHOTOGRAPHERS, 2nd Ed.

Dave Montizambert

Whether you are shooting portraits, cars, tabletop, or any other subject, Dave Montizambert teaches you the skills you need to take complete control of your lighting. $34.95 list, 8.5x11, 120p, 80 color photos, order no. 1666.

MACRO & CLOSE-UP PHOTOGRAPHY HANDBOOK

Stan Sholik and Ron Eggers

Learn to get close and capture breathtaking images of small subjects—flowers, stamps, jewelry, insects, etc. Designed with the 35mm shooter in mind, this is a comprehensive manual full of step-by-step techniques. $29.95 list, 8.5x11, 120p, 80 b&w and color photos, order no. 1686.

CORRECTIVE LIGHTING, POSING & RETOUCHING FOR
DIGITAL PORTRAIT PHOTOGRAPHERS, 2nd Ed.

Jeff Smith

Learn to make every client look his or her best by using lighting and posing to conceal real or imagined flaws—from baldness, to acne, to figure flaws. $34.95 list, 8.5x11, 120p, 150 color photos, order no. 1711.

PORTRAIT PHOTOGRAPHER'S HANDBOOK, 3rd Ed.

Bill Hurter

A step-by-step guide that easily leads the reader through all phases of portrait photography. This book will be an asset to experienced photographers and beginners alike. $34.95 list, 8.5x11, 128p, 175 color photos, order no. 1844.

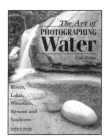

THE ART OF PHOTOGRAPHING WATER

Cub Kahn

Learn to capture the dazzling interplay of light and water with this beautiful, compelling, and comprehensive book. Packed with practical information you can use right away to improve your images! $29.95 list, 8.5x11, 128p, 70 color photos, order no. 1724.

DIGITAL IMAGING FOR THE UNDERWATER PHOTOGRAPHER, 2nd Ed.

Jack and Sue Drafahl

This book will teach readers how to improve their underwater images with digital image-enhancement techniques. This book covers all the bases—from color balancing your monitor, to scanning, to output and storage. $39.95 list, 6x9, 224p, 240 color photos, order no. 1727.

PROFESSIONAL TECHNIQUES FOR
DIGITAL WEDDING PHOTOGRAPHY, 2nd Ed.

Jeff Hawkins and Kathleen Hawkins

From selecting equipment, to marketing, to building a digital workflow, this book teaches how to make digital work for you. $34.95 list, 8.5x11,

PHOTOGRAPHER'S GUIDE TO
WEDDING ALBUM DESIGN AND SALES

Bob Coates

Enhance your income and creativity with these techniques from top wedding photographers. $29.95 list, 8.5x11, 128p, 150 color photos, index, order no. 1757.

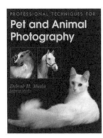

PROFESSIONAL TECHNIQUES FOR
PET AND ANIMAL PHOTOGRAPHY

Debrah H. Muska

Adapt your portrait skills to meet the challenges of pet photography, creating images for both owners and breeders. $29.95 list, 8.5x11, 128p, 110 color photos, index, order no. 1759.

THE ART AND TECHNIQUES OF
BUSINESS PORTRAIT PHOTOGRAPHY

Andre Amyot

Learn the business and creative skills photographers need to compete successfully in this challenging field. $29.95 list, 8.5x11, 128p, 100 color photos, index, order no. 1762. 128p, 85 color images, order no. 1735.

THE MASTER GUIDE FOR WILDLIFE PHOTOGRAPHERS

Bill Silliker, Jr.

Discover how photographers can employ the techniques used by hunters to call, track, and approach animal subjects. Includes safety tips for wildlife photo shoots. $29.95 list, 8.5x11, 128p, 100 color photos, index, order no. 1768.

HEAVENLY BODIES
THE PHOTOGRAPHER'S GUIDE TO ASTROPHOTOGRAPHY

Bert P. Krages, Esq.

Learn to capture the beauty of the night sky with a 35mm camera. Tracking and telescope techniques are also covered. $29.95 list, 8.5x11, 128p, 100 color photos, index, order no. 1769.

LIGHTING TECHNIQUES FOR
LOW KEY PORTRAIT PHOTOGRAPHY

Norman Phillips

Learn to create the dark tones and dramatic lighting that typify this classic portrait style. $34.95 list, 8.5x11, 128p, 100 color photos, index, order no. 1773.

THE BEST OF WEDDING PHOTOJOURNALISM

Bill Hurter

Learn how top professionals capture these fleeting moments of laughter, tears, and romance. Features images from over twenty renowned wedding photographers. $34.95 list, 8.5x11, 128p, 150 color photos, index, order no. 1774.

THE DIGITAL DARKROOM GUIDE WITH ADOBE® PHOTOSHOP®

Maurice Hamilton

Bring the skills and control of the photographic darkroom to your desktop with this complete manual. $29.95 list, 8.5x11, 128p, 140 color images, index, order no. 1775.

BEGINNER'S GUIDE TO ADOBE® PHOTOSHOP® ELEMENTS®

Michelle Perkins

Packed with easy lessons for improving virtually every aspect of your images—from color balance, to creative effects, and more. $29.95 list, 8.5x11, 128p, 300 color images, index, order no. 1790.

BEGINNER'S GUIDE TO PHOTOGRAPHIC LIGHTING

Don Marr

Create high-impact photographs of any subject with Marr's simple techniques. From edgy and dynamic to subdued and natural, this book will show you how to get the myriad effects you're after. $34.95 list, 8.5x11, 128p, 150 color photos, index, order no. 1785.

POSING FOR PORTRAIT PHOTOGRAPHY
A HEAD-TO-TOE GUIDE

Jeff Smith

Author Jeff Smith teaches surefire techniques for fine-tuning every aspect of the pose for the most flattering results. $34.95 list, 8.5x11, 128p, 150 color photos, index, order no. 1786.

PROFESSIONAL MODEL PORTFOLIOS
A STEP-BY-STEP GUIDE FOR PHOTOGRAPHERS

Billy Pegram

Learn to create portfolios that will get your clients noticed—and hired! $34.95 list, 8.5x11, 128p, 100 color images, index, order no. 1789.

THE PORTRAIT PHOTOGRAPHER'S
GUIDE TO POSING

Bill Hurter

Posing can make or break an image. Now you can get the posing tips and techniques that have propelled the finest portrait photographers in the industry to the top. $34.95 list, 8.5x11, 128p, 200 color photos, index, order no. 1779.

MASTER LIGHTING GUIDE
FOR PORTRAIT PHOTOGRAPHERS

Christopher Grey

Efficiently light executive and model portraits, high and low key images, and more. Master traditional lighting styles and use creative modifications that will maximize your results. $29.95 list, 8.5x11, 128p, 300 color photos, index, order no. 1778.

PROFESSIONAL DIGITAL IMAGING FOR WEDDING AND PORTRAIT PHOTOGRAPHERS

Patrick Rice

Build your business and enhance your creativity with practical strategies for making digital work for you. $29.95 list, 8.5x11, 128p, 200 color photos, index, order no. 1780.

STUDIO LIGHTING
A PRIMER FOR PHOTOGRAPHERS

Lou Jacobs Jr.

Get started in studio lighting. Jacobs outlines equipment needs, terminology, lighting setups and much more, showing you how to create top-notch portraits and still lifes. $29.95 list, 8.5x11, 128p, 190 color photos index, order no. 1787.

CLASSIC PORTRAIT PHOTOGRAPHY

William S. McIntosh

Learn how to create portraits that stand the test of time. Master photographer Bill McIntosh discusses his best images, giving you an inside look at his timeless style. $29.95 list, 8.5x11, 128p, 100 color photos, index, order no. 1784.

ARTISTIC TECHNIQUES WITH ADOBE® PHOTOSHOP® AND COREL® PAINTER®

Deborah Lynn Ferro

Flex your creativity and learn how to transform photographs into fine-art masterpieces. Step-by-step techniques make it easy! $34.95 list, 8.5x11, 128p, 200 color images, index, order no. 1806.

MASTER GUIDE FOR
UNDERWATER DIGITAL PHOTOGRAPHY

Jack and Sue Drafahl

Make the most of digital! Jack and Sue Drafahl take you from equipment selection to underwater shooting techniques. $34.95 list, 8.5x11, 128p, 250 color images, index, order no. 1807.

DIGITAL PHOTOGRAPHY BOOT CAMP

Kevin Kubota

Kevin Kubota's popular workshop is now a book! A down-and-dirty, step-by-step course in building a professional photography workflow and creating digital images that sell! $34.95 list, 8.5x11, 128p, 250 color images, index, order no. 1809.

WEDDING AND PORTRAIT PHOTOGRAPHERS' LEGAL HANDBOOK

N. Phillips and C. Nudo, Esq.

Don't leave yourself exposed! Sample forms and practical discussions help you protect yourself and your business. $29.95 list, 8.5x11, 128p, 25 sample forms, index, order no. 1796.

PROFITABLE PORTRAITS
THE PHOTOGRAPHER'S GUIDE TO CREATING PORTRAITS THAT SELL

Jeff Smith

Learn how to design images that are precisely tailored to your clients' tastes—portraits that will practically sell themselves! $29.95 list, 8.5x11, 128p, 100 color photos, index, order no. 1797.

RANGEFINDER'S PROFESSIONAL PHOTOGRAPHY

edited by Bill Hurter

Editor Bill Hurter shares over one hundred "recipes" from *Rangefinder's* popular cookbook series, showing you how to shoot, pose, light, and edit fabulous images. $34.95 list, 8.5x11, 128p, 150 color photos, index, order no. 1828.

BEGINNER'S GUIDE TO ADOBE® PHOTOSHOP®, 3rd Ed.

Michelle Perkins

Enhance your photos or add unique effects to any image. Short, easy-to-digest lessons will boost your confidence and ensure outstanding images. $34.95 list, 8.5x11, 128p, 80 color images, 120 screen shots, order no. 1823.

PROFESSIONAL FILTER TECHNIQUES
FOR DIGITAL PHOTOGRAPHERS

Stan Sholik

Select the best filter options for your photographic style and discover how their use will affect your images. $34.95 list, 8.5x11, 128p, 150 color images, index, order no. 1831.

MASTER'S GUIDE TO WEDDING PHOTOGRAPHY
CAPTURING UNFORGETTABLE MOMENTS AND LASTING IMPRESSIONS

Marcus Bell

Learn to capture the unique energy and mood of each wedding and build a lifelong client relationship. $34.95 list, 8.5x11, 128p, 200 color photos, index, order no. 1832.

MASTER LIGHTING GUIDE
FOR COMMERCIAL PHOTOGRAPHERS

Robert Morrissey

Use the tools and techniques pros rely on to land corporate clients. Includes diagrams, images, and techniques for a failsafe approach for shots that sell. $34.95 list, 8.5x11, 128p, 110 color photos, 125 diagrams, index, order no. 1833.

DIGITAL CAPTURE AND WORKFLOW
FOR PROFESSIONAL PHOTOGRAPHERS

Tom Lee

Cut your image-processing time by fine-tuning your workflow. Includes tips for working with Photoshop and Adobe Bridge, plus framing, matting, and more. $34.95 list, 8.5x11, 128p, 150 color images, index, order no. 1835.

PROFESSIONAL PORTRAIT LIGHTING
TECHNIQUES AND IMAGES FROM MASTER PHOTOGRAPHERS

Michelle Perkins

Get a behind-the-scenes look at the lighting techniques employed by the world's top portrait photographers. $34.95 list, 8.5x11, 128p, 200 color photos, index, order no. 2000.

PROFESSIONAL PORTRAIT POSING
TECHNIQUES AND IMAGES FROM MASTER PHOTOGRAPHERS

Michelle Perkins

Learn how master photographers pose subjects to create unforgettable images. $34.95 list, 8.5x11, 128p, 175 color images, index, order no. 2002.

MASTER LIGHTING GUIDE
FOR WEDDING PHOTOGRAPHERS

Bill Hurter

Capture perfect lighting quickly and easily at the ceremony and reception—indoors and out. Includes tips from the pros for lighting individuals, couples, and groups. $34.95 list, 8.5x11, 128p, 200 color photos, index, order no. 1852.

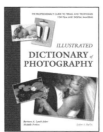

ILLUSTRATED DICTIONARY OF PHOTOGRAPHY

Barbara A. Lynch-Johnt & Michelle Perkins

Gain insight into camera and lighting equipment, accessories, technological advances, film and historic processes, famous photographers, artistic movements, and more with the concise descriptions in this illustrated book. $34.95 list, 8.5x11, 144p, 150 color images, index, order no. 1857.

MASTER GUIDE FOR TEAM SPORTS PHOTOGRAPHY

James Williams

Learn how adding team sports photography to your repertoire can help you meet your financial goals. Includes technical, artistic, organizational, and business strategies. $34.95 list, 8.5x11, 128p, 120 color photos, index, order no. 1850.

THE PHOTOGRAPHER'S GUIDE TO COLOR MANAGEMENT
PROFESSIONAL TECHNIQUES FOR CONSISTENT RESULTS

Phil Nelson

Learn how to keep color consistent from device to device, ensuring greater efficiency and more accurate results. $34.95 list, 8.5x11, 128p, 175 color photos, index, order no. 1838.